THE A. W. MELLON LECTURES IN THE FINE ARTS

DELIVERED AT

THE NATIONAL GALLERY OF ART

WASHINGTON, D. C.

BOLLINGEN SERIES XXXV · 13

JAKOB ROSENBERG

ON QUALITY IN ART

CRITERIA OF EXCELLENCE, PAST AND PRESENT

THE A. W. MELLON LECTURES

IN THE FINE ARTS 1964

THE NATIONAL GALLERY OF ART

WASHINGTON, D.C.

BOLLINGEN SERIES XXXV·13/PRINCETON UNIVERSITY PRESS

Library of Congress catalogue card No. 67-22342

Copyright © 1967 by the Trustees of
The National Gallery of Art, Washington, D.C.
Published for Bollingen Foundation, New York, N.Y.
by Princeton University Press, Princeton, New Jersey
Manufactured in the U.S.A.

Designed by Klaus Gemming

TABLE OF CONTENTS

LIST OF ILLUSTRATIONS

Unless otherwise indicated, the photographs have been supplied by the administration of the respective museum or gallery, and permission to reproduce is gratefully acknowledged. Specific acknowledgment is further made as follows: (Amsterdam) Copyright Fotocommissie Rijksmuseum, 45, 49, 50, 60, 62, 66, 67, 68. (Chatsworth) The Trustees of the Chatsworth Settlement, 141. (Dresden) Staatliche Kunstsammlungen (Deutsche Fotothek), 17, 25, 33, 39, 72, 73. (Florence) Soprintendenza alle Gallerie di Firenze, 1, 3, 9, 10, 16, 104. (London) The Trustees, The National Gallery, 7, 26, 55, 59, 77. (New York) The New York Graphic Society Publishers, Ltd., 81, 82, 83, 84. (Paris) Clichés des Musées Nationaux, 6, 11, 36, 37, 69, 70, 78, 79, 133, 142. (Rome) Gabinetto Fotografico Nazionale, 8, 31, 34.—An asterisk indicates an illustration in color.

ACKNOWLEDGMENTS

My sincere thanks for help in this undertaking should go to a number of people, named and unnamed. Many a conversation with colleagues, collectors, and friends of art has contributed to the development of my ideas about the subject—and not least, the students, by their lively answers when asked definite questions about definite examples. A decisive impetus to bring the treatment of our theme to a more final form came through the invitation of the National Gallery of Art, more specifically of its Director, John Walker, to deliver the A. W. Mellon Lectures in 1964 on the problem of quality. I am also indebted to Bollingen Series for the care given to the production of the book, and to Miss Berenice Hoffman for her excellent editorial work. I have acknowledged the sources of the photographs in the List of Illustrations. As in all my former works written in English, Miss Ruth S. Magurn has helped greatly by her patient and intelligent supervision of the literary formulation and the clarification of various passages. To my wife I feel deeply indebted for many discussions on the subject, from which I frequently profited.

JAKOB ROSENBERG

In recent years we have witnessed an astonishing rise in the prices paid for works of art, both of old and of modern masters. It has been a rise sensational to a degree hardly ever equaled in the past. Naturally one wonders about the causes and the justification for such a development, and this leads to a feeling of uncertainty about the real value of these works of art. We are not concerned here with the prices of art objects, with their material value, but with their aesthetic value, their quality. Yet if the art market acts on a sound basis, the material value should reflect the true artistic value or quality. Thus the problem with which we are concerned in this volume, namely, how to make a proper quality judgment, is as important for the art historian and the art critic as it is for the collector, the museum man, and the serious art dealer.

Our first question, then, is: What do we mean by quality, or, more specifically, by artistic quality? To put it simply, we mean the artistic value or the degree of excellence; therefore, our chief concern will be to search for valid criteria of excellence in works of art. Before going further, I want to say that quality is sometimes confused with such terms as "beauty," "taste," or "style." All of these, while to a certain extent their meaning can overlap the meaning of quality, are different phenomena, and we must therefore beware of confusion and avoid identifying quality with any of them, however tempting it may be.

Our second great question is whether artistic value can be "objectively" traced in a work of art, or whether it is only "subjectively" felt and thus simply a matter of personal opinion rather than of common agreement. This question leads us into the realm of philosophy or aesthetics. We shall not linger there very long. However, I want to cite three prominent contemporary opinions which throw some light on this problem, before defining my own position.

First, the art historian Erwin Panofsky, who, in his *Meaning in the Visual Arts*, says in a footnote:

"A scale of values is partly a matter of personal reactions and partly a matter of tradition. Both these standards, of which the second is the comparatively

more objective one, have continually to be revised, and every investigation, however specialized, contributes to this process." He adds, however: "When a 'masterpiece' is compared and connected with as many 'less important' works of art as turn out, in the course of the investigation, to be comparable and connectable with it, the originality of its invention, the superiority of its composition and technique, and whatever other features make it 'great', will automatically become evident."[1]

The important sentence here is: "A scale of values is partly a matter of personal reactions and partly a matter of tradition." This hardly leaves room for an objective description of quality, and it throws the phenomenon essentially on the side of subjective reaction. Still, there is a hint that quality is somewhat objectively traceable when Panofsky goes on to say that in the comparison of works of great and minor masters, originality of invention and superiority of composition and technique will automatically become evident. Moreover, he admits degrees of "objectivity" when he says that the standard of tradition is comparatively more objective than personal reactions.

Theodore M. Greene, the aesthetician, takes a somewhat different stand toward our problem. In *The Arts and the Art of Criticism,* in the chapter "Artistic Quality and Perfection," he says:

"The unique character of the artistic quality of a work of art can only be immediately intuited, and though it can be exhibited and denoted, it cannot be defined or even described. As a simple and ultimate quality it eludes analysis as inevitably as do sound and color. The artistically sensitive and trained observer will be able to recognize and appraise it with great assurance when he is in its presence; and the more artistically sensitive he is, the more will he appreciate the inescapable limitations of all formal analysis. But though analysis cannot define artistic quality itself, it can exhibit some of its determining conditions."[2]

The important statements here for our problem are first: "The unique character of the artistic quality of a work of art can only be immediately intuited, and though it can be exhibited and denoted, it cannot be defined or even described"; and further, "The artistically sensitive and trained ob-

[1] The notes (pp. 235 ff.) are documentary unless an asterisk follows the reference number, to indicate a comment.

server will be able to recognize and appraise it with great assurance when he is in its presence." Greene, then, although he stresses its indefinable character, accepts the objective existence of quality.

We finally bring in the opinion of a literary critic, I. A. Richards, who, in *Practical Criticism,* takes the following position regarding the value problem:

"There is, it is true, a valuation side to criticism. When we have solved, completely, the communication problem, when we have got, perfectly, the experience, the *mental condition* relevant to the poem, we have still to judge it, still to decide upon its worth. But the later question nearly always settles itself; or rather, our own inmost nature and the nature of the world in which we live decide it for us. Our prime endeavour must be to get the relevant mental condition and then see what happens. If we cannot then decide whether it is good or bad, it is doubtful whether any principles, however refined and subtle, can help us much. Without the capacity to get the experience they cannot help us at all. . . . Value cannot be demonstrated except through the communication of what is valuable.

"Critical principles, in fact, need wary handling. They can never be a substitute for discernment though they may assist to avoid unnecessary blunders. There has hardly been a critical rule, principle or maxim which has not been for wise men a helpful guide but for fools a will-o'-the-wisp. . . . Everything turns upon how the principles are applied. It is to be feared that critical formulas, even the best, are responsible for more bad judgment than good, because it is far easier to forget their subtle sense and apply them crudely than to remember it and apply them finely." [3]

Richards thus also accepts the phenomenon of artistic value as something real and traceable, but traceable only when we put ourselves into the relevant mental condition and find the proper communication with the work of art. Then, he says, the problem of worth settles itself. Then we get the artistic value as a result of direct experience, not definition. The most important statement of the passage is perhaps: "Value cannot be demonstrated except through the communication of what is valuable."

I am glad to say that I can accept a great deal of the attitude of these three authorities toward our problem of artistic value, although I cannot help differing with some of their opinions. Instead of discussing each point, I prefer to

state my own position; the ways in which I differ with the opinions above, though not serious, will then be apparent. Whether or not my own position is justifiable should become clearer through the further development of the subject, and I ask therefore that the reader reserve judgment.

1) "Artistic value" or "quality" in a work of art is not merely a matter of personal opinion but to a high degree also a matter of common agreement among artistically sensitive and trained observers and to a high degree objectively traceable.

Our value judgment is a composite of "subjective" and "objective" elements. "Subjective" I call those which are the purely personal responses of an individual; "objective," those which are agreed upon by trained observers and therefore meet with general acceptance. The composite nature of value judgment leaves room for the strengthening of the objective aspect, thus allowing us to attain a measure of validity. This, then, is what we are striving for in our investigation.

2) Quality may be sensed in a work of art without a proper approach and analysis, but it cannot be fully experienced without these means and without a thorough and definite effort on the part of the observer.

In the selections I have quoted above, only Panofsky has pointed to the importance of tradition for value judgment. While tradition has in its favor the "test of time," it does not necessarily create a scale of values more objective than our own personal reaction. But because of its importance and the accumulated experience which the value judgments of the past present to us, I have decided to give this matter considerable attention before venturing into our own investigation. Not only can we learn from the achievements and failures of earlier critics; the historical approach will also help us to gain greater perspective. I have therefore divided this series of lectures into two parts, the first dealing with the value judgments of the past, the second with the quality problem today as I see it. Because of limitations of space we shall confine our selections to one great and representative critic from each century, from the Renaissance to the twentieth.

Quality Judgment in the Past

CHAPTER I

The Sixteenth Century

GIORGIO VASARI [1511–1574]

WE begin with Giorgio Vasari [1], the "father of art history," as his best interpreter, Julius von Schlosser,[1] calls him. Vasari's *Vite de' più eccellenti pittori, scultori ed architettori* appeared in Florence first in 1550 and then, in an enlarged second edition, in 1568. It is from this second edition[2] that I shall quote, because the revision and the enlargement of the text were done by the author himself and show an improvement of critical judgment over the first edition. Selected quotations will help to indicate the actual flavor of Vasari's opinions, which a mere paraphrase cannot fully convey. They will also provide a glimpse of some of the highlights of Renaissance art.

Vasari was a noteworthy painter and an excellent architect—as the building of the Uffizi Gallery shows—and through his close relationship with Michelangelo and his comprehensive knowledge of Italian art of the Renaissance[3]* he was highly qualified for his patriarchal role in art history. Four centuries have gone by, and it is remarkable how much of Vasari's judgment has withstood the test of time and has maintained its validity. Naturally there were limitations, but Vasari was endowed with a real sense of the historian's craft as well as with a feeling for quality, as is indicated in the following passages from the Preface to the Second Part, which contains much of the substance

3

of his theory. Here he says: "These writers [he means the competent historians] have not contented themselves with a mere dry narration of facts and events, occurring under this prince or in that republic, but have set forth the grounds of the various opinions, the motives of the different resolutions, and the character of the circumstances by which the prime movers have been actuated."[4]

And Vasari's serious effort to arrive at a proper quality judgment is evident from the following:

"I have endeavoured, not only to relate what has been done, but to set forth and distinguish the better from the good, and the best from the better, the most distinguished from the less prominent qualities and works, of those who belong to our vocation."[5]

The limitations of Vasari's value judgment, which we mentioned above, may be traced to two sources: first, his concept of history, which led him to believe that his own century, by attaining and even surpassing the level of classical antiquity, ranked highest of all in artistic achievement; second, his unconditional devotion to Michelangelo. Vasari regarded Michelangelo as the greatest artist who had ever lived, and the one who set the ultimate standards for individual achievement. It is true that in the second edition of the Lives, Vasari raised Raphael close to Michelangelo in artistic rank, but the supreme position of the latter was not modified.

Adapting the general retrospective view of history prevalent in the Renaissance, Vasari divides Western art into three ages: the *età antica,* that is, antiquity; the *età vecchia,* which we now call the Middle Ages; and the *età moderna,* which he identifies with the period of the *rinascimento* inaugurated by Cimabue and Giotto. According to Vasari, antiquity saw the development of great art with the figures of Apelles and Zeuxis, the Middle Ages were a period of darkness—he calls it *secolo infelice* or *tenebre*—and the *rinascimento* not only brought back the standards of classical art but, in the work of Michelangelo, surpassed them. Like history as a whole, antiquity and the Renaissance are each marked by a tripartite division that parallels the sequence of growth in life and nature: childhood, youth, and maturity. The childhood of the *rinascimento* he identifies more or less with the Trecento, its youth with the Quattrocento, and its maturity with his own century. Each

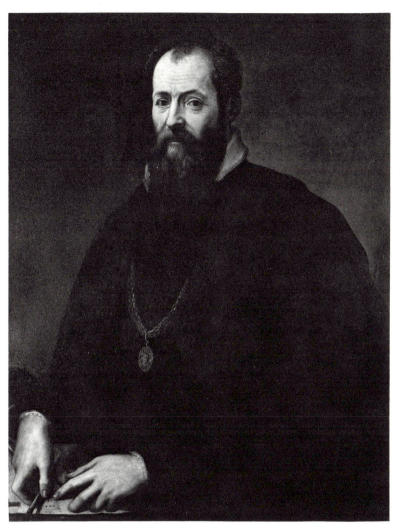

1 Giorgio Vasari: *Self-Portrait*

phase has its own great men, but their art is subjected to the progressive stages of qualitative growth from phase to phase. Thus, a Quattrocento artist is naturally superior to a Trecento artist of similar caliber, and accordingly the Quattrocento artist is surpassed by a Cinquecento one. The individual can be great but he cannot escape the limitations of his period.

Let us now see how Vasari himself explains these period qualifications.[6]* Of Giotto and his forerunner Cimabue, Vasari says:

"Thus we have seen that the Greek, or Byzantine manner [2], first attacked

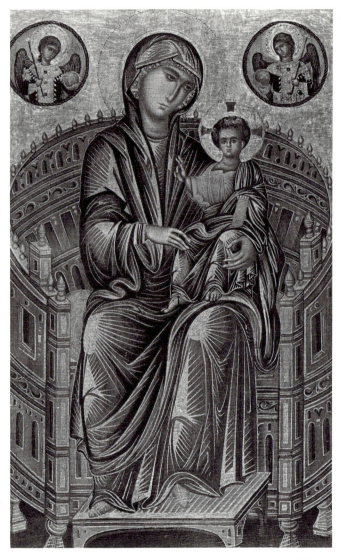

2 Byzantine School, 13th century: *Madonna and Child*

by Cimabue, was afterwards entirely extinguished by the aid of Giotto, and there arose a new one, which I would fain call the manner of Giotto [3], since it was discovered by him ... By Giotto and his disciples, the hard angular lines by which every figure was girt and bound, the senseless and spiritless eyes, the long pointed feet planted upright on their extremities, the sharp formless hands, the absence of shadow, and every other monstrosity of those Byzantine painters, were done away with ... the heads received a better

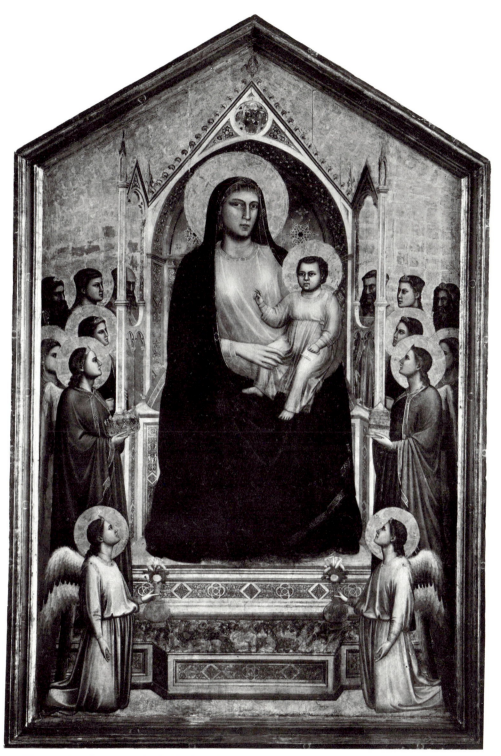

3 Giotto: *Madonna and Child*, detail

grace and more softness of colour. Giotto himself, in particular, gave more easy attitudes to his figures [4, 5]; he made some approach to vivacity and spirit in his heads, and folded his draperies, which have more resemblance to reality than those of his predecessors; he discovered, to a certain extent, the necessity of foreshortening the figure, and began to give some intimation of the passions and affections, so that fear, hope, anger, and love were, in some sort, expressed by his faces . . . if he did not give his eyes the limpidity and beauty of life, if he did not impart to them the speaking movement of reality, let the difficulties he had to encounter plead his excuse for this, as well as for the want of ease and flow in the hair and beards . . . let it be remembered that Giotto had never seen the works of any better master than he was himself.

4 Giotto: *Lamentation.* Padua, Arena Chapel

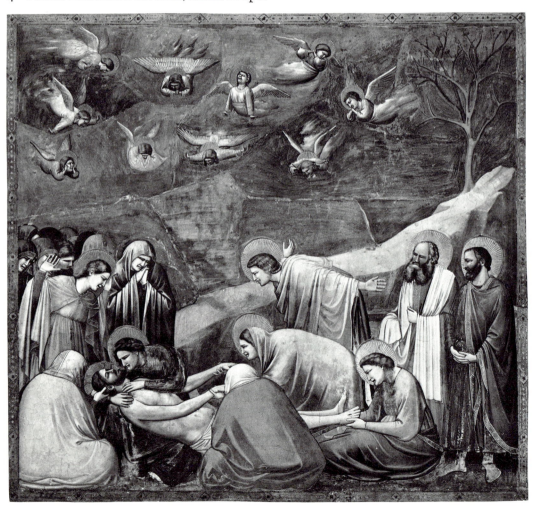

And let all reflect on the rectitude of judgment displayed by this artist in his paintings, at a time when art was in so poor a state . . ."[7]

In regard to the Quattrocento, which we illustrate with a painting by Fra Filippo Lippi and one by Antonio del Pollaiuolo [6, 7], Vasari says:

"And now that we have raised these three arts [sculpture, painting, and architecture], so to speak, from their cradle, and have conducted them through their childhood, we come to the second period, in which they will be seen to have infinitely improved at all points: the compositions comprise more figures; the accessories and ornaments are richer, and more abundant; the drawing is more correct, and approaches more closely to the truth of nature; and, even where no great facility or practice is displayed, the works

Giotto: *Lamentation,* detail

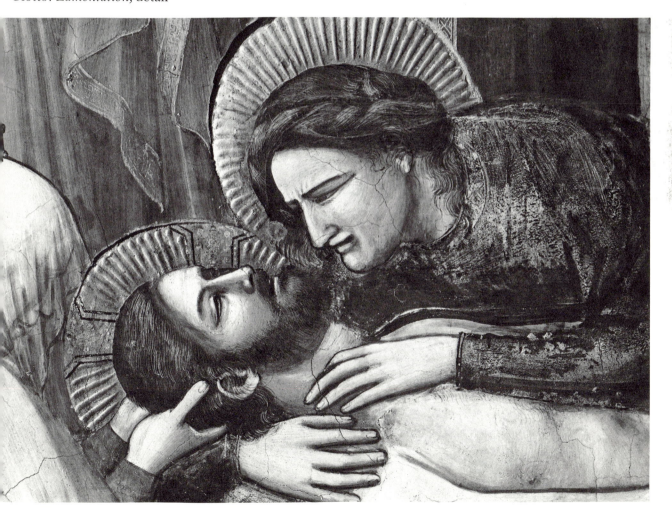

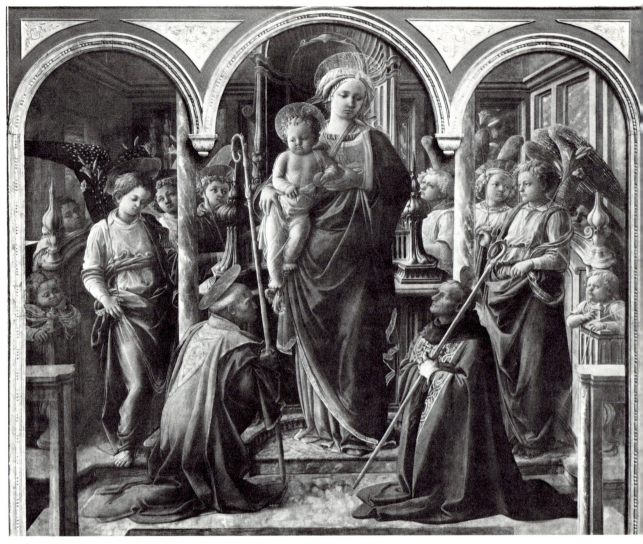

6 Fra Filippo Lippi: *Madonna and Child Adored by Saints and Angels*

yet evince much thought and care; the manner is more free and graceful;
the colouring more brilliant and pleasing, insomuch that little is now required
to the attainment of perfection in the faithful imitation of nature."[8]

He adds, in the Preface to the Third Part:

"The masters of the second period, although they effected very important
ameliorations in art . . . were yet not so far advanced as to be capable of con-
ducting it to its ultimate perfection; there was yet wanting to their rule a

10

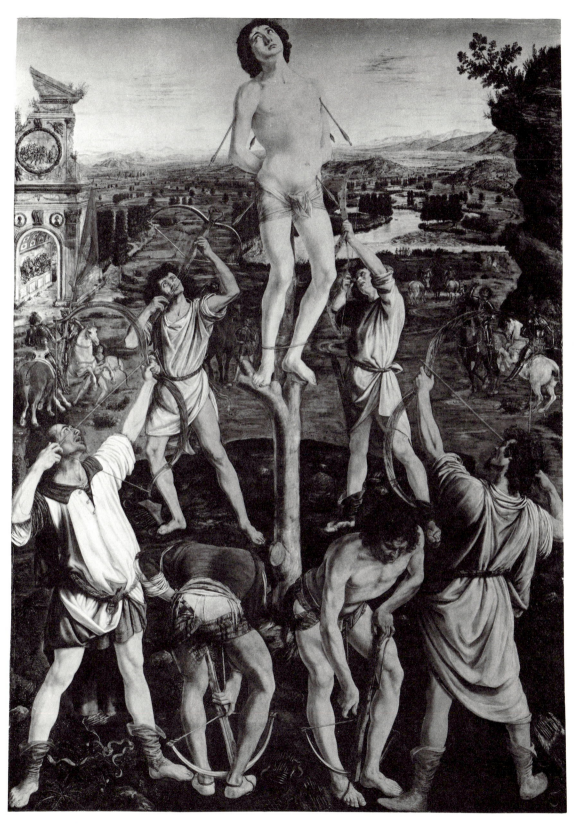

7 Antonio del Pollaiuolo: *Martyrdom of St. Sebastian*

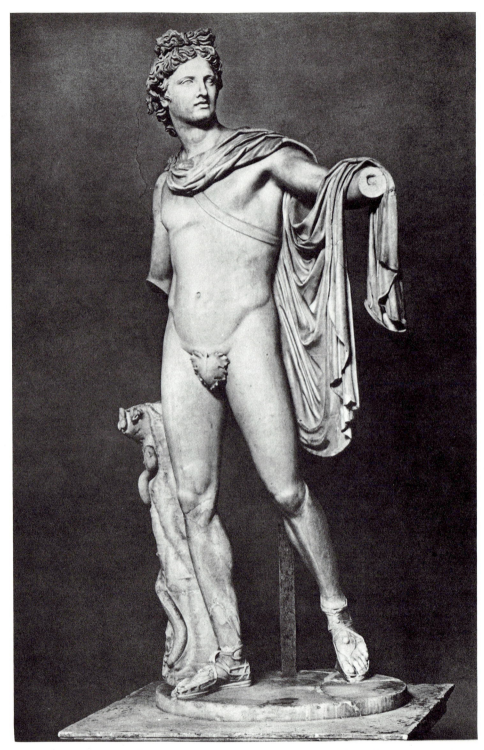

8 Greek sculpture, 4th century B.C. (Roman copy): *Apollo Belvedere*

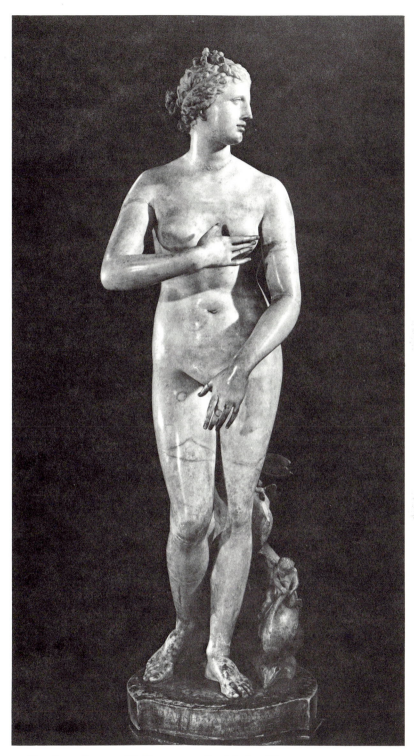

9 Greek sculpture, Hellenistic: *The Medici Venus*

certain freedom . . . a certain perception of beauty . . . In proportion, there was still wanting that rectitude of judgment which, without measurement, should give to every figure, in its due relation, a grace exceeding measurement. In drawing, the highest eminence had not been attained; for although the arm was made round and the leg straight, there was yet not that judicious treatment of the muscles, nor that graceful facility . . . the masters, on the contrary, had in this respect something crude and excoriated in their practice, producing an effect that was displeasing to the eye and which gave hardness to the manner."[9]

Vasari then points out how at the turn of the fifteenth century the discovery of great classical art, such as the *Apollo Belvedere* [8], the *Laocoön*, the *Belvedere Torso* and the *Medici Venus* [9]—whose excavation caused the greatest sensation—helped the artists of the third (Cinquecento) period to reach perfection. In these antiquities Vasari finds "softness and power are alike visible . . . roundness and fullness justly restrained, and which, reproducing the most perfect beauty of nature with attitudes and movements wholly free from distortion . . . exhibit everywhere the flexibility and ease of nature, with the most attractive grace."[10]

Going on to report the great success of Francesco Francia and Perugino [10] toward the end of the fifteenth century, Vasari states:

"[People believed] then that it would be absolutely impossible ever to do better; but the error of this judgment was clearly demonstrated soon after by the works of Leonardo da Vinci [11], with whom began that third manner, which we will agree to call the modern; for, in addition to the power and boldness of his drawing, and to say nothing of the exactitude with which he copied the most minute particulars of nature . . . he displays perfect rule, improved order, correct proportion, just design, and a most divine grace . . . he may be truly said to have imparted to his figures, not beauty only, but life and movement."[11]

Thus Vasari describes the gradual growth of quality through the three phases of the *rinascimento*—until it reaches its ultimate height in the work of Michelangelo.

All the quotations above are related to what we may call Vasari's quality judgment on periods or phases of the *rinascimento;* now we may give special

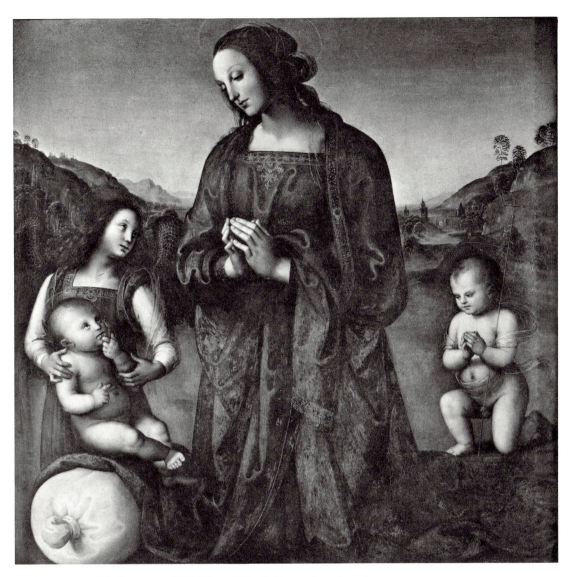

10 Perugino: *Madonna and Child with St. John and an Angel*

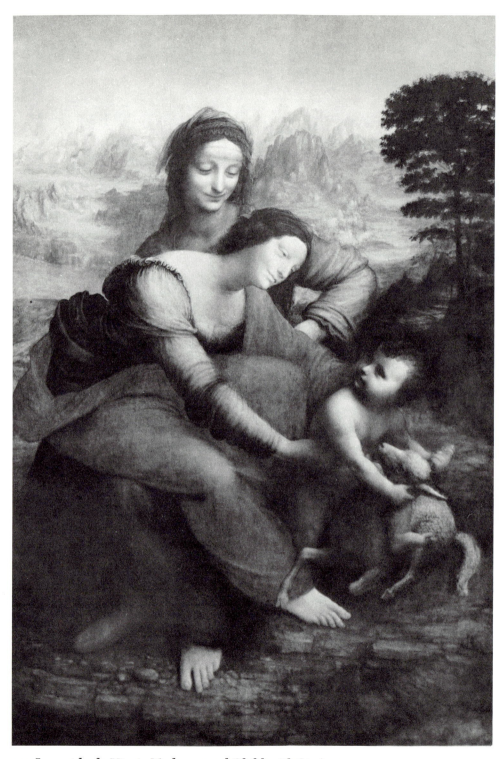

11 Leonardo da Vinci: *Madonna and Child with St. Anne*

attention to his evaluation of the individual artists. We have said that Michelangelo's work [12, 13] represents to Vasari the climax of all art. He formulates this opinion, also in the Preface to the Third Part, as follows:

"But he who bears the palm from all, whether of the living or the dead; he who transcends and eclipses every other, is the divine Michelagnolo Buonarroti, who takes the first place, not in one of these arts only, but in all three [painting, sculpture, architecture]. This master surpasses and excels not only all those artists who have well nigh surpassed nature herself, but even all the most famous masters of antiquity, who did, beyond all doubt, vanquish her most gloriously: he alone has triumphed over the later as over the earlier, and even over nature herself, which one could scarcely imagine to be capable of exhibiting any thing, however extraordinary, however difficult, that he would not, by the force of his most divine genius, and by the power of his art, design, judgment, diligence, and grace, very far surpass and excel . . ."[12]

Now, these superlatives, although Vasari easily revels in such, can hardly be surpassed. But in the same Preface, prior to his panegyric on Michelangelo, Vasari certainly shows a fair share of enthusiasm for Raphael, of whom he says:

"But above all is to be distinguished the most graceful Raffaello da Urbino [14, 15], who, examining and studying the works both of the earlier and the later masters, took from all their best qualities, and, uniting these, enriched the domain of art with paintings of that faultless perfection anciently exhibited by the figures of Apelles and Zeuxis; nay, we might even say more perchance, could the works of Raffaello be compared or placed together with any by those masters; nature herself was surpassed by the colours of Raphael, and his invention was so easy and original, that the historical pieces of his composition are similar to legible writings, as all may perceive who examine them: in his works, the buildings, with their sites and all surrounding them, are as the places themselves, and whether treating our own people or strangers, the features, dresses, and every other peculiarity were at pleasure represented, with equal ease. To the countenances of his figures Raphael imparted the most perfect grace and truth . . . each and all have their appropriate character . . . his children charm us, now by the exquisite beauty of the eyes and expression, now by the spirit of their movement and the grace of their attitudes; his

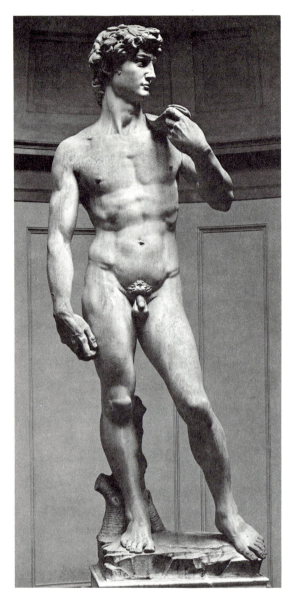

12 Michelangelo: *David*

draperies are neither too rich and ample, nor too simple and meagre in their folds, still less are they complicated or confused, but all are so arranged and ordered . . . that they appear to be indeed what they represent."[13]

We shall return to Vasari's effort to do justice to the individual artist, but let us consider at this point what principles underlie his appreciation of periods and individuals. These we can define only approximately, since Vasari is not as consistent a theoretician as his descendants in the seventeenth century will be, and he is by no means free of contradictions. But we may say

that he set into motion the idealization of classicism (of the Roman brand), which was to have a long-standing influence on the development of European art and criticism. To Vasari, as to his contemporaries, classical antiquity, we have stated, furnished the standards of greatness in art and was surpassed only in his own time. Classical art attained perfection because it was based on both "truth to Nature" and "selection" of her most beautiful parts—united within the higher form of a work of art.[14]* With these two principles as a foundation—we may call them "naturalism" and "selectiveness"—the artist gains *grazia* and *perfezione*, which nature alone cannot have. Classical art is preferable to nature as a model, since therein the proper selection has already been made. Two additional concepts play a decisive role in Vasari's critical canon:

13 Michelangelo: *Creation of Adam,* detail. Sistine Chapel

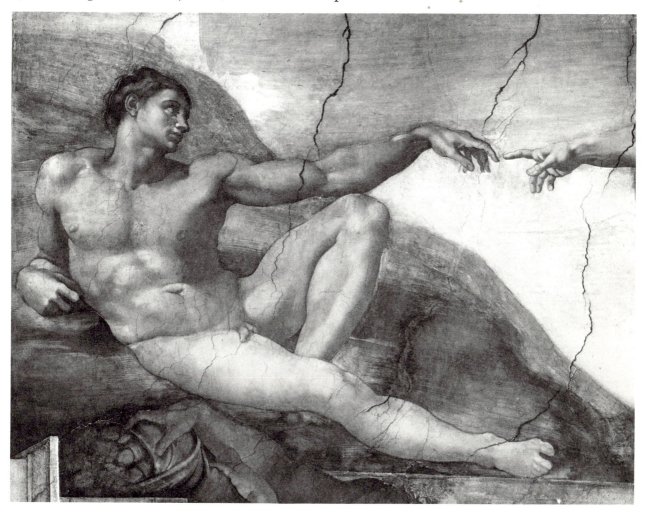

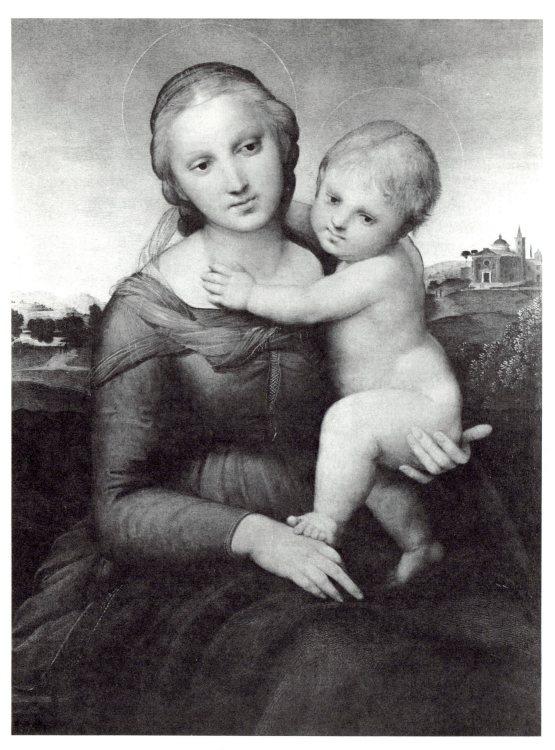

14 Raphael: *The Small Cowper Madonna*

invenzione and *disegno*. The exact meaning of these terms is not easily conveyed, because of Vasari's vagueness in matters of definition. They can be related only loosely to the terms "content" and "form" to which we are accustomed, yet such an analogy may be helpful to the modern reader.

Invenzione presupposes the study of good painting and sculpture and an understanding of (nature and) life. "Hence springs the invention which groups figures . . . in such a manner as to represent battles and other great subjects of art. This invention demands an innate propriety springing out of harmony and obedience; thus if a figure move to greet another, the figure saluted having to respond should not turn away. . . . The subject may offer many varied motives different one from another, but the motives chosen must

Raphael: *The School of Athens*

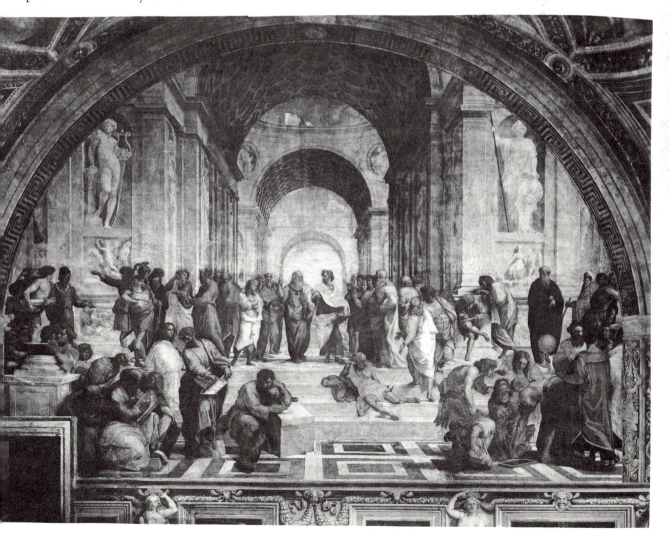

always bear relation to the work in hand, and to what the artist is in process of representing."[15]

Even more difficult to define clearly is Vasari's concept of *disegno*. It comprises a great deal of what we now call "form" in contradistinction to content. It means "drawing" in the narrower sense and also design or composition—but does not include color, which is considered of secondary importance and only an incidental attribute of form, as Leonardo had also understood it. The *disegno* is perfect when the figures attain full roundness or relief effect, when their contours are soft-flowing and show correct foreshortening, proper proportion, and a display within a judicious order or composition. These criteria sound unpleasantly academic, yet they are not used with the pedantry of later Academicians.

A great deal of what Vasari means by *disegno* and his emphasis on its all-important role we learn from his Life of Titian. Vasari admires Titian [17], even more than Giorgione [16], as one of the great participants in the Golden Age of the Renaissance, but with definite reservations about the Venetian's

16 Giorgione: *Sleeping Venus*

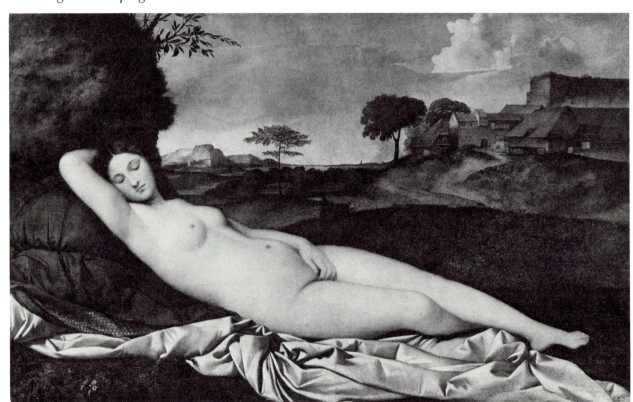

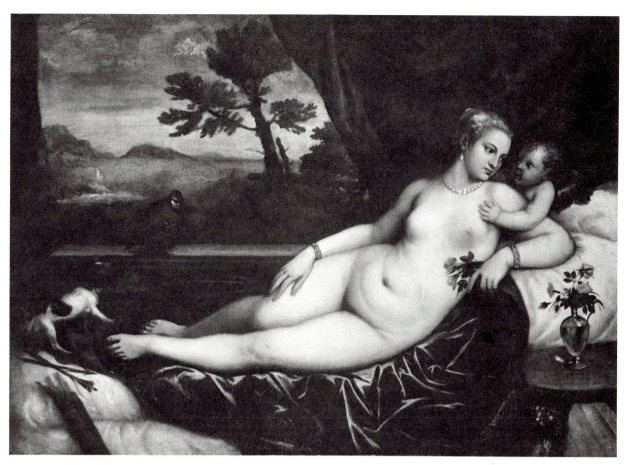

17 Titian: *Venus and Cupid*

overrating of color at the expense of the *disegno*. Since this is a point of great consequence for the value judgment of later centuries (the last great protagonists in this controversy were Ingres and Delacroix), it will again be helpful to quote Vasari directly. Such selections will also show Vasari's relative appreciation of Venetian colorism in its best representatives, in spite of his prejudice in favor of *disegno*. In the Life of Titian he tells us first how the young artist learned from Giovanni Bellini, who is criticized for his "dry" and "hard" Quattrocento manner. And then Vasari explains how Titian came under the influence of Giorgione, who, "not being satisfied with that mode of proceeding, began to give his works an unwonted softness and relief, painting them in a very beautiful manner; yet he by no means neglected to draw from

the life, or to copy nature with his colours as closely as he could, and in doing the latter he shaded with colder or warmer tints as the living object might demand, but without first making a drawing, since he held that, to paint with the colours only, without any drawing on paper, was the best mode of proceeding and most perfectly in accord with the true principles of design.

"But herein he failed to perceive that he who would give order to his composition, and arrange his conceptions intelligibly, must first group them in different ways on paper, to ascertain how they may all go together . . . The nude form also demands much study before it can be well understood, nor can this ever be done without drawing the same on paper . . ."[16]

Thus *disegno* and some of its basic qualities are here identified with "drawing" as the very foundation of art, and we hear more about this when, tracing Titian's development, Vasari goes on to say:

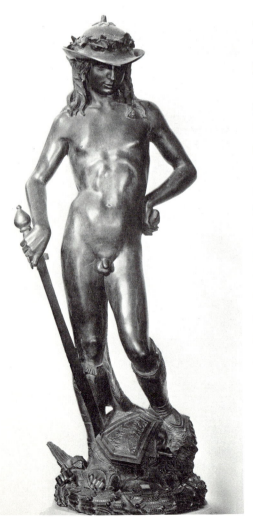

"In the year 1508 [when Titian had gained fame equal to that of Giorgione], Titian published a wood engraving of the Triumph of Faith; it comprised a vast number of figures . . . here Titian displayed much boldness, a fine manner, and improving facility. I remember that Fra Bastiano del Piombo, speaking on this subject, told me that if Titian had then gone to Rome, and seen the work of Michelagnolo, with those of Raphael and the ancients, he was convinced, the admirable facility of his colouring considered, that he would have produced works of the most astonishing perfection, seeing that, as he well deserved to be called the most perfect imitator of Nature of our times, as regards colouring, he might thus have rendered himself equal to the Urbinese or Buonarroto, as regarded the great foundation of all, design."[17]*

18 Donatello: *David*

19 Donatello: *Cantoria*, detail. Florence, Duomo

Such criticism of the Venetians and the strictness of his principles were, however, often softened by passages in which Vasari's judgment seems to rise above his theoretical concepts. In these passages Vasari's judgment also rises above the standards of his time, and we detect his desire to do full justice to the individual artist. Two quotations may suffice to illustrate these points, one of them relating to Donatello, the other again to Titian, but to the late Titian. In commenting on Donatello [18, 19], whom Vasari was bound to consider inferior to the Cinquecento sculptors in accordance with his qualitative theory of the successive periods within the Renaissance, he says, in the Preface to the Second Part:

"Respecting this master, I could not for some time determine whether I were not called on to place him in the third epoch, since his productions are equal to good works of antiquity;—certain it is, that if we assign him to the second period, we may safely affirm him to be the type and representative of all the other masters of that period; since he united within himself the qualities which were divided among the rest, and which must be sought among

20 Titian: *The Three Ages of Man*

many, imparting to his figures a life, movement, and reality which enable them to bear comparison with those of later times—nay even, as I have said, with the ancients themselves."[18]

And in the Life of Titian we find an astonishing passage on the master's late manner—a passage that almost anticipates an appreciation of Baroque painting. Here, regarding some pictures done for Philip II in the late 1550's, such as the *Andromeda Delivered by Perseus, Diana and Actaeon,* and the *Rape of Europa* [21], Vasari writes:

"It is nevertheless true that his [Titian's] mode of proceeding in these last-mentioned works is very different from that pursued by him in those of his youth, the first being executed with a certain care and delicacy, which renders the work equally effective, whether seen at a distance or examined closely [20]; while those of a later period, executed in bold strokes and with dashes, can scarcely be distinguished when the observer is near them, but if viewed from the proper distance they appear perfect. This mode of his, imitated by

artists who have thought to show proof of facility, has given occasion to many wretched pictures, which probably comes from the fact that whereas many believe the works of Titian, done in the manner above described, to have been executed without labour, that is not the truth, and these persons have been deceived; it is indeed well known that Titian went over them many times, nay, so frequently, that the labour expended on them is most obvious. And this method of proceeding is a judicious, beautiful, and admirable one, since it causes the paintings so treated to appear living, they being executed with profound art, while that art is nevertheless concealed."[19]

21 Titian: *The Rape of Europa*

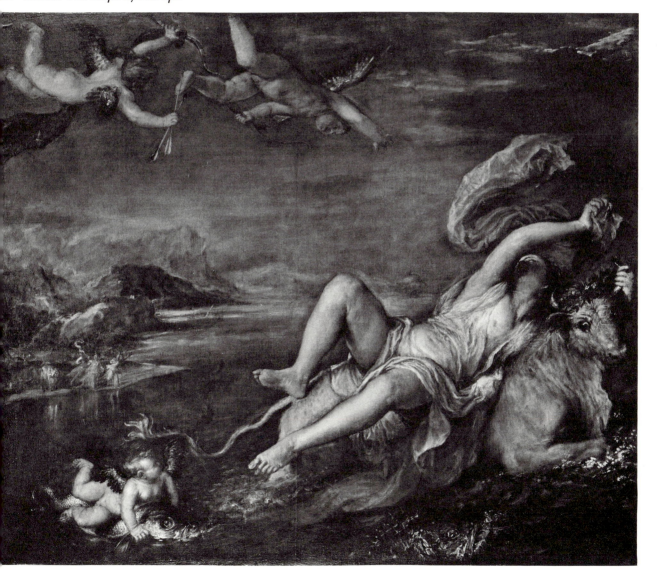

If we look back over the various manifestations of Vasari's critical judgment and the theory or standards of value which lie behind it, we come to certain conclusions which may be helpful for our future considerations:

1) As for his quality judgment on periods, he was dependent on the standards of his own time, which seems natural. But these standards—seen from today—appear too rigid in regard to the supreme position of classical art and the ultimate perfection of art in his own time. The consequences were disastrous for the appreciation of styles other than the classical. The most conspicuous example of this is Vasari's contempt for medieval art. This should make us cautious about value judgments on whole periods and aware of the fact that quality depends more upon the individual than the period, which merely sets the framework for individual achievement. In fact, we have seen the difficulty Vasari had in explaining Donatello's greatness, since, within the context of Vasari's judgment on periods (devaluating the Quattrocento), he was bound to consider Donatello inferior to the great Cinquecento masters.

2) As for the overwhelming domination by one great master—in Vasari's case it was Michelangelo—from whose works the critic derives his notion of highest achievement, this is understandable, and in this respect Vasari also reflected the judgment of his time. Such admiration for one truly great individual is not necessarily detrimental to the objectivity of the critic's value judgment. It can be very helpful in setting high standards, but it can also be an obstacle to the proper appreciation of a very different individual of high caliber. In the case of Raphael, at least, Vasari escaped this pitfall.

3) Finally, as for Vasari's occasional glimpses beyond the standards of his time—one is almost tempted to call this his "free" judgment (we noticed it in Vasari's reaction to Donatello and to the late Titian, and there are other instances)—it proves that his intuitive feeling for quality could not be fully suppressed by the prevailing theories. This occasional tension between the rationalized and standardized judgment, on the one hand, and the merely intuitive on the other, is an interesting phenomenon which we shall also notice in the work of gifted critics of later times. It speaks, I believe, for Vasari's innate power of discrimination, and is not the least reason why the record of the validity of his value judgment is a very impressive one. It is true that the standards of classicism so revered by Vasari—*grazia* and *bellezza*, harmony,

and *perfezione,* proper proportions, correct foreshortening, and perspective, etc.—had begun even in his own day to lose their original forcefulness and motivating power, as the genius of the artist began to turn toward a more subjective and personalized concept of the object—which would seem to have reached its ultimate expression in our own time. But it should also be noted, as I have indicated at the beginning of this paragraph, that Vasari's sensibility responded as well to other factors in works of art, which led him to be appreciative of the originality of a great artist, of his power, of boldness, of ease or facility that shows no trace of labor, of richness and variety in form and invention, of delicacy, of flexibility—all of which are still relevant qualities today.

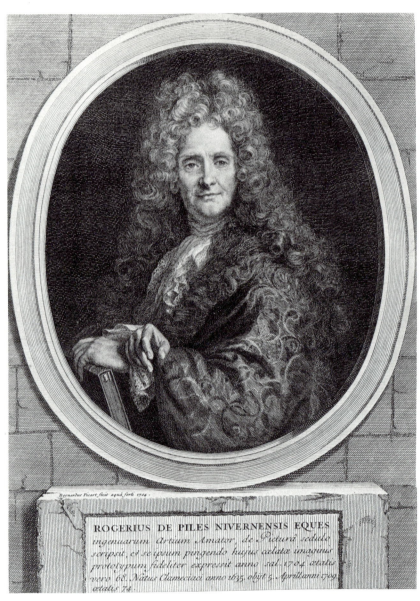

ROGERIUS DE PILES NIVERNENSIS EQUES
ingenuarum Artium Amator, de Pictura sedulo
scripsit, et se ipsum pingendo hujus calatae imaginis
prototypum fideliter expressit anno sal. 1704 aetatis
vero 68. Natus Clameciaci anno 1635, obijt 5. Aprili anni 1709
aetatis 74.

22 Bernard Picart: *Portrait of Roger de Piles*

CHAPTER II

The Seventeenth Century

ROGER DE PILES [1635–1709]

THE criteria of excellence established by the classicism of the Renaissance persisted into the seventeenth century, with only minor modifications. To study the further development, we move from Italy to France, from Rome and Florence—where Vasari, Michelangelo, and Raphael lived and worked—to Paris, which in the second half of the seventeenth century, at the time of Louis XIV, gradually took over the cultural leadership of the world. On the whole, the critical judgment of the century, which has come down to us in literary sources, was still dominated by the tenets of classicism. These tenets had even hardened; we have only to think of the French Academy and the rigid theories of its most prominent leader, Charles Le Brun. But in Le Brun's lifetime (1619–1690) serious cracks in the structure had begun to appear, and decisive changes were in the making which were to allow a fuller appreciation of the best of Baroque art and were ultimately to lead toward the broader approach of modern times. The leader of this development was the French critic and *amateur* Roger de Piles, whom we therefore have chosen as our next example of quality judgment in the past.

Roger de Piles [22] was not a revolutionary. He did not make a sensational break with classical standards. He merely modified and broadened them, in-

sistently adding one essential point: the full appreciation of color. The study of antiquity was to him still an indispensable foundation, as were the laws of proportion derived from antiquity, and a knowledge of anatomy and perspective. Last but not least, he believed in the classicistic hierarchy of subject matter, in which historical painting occupied the highest position, and was alone considered suitable for the "grand manner" (a major tenet of Le Brun). Accordingly, de Piles did not rebel against the fact that Raphael and Poussin were the adored models of the Academicians. But he fought valiantly for an equal status for Titian, and particularly for Rubens, on whom he wrote brilliantly.[1] His great crusade—as we have said—was to have color recognized as equal in importance to drawing, or *disegno,* on whose priority Vasari and after him the French Academicians had so vigorously insisted. Other important points in de Piles's program were his advocacy of the study of *all* the great masters without prejudice, in contradistinction to the exclusive concentration on one figure, and his belief that, after acquiring a knowledge of the antique, the artist should turn back to nature as the measure of truth in art. In his *Cours de peinture,* he says:

"I love all that is good in the works of the great masters without discrimination between names and without complacency. I like the diversity of the celebrated schools; I like Raphael, I like Titian, I like Rubens; I do everything in my power to fathom the rare qualities of these great painters."

And he adds characteristically:

"But whatever perfection they possess, I love Truth still better."[2]

It is an enlightened and critical eclecticism which he thus recommends. And by constructing two degrees of truth, *le vrai simple* and *le vrai idéal,* he allows "truth" to embrace both realism and classicism.

Roger de Piles's method of appreciation was more articulate than Vasari's. He analyzed in a painting four essential components: composition, drawing, color, and expression—whereas Vasari had primarily contented himself with a lively description of the subject matter (there are bits of artistic appreciation but no coherent formal analysis). Regarding color, de Piles's new point, he was rather specific, saying in his *Cours de peinture* that nothing contributes to the appeal of a painting as much as "the coloring, composed of all its parts, namely, chiaroscuro, color harmony, and those various hues which

we call local when they faithfully imitate, each one in particular, the color of the natural objects which the painter wishes to represent."[3]

It was not enough to analyze the paintings for their formal achievement. De Piles also asked for a clarification of the aesthetic principles on which the art of painting should be based, and for a clear reasoning of the causes of the effect. Thus, in his *Elémens de peinture pratique,* he says:

"Those who have not cultivated their minds by an understanding of principles, at least in a speculative manner, can be sensitive to the effect of a good picture, to be sure, but they will never be able to give reasons for their judgment."[4]

Roger de Piles was the prototype of the modern scholarly connoisseur. He was as much concerned with the proper approach and training of the *amateur* and the art critic as he was with the education of the artist. In the process of forming a judgment, he thought that first one should be open to an unprejudiced impression of the original, then one should search for the reasons for the effect, and only finally should one consider whether or not the rules have been observed. And as for the proper judgment on quality, de Piles writes in his *Première conversation sur la peinture:*

"The true understanding of painting consists in knowing whether a picture is good or bad, in distinguishing between that which is good in a certain work and that which is bad, and in giving reasons for one's judgment."[5]

Clearly, de Piles does not favor an all-out admiration of a work of art, but is prepared to find weaknesses—even in a great work.

Altogether, Roger de Piles's effort to attain the highest possible degree of independence of critical judgment, the new breadth of his approach, and his attempt to achieve an analytical appreciation distinguish his attitude from that of the contemporary Academicians and make him indeed an important forerunner of modern critics.

As an example of de Piles's analytic capacity and method, I choose his discussion of Rubens' large *Fall of the Damned* [23]. This monumental picture ($8'5\frac{5}{8}''$ x $7'4\frac{5}{8}''$) was in the collection of the duc de Richelieu in de Piles's times, and is described in his *Dissertation sur les ouvrages des plus fameux peintres,* dedicated to Richelieu. De Piles says:

"The character of this picture is literally that of confusion and despair, for

which Rubens had no other model than the idea expressed in the words of the Gospel: 'Depart from me, ye cursed, into everlasting fire'—the abode of confusion and horror. This horror and confusion are apparent throughout the work. There are great numbers of unfortunates given over to rage and despair, who by the natural weight of their bodies, and by the manner in which they are placed, seem to be in the very act of an actual, precipitous fall, while countless others are burning in the flames, or plunging, in the words of the Scriptures, into a lake of brimstone. To achieve diversity in his figures, he has pictured these damned in the ugly clutches of the seven deadly sins, which he has represented by the seven-headed dragon of the Apocalypse; and each one is variously tormented according to the nature of his crime and the way in which he has sinned, but all this with a variety so ingenious that nothing could be added; and the only thing in which all these figures resemble one another is in the fact that all bear the character of malediction."[6]

De Piles then enumerates the special sins represented by the different beasts at the bottom of the picture—thus revealing that knowledge of religious (as well as mythological) iconography was not lacking in his time.

We have said that de Piles usually separates formal analysis or appreciation into four components: composition, drawing, color, and expression. In his discussion of the *Fall of the Damned,* he examines these points as follows:

"The drawing is masterly and shows great style; and the extreme difficulty, not to say the impossibility, of making use of the natural, in order to paint or draw actions like this, which are suspended in air, must fully convince us that Rubens was most skillful in the category of drawing, and that his genius, joined to consummate experience, made him an absolute master of his art and its rules.

"The expression of the heads is lively and penetrating; one sees in them the nature of their crime and the excess of their torment.

"The connection between the objects, so necessary in painting, or to speak as the painters do, the groups that join one another in this picture are invented with so much imagination, so much spirit, and so much art, that they far surpass everything hitherto done in this genre, and however disentangled these groups are, and separated one from another, they nevertheless contribute to the massing of lights and shadows, and to the effect of the ensemble;

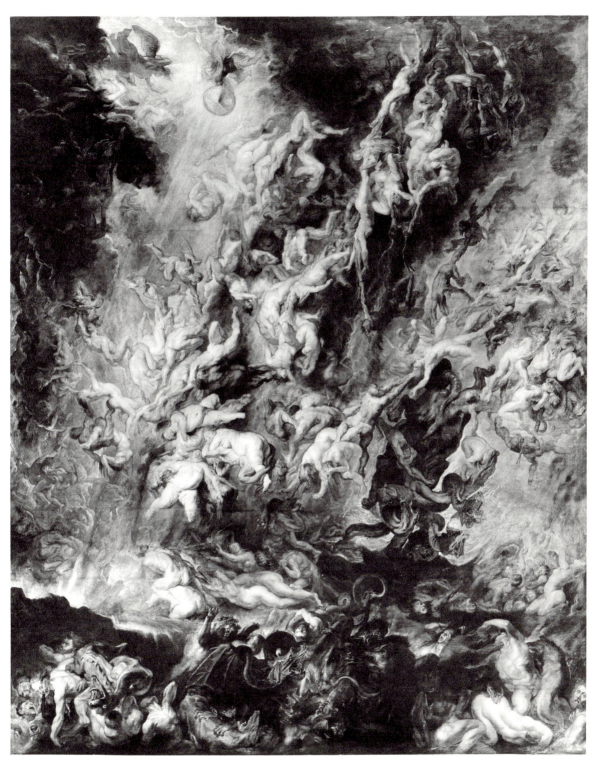

23 Rubens: *"Large" Fall of the Damned*

so that this great crush of figures may be looked at with as much ease and repose as if there were only one of them. And what is remarkable, among other things in this great work, is the fact that there is nothing superfluous, and that the slightest things, considered in detail, appear to be an effort of the painter's imagination. In fact, everything contributes to the unity of the objects, by an admirable understanding of light and shade, just as everything contributes to the unity of action, by an expression, both general and particular, of all that one can imagine as most terrible.

"The artifice of the coloring is marvelous in its harmony, in its contrast, and in its variety of flesh tones among such a great number of nude figures; this is not the least of the perfections of the picture.

"There is so much of beauty, both general and particular, in this work, that it would require a long discourse to give an exact description of it. And after all, I confess that what I should strive to do would fall far short of the idea I conceive of it. I will add only that this work, which is the despair of the damned, is also the despair of the painters. For the sight of other works of Rubens stirs their imagination and leads them to believe that in attempting to imitate his works they could in time attain something similar; but in seeing this one, they all confess that it is inimitable, and that if Rubens, with his other productions, has either equaled or surpassed all the painters, he has with this one surpassed himself, allowing no hope that in the future we shall be able to see anything to approach it."[7]

De Piles's quality judgment of the individual masters is recorded in an astonishing document, of great interest for our discussion—the "Balance des peintres," which he appended to the first edition of his *Cours de peinture*. In the "Balance" he evaluates the best-known artists of the past and present in a very special way: the artists are graded in each of the four categories already mentioned (composition, drawing, color, and expression). He scores each category against an ultimate grade of 20, which would indicate perfection. But because he believes that perfection is unattainable, the grade 18 stands for the highest attainable achievement. De Piles does not give us the sum total of the four grades for each artist, but we can easily do the addition. I will now list some of his estimations, not in alphabetical order as he did, but by period, nationality, and local school.

The great HIGH RENAISSANCE masters do not all rank on the top level: Raphael scores highest, with a total of 65 for the four categories:

composition	drawing	color	expression
17	18	12	18

Michelangelo, however, gets a total of only 37 because he is low in composition and expression, and particularly in color:

8	17	4	8

Andrea del Sarto [24] fares better with 45; his weaknesses are color and expression:

12	16	9	8

Correggio [25] stands near the first rank with a total of 53:

13	13	15	12

Giulio Romano is also rated fairly high, with a total of 49, but he falls down in color:

15	16	4	14

and Leonardo at least equals him (49). He receives the same low grade in color:

15	16	4	14

The VENETIANS of the Renaissance get their proper share, with some noticeable exceptions:

Titian has a total of 51; he is ranked low only in expression:

12	15	18	6

while Giorgione receives a remarkably low 39, and is considered strong only in color:

8	9	18	4

Veronese [26] surpasses him with 44:

15	10	16	3

and Tintoretto [28] is rated still higher with a total of 49:

15	14	16	4

Both Veronese and Tintoretto, then, receive good grades in color and composition, and do poorest in expression. But the greatest Venetian master of

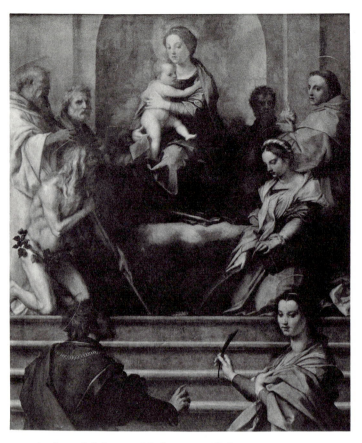

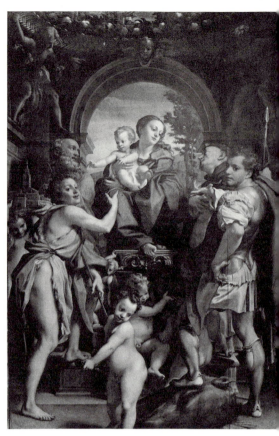

24 Andrea del Sarto: *Madonna with Saints* 25 Correggio: *Madonna with Saints*

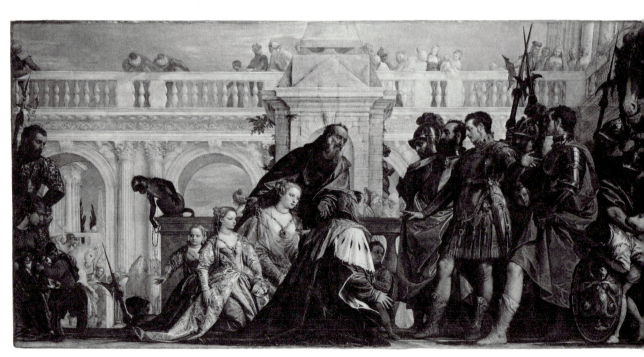

26 Veronese: *Alexander and the Family of Darius*

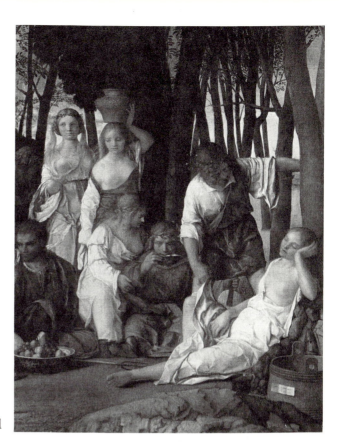

27 Giovanni Bellini:
Feast of the Gods, detail

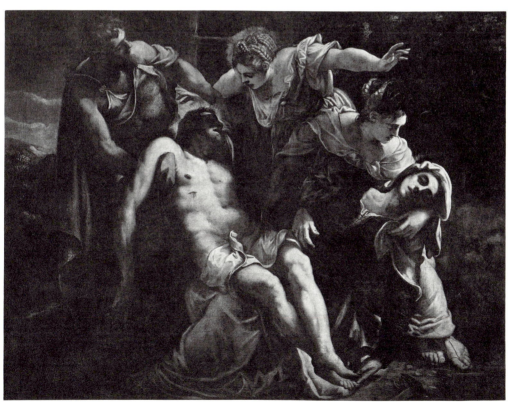

28 Tintoretto: *Deposition*

29 Parmigianino: *Madonna with*
 SS. Stephen and John the Baptist

30 Taddeo Zuccaro: *Conversion of St. Paul*

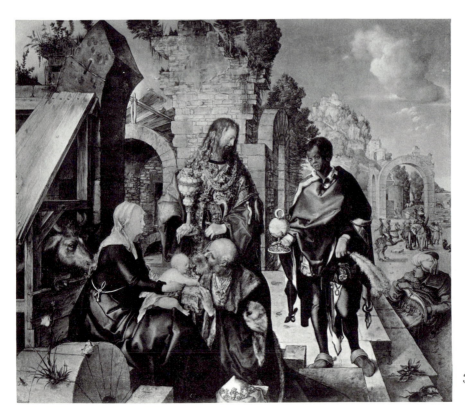

31 Dürer: *Adoration*
 of the Kings

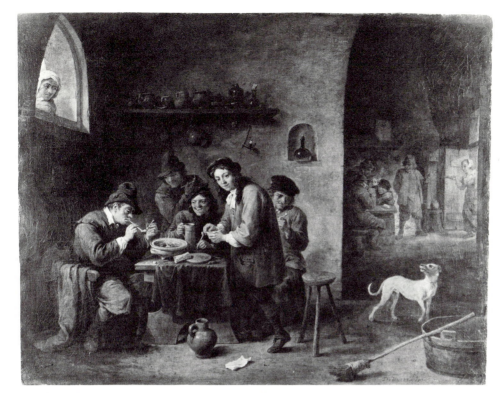

32 David Teniers the Younger: *The Smokers*

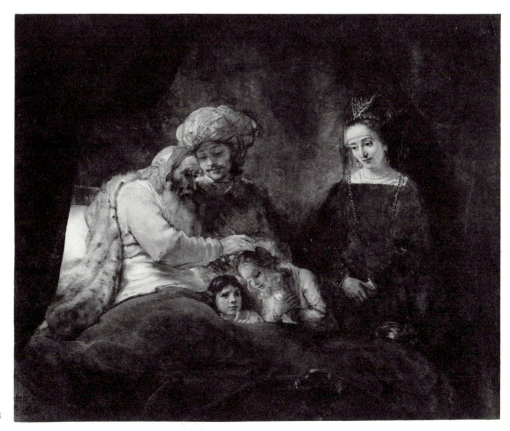

33 Rembrandt:
*Jacob Blessing
the Sons of Joseph*

the Quattrocento, Giovanni Bellini [27], receives a total of only 24, with very low individual grades, except in color:

composition	drawing	color	expression
4	6	14	0

The NORTHERN RENAISSANCE artists fare a little better than Bellini: Albrecht Dürer's [31] total is 36:

8	10	10	8

and Hans Holbein the Younger is comparatively high with 48:

9	10	16	13

but Lucas van Leyden is low, as low as Bellini (24). He does not even excel in color:

8	6	6	4

The MANNERISTS are by no means underestimated:
Federigo Baroccio receives a total of 45:

14	15	6	10

Daniele da Volterra reaches 40:

12	15	5	8

Parmigianino [29] has 37:

10	15	6	6

Primaticcio, 46:

15	14	7	10

and Taddeo Zuccaro [30] is given the same total (46):

13	14	10	9

The Mannerists are all considered high in drawing and composition and low in color and expression.

High grades are granted to various BAROQUE masters of de Piles's own century.
Here Rubens leads with 65, which makes him equal to Raphael. His individual grades are:

18	13	17	17

Van Dyck is not too far below Rubens, with 55:

composition	drawing	color	expression
15	10	17	13

Rembrandt [33] surprises us, for that time, with a total of 50. Only in drawing is he graded low:

15	6	17	12

This seems curious, because de Piles himself collected Rembrandt's drawings, and says that the Dutch master has drawn "an infinity of thoughts that have no less flavor and point than the productions of the best painters."[8] But de Piles is still enough of a classicist to reprove Rembrandt for the lack of classical taste and correct draftsmanship. Nevertheless, Rembrandt, with his total of 50, ranks close to Poussin, who reaches 53. Poussin falls down on color:

15	17	6	15

On the other hand, Rembrandt is not considered much higher than David Teniers [32], who receives, to our surprise, a total of 46:

15	12	13	6

As expected, the BOLOGNESE masters receive high marks. They appealed to the Academicians.

The Carracci [34] are credited with 58:

15	17	13	13

Domenichino fares equally well (58):

15	17	9	17

Guercino is lower, with 42, although he attains the highest given rating in composition:

18	10	10	4

Caravaggio [35], on the other hand, ranks very low, with a mere 28; in expression he receives a straight zero:

6	6	16	0

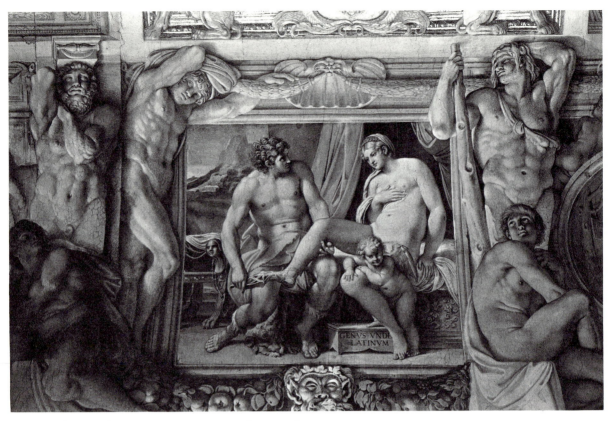

34 Annibale and Agostino Carracci: *Anchises and Venus*

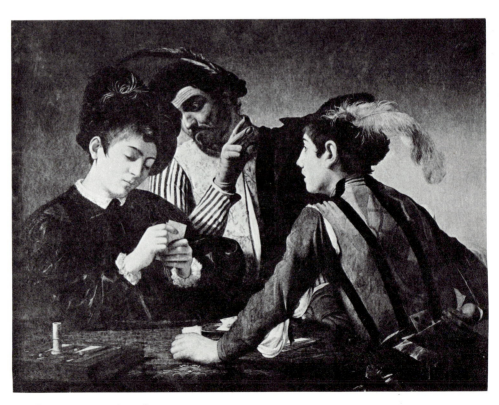

35 Caravaggio: *The Cheat*

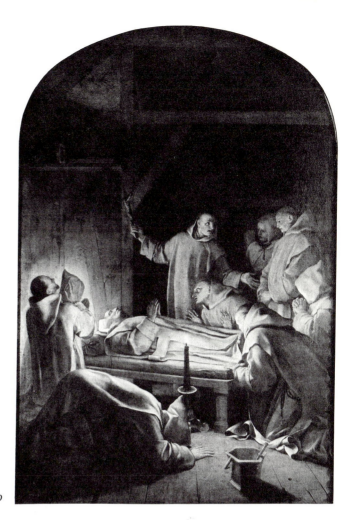

36 Eustache Le Sueur: *Death of St. Bruno*

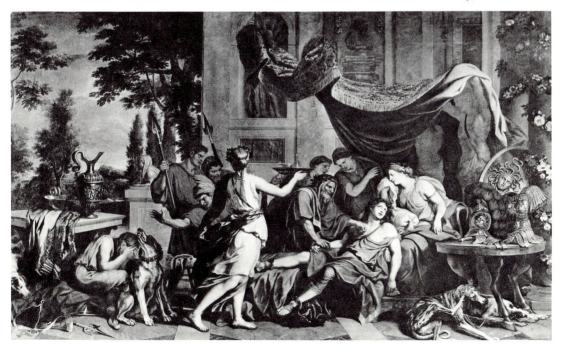

37 Charles Le Brun: *Death of Meleager*

And among the FRENCH CONTEMPORARIES:

Charles Le Brun [37] tops all of them with a total of 56:

composition	drawing	color	expression
16	16	8	16

But Le Sueur [36] also has an impressive total, of 49:

15	15	4	15

We wonder finally that such a mediocre artist as Otto van Veen receives no less than 47 points:

13	14	10	10

obviously because he was the teacher of de Piles's hero, Rubens.

From our present-day point of view, de Piles's quality judgment, as expressed in this list, is certainly disappointing after what we have read of his broadening of the classicist approach, his improved method of analysis and appreciation, and his great effort to reach a higher level of objectivity. We are disappointed that he rates Michelangelo (37) much lower than Andrea del Sarto (45) or Giulio Romano (49); and that Giorgione (39) falls far below Titian (51) and Tintoretto (49). We cannot understand why Dürer receives a grade of only 36, when a second-rate Mannerist like Taddeo Zuccaro gets a total of 46. Our admiration for the relatively high rating of Rembrandt (50) cools when we see Teniers follow fairly closely (with 46). We shake our heads at the curious underestimation of Caravaggio (28), when the Carracci and the Bolognese in general get high marks (58, etc.). And we are by no means happy about Giovanni Bellini's very low grade of 24. In this case it is certainly small consolation that Lucas van Leyden suffers the same fate. On the other hand, why does Charles Le Brun (56), this driest of the Academicians, rank higher than Poussin (53), Leonardo (49), Correggio (53), Titian (51), and Rembrandt (50)? Is there any sense to de Piles's criteria when they lead to such failures in his value judgment, at least as seen from our own time and point of view, which is backed by the accumulated experience of three more centuries?

I believe we must visualize de Piles in his special historical situation in order to justly evaluate both his merits and his failures. He had to fight very

hard indeed to effect even *one* breach in the closely defended classicistic wall of his day; and it seems that he expended, if not exhausted, his best energies in the battle to establish the importance of color. Thus he brought Rubens to the front ranks of the great artists, and Titian and Rembrandt at least close to it. But in all other respects he remained more or less in line with the Academicians. This explains his low estimate of the Quattrocento artist Bellini and of the Northern Renaissance masters, his devaluation of Michelangelo as compared to Raphael and Raphaelesque artists like Giulio Romano, and finally his preference for the Bolognese over Caravaggio.

Whatever our final judgment of de Piles's critical ability, there are many good things in his writings which we should take to heart when we ourselves make the effort to work out valid criteria of excellence. These are: his insistence that we derive our standards from the study of as many great masters as possible, that we evaluate by comparison,[9]* that we keep our minds critical and independent, that we form our judgments from originals only.

He also insists that we must analyze a work of art in terms of its components in order to penetrate to its true merits and in order to deepen our understanding of the principles of art. If de Piles himself often failed to make adequate judgments of particular artists and their works, again it was due to the restrictive hold classicism still had on him. While his method of analysis was progressive in breaking down the appreciation of painting into the four components of composition, drawing, color, and expression, it was only in his judgment of color that he was free from the prevailing prejudices. But in freeing himself even to that extent, he contributed to a truer understanding of painting, which in turn led to a truer appreciation of the great seventeenth-century masters.

CHAPTER III

The Eighteenth Century

SIR JOSHUA REYNOLDS
[1723–1792]

FOR the eighteenth century we move from France to England, which developed in the later half of the century an important national school of its own. Here the economic and social crises that led to the French Revolution were not so deeply felt. Even prior to the Revolution the English were able to acquire many art treasures from the financially straitened French aristocracy. London thus became a greater art market than Paris as well as a cultural center of high importance. The Royal Academy was founded in 1768, and Sir Joshua Reynolds [38], to whom we now turn, became its first president. As for eighteenth-century theories of art, classicism continued to hold sway even though the anti-classical Rococo style had appeared. Reynolds was one of the last great representatives of classicistic thinking. He formulated his ideas in his famous Discourses, which were delivered from 1769 to 1790 at various of the annual award presentations of the Royal Academy, and by which he sought to direct the education of the young artists. As the president of that respected institution and as a painter of considerable stature, he spoke with authority, and his voice was heard throughout England and beyond its borders for some time.

49

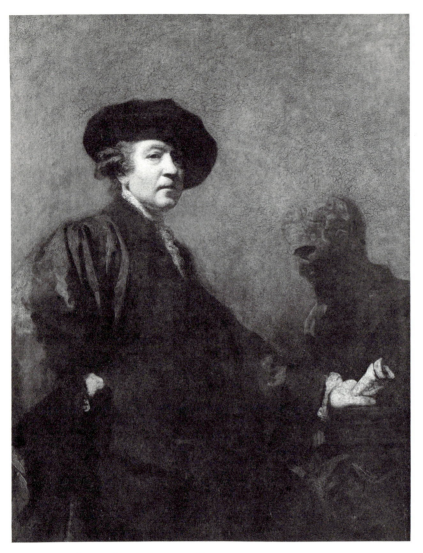

38 Joshua Reynolds: *Self-Portrait*

As was true of Vasari and Roger de Piles—to both of whom he was deeply indebted—Reynolds' classicistic theory was by no means rigid; certain of his personal tastes and keen critical discernments might have endangered the structure of his aesthetic edifice if he had been less flexible in his adaptation of the traditional principles. These principles—such as the classical ideal of beauty, the insistence on the "grand manner" and on the qualitative scale of subject matter that placed historical painting at the top, and portraiture, land-scape, and genre in descending order—were still forcefully maintained in his

writings. He did, however, open some doors to a broader appreciation, first, by developing his theory of the three styles: the "grand," the "ornamental," and the "characteristic." The "grand" style alone raised art to the highest level, giving expression to the great ideals of mankind, whereas the other two were limited by the imitation of nature—the "ornamental" adding some artistic attraction, the "characteristic" intensifying the character of the subject. He also broadened critical theory by embracing various concepts which anticipated the Romantic period. Important among these were his eclecticism, which allowed him to learn from other than classical masters—as a painter he was indebted to Titian and to Van Dyck, to Rubens and to Rembrandt, as well as to Raphael and to Guido Reni—and his association theory, which linked the field of art with the full range and expression of human thought and emotion, and with poetry in particular. Finally, there was also a foretaste of Romanticism in Reynolds' emphasis on fancy and imagination in addition to pure reasoning.

It is not our plan here to give a full summary of Sir Joshua's art theory, since it contains little that is essentially new. But he can hardly be by-passed, representing as he does the last great bulwark of classicism in aesthetic theories prior to the radical breakthrough of Realism in the mid-nineteenth century. Reynolds' slightly ambivalent position—his insight into the artistic merits of the "realistic" painting of seventeenth-century Holland, yet his firm retention of the traditional scales of value—is often revealed in his writings, in the *Discourses* as well as in the *Journey to Flanders and Holland* (1781). We shall quote several passages from these works which show how, in spite of his keen interest in Flemish and Dutch art, Reynolds' aesthetic differs from that of the nineteenth century.

We find, in the *Journey to Flanders and Holland,* some summary remarks on the Dutch School, following Reynolds' reports on the collections in The Hague and in Amsterdam.

"The account which has now been given of the Dutch pictures is, I confess, more barren of entertainment, than I expected. One would wish to be able to convey to the reader some idea of that excellence, the sight of which has afforded so much pleasure; but as their merit often consists in the truth of representation alone, whatever praise they deserve, whatever pleasure they

give when under the eye, they make but a poor figure in description. It is to the eye only that the works of this school are addressed; it is not therefore to be wondered at, that what was intended solely for the gratification of one sense, succeeds but ill when applied to another.

"A market-woman with a hare in her hand [39], a man blowing a trumpet, or a boy blowing bubbles, a view of the inside or outside of a church [40], are the subjects of some of their most valuable pictures; but there is still entertainment, even in such pictures; however uninteresting their subjects, there is some pleasure in the contemplation of the truth of the imitation. But to a painter they afford likewise instruction in his profession; here he may learn the art of colouring and composition, a skilful management of light and shade,

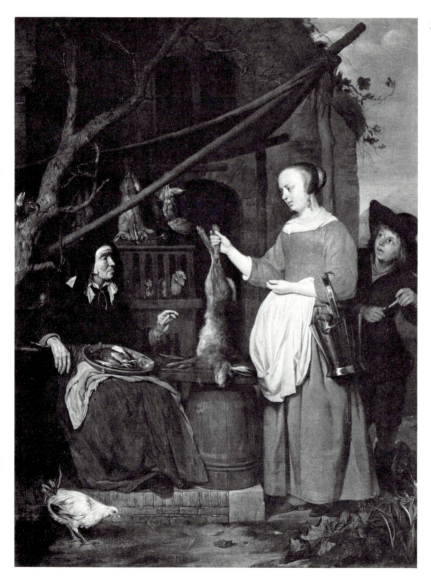

39 Gabriel Metsu:
 The Poultry Dealer

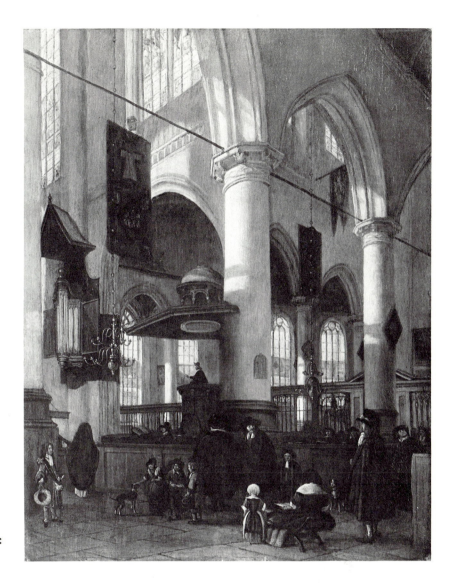

40 Emanuel de Witte:
 Church Interior

and indeed all the mechanical parts of the art, as well as in any other school whatever. The same skill which is practised by Rubens and Titian in their large works, is here exhibited, though on a smaller scale. Painters should go to the Dutch school to learn the art of painting, as they would go to the grammar school to learn languages. They must go to Italy to learn the higher branches of knowledge.

"We must be contented to make up our idea of perfection from the excellencies which are dispersed over the world. A poetical imagination, expression, character, or even correctness of drawing, are seldom united with that power of colouring, which would set off those excellencies to the best advantage; and in this perhaps no school ever excelled the Dutch."[1]

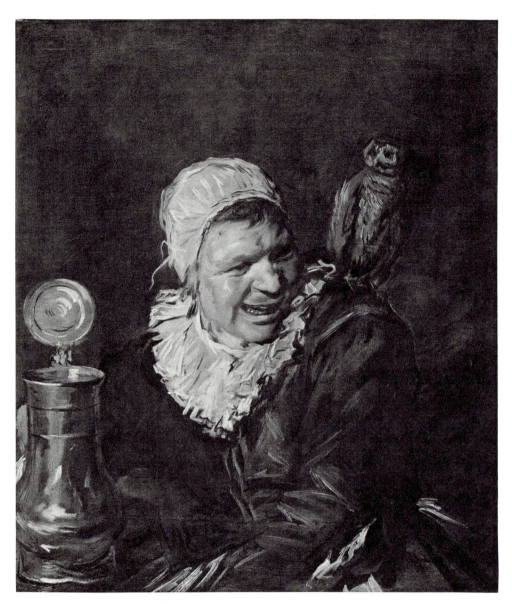

41 Frans Hals: *Malle Babbe*

And then we find scattered throughout the *Discourses* appreciative remarks on the individual Dutch masters, characteristically modified by Reynolds' classicistic convictions. Thus he writes of Frans Hals [41, 42] in the Sixth Discourse:

"In the works of Frank Halls, the portrait-painter may observe the composition of a face, the features well put together, as the painters express it; from whence proceeds that strong-marked character of individual nature,

which is so remarkable in his portraits, and is not found in an equal degree in any other painter. If he had joined to this most difficult part of the art, a patience in finishing what he had so correctly planned, he might justly have claimed the place which Vandyck, all things considered, so justly holds as the first of portrait-painters."[2]

In other words, a too sketchy quality in painting did not accord with Reynolds' classicistic credo, and it is obviously the later, smoother Van Dyck (who had been influenced by Titian) whom Reynolds has in mind. On the other hand, it should not be overlooked that Reynolds was by no means insensitive

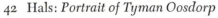

42 Hals: *Portrait of Tyman Oosdorp*

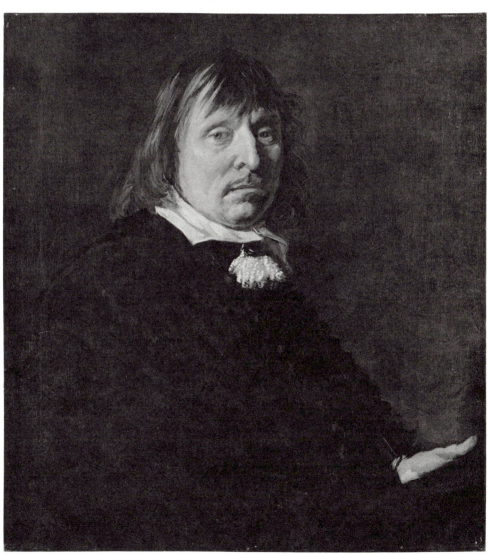

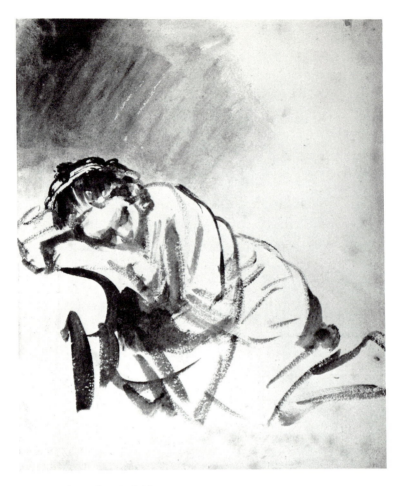

43 Rembrandt: *Girl Sleeping*

to the charm of sketches and drawings [43, 44]—in fact, he assembled one of the most remarkable collections of drawing of all times.[3] His comments in the Eighth Discourse on the attraction and special value of drawings are well worth reading.

"It is true, sketches or such drawings as painters generally make for their works, give this pleasure of imagination to a high degree. From a slight un-determined drawing, where the ideas of the composition and character are, as I may say, only just touched upon, the imagination supplies more than the painter himself, probably, could produce; and we accordingly often find that the finished work disappoints the expectation that was raised from the sketch;

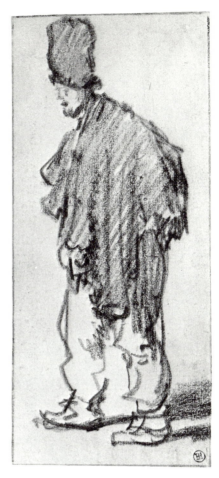

44 Rembrandt: *Beggar*

and this power of imagination is one of the causes of the great pleasure we have in viewing a collection of drawings by great painters."[4]

Yet, as we noted in his criticism of Frans Hals, Reynolds rejected such sketchy character as "unfinished" when it appeared in the paintings themselves.

Classicistic restriction also marks Reynolds' judgment of Jan Steen [45, 46], as is evident in the passage which immediately follows his statements on Hals.

"Others in the same school have shewn great power in expressing the character and passions of those vulgar people, which were the subjects of their study and attention. Among those Jean Stein seems to me one of the most

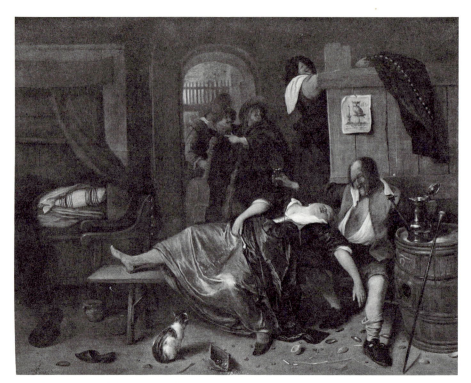

45 Jan Steen: *After a Drinking Bout*

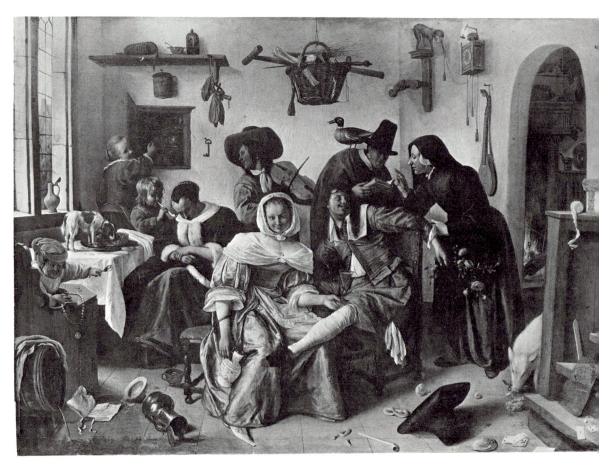

46 Steen: *The World Upside Down*

diligent and accurate observers of what passed in those scenes which he fre-
quented, and which were to him an academy. I can easily imagine, that if
this extraordinary man had had the good fortune to have been born in Italy,
instead of Holland, had he lived in Rome instead of Leyden, and been
blessed with Michael Angelo and Raffaelle for his masters, instead of Brower
and Van Gowen [Goyen]; the same sagacity and penetration which distin-
guished so accurately the different characters and expression in his vulgar
figures, would, when exerted in the selection and imitation of what was great
and elevated in nature, have been equally successful; and he now would have
ranged with the great pillars and supporters of our Art."[5]

And in the work of Rembrandt—from whom Reynolds had borrowed motifs
and devices—he admired above all the strong unification that the use of chi-
aroscuro effected, but he also censured Rembrandt's exclusive concentration
on this feature, which ran counter to Reynolds' classicistic preference for
moderation and a balanced use of the essential artistic devices. In the Eighth
Discourse, after having stressed the value of simplicity, provided it is not
excessive, he goes on to say:

"On the other hand, absolute unity, that is, a large work, consisting of one
group or mass of light only, would be as defective as an heroick poem without
episode, or any collateral incidents to recreate the mind with that variety
which it always requires.

"An instance occurs to me of two painters, (Rembrandt [47] and Poussin
[48]), of characters totally opposite to each other in every respect, but in
nothing more than in their mode of composition, and management of light
and shadow. Rembrandt's manner is absolute unity; he often has but one
group, and exhibits little more than one spot of light in the midst of a large
quantity of shadow; if he has a second mass, that second bears no proportion
to the principal. Poussin, on the contrary, has scarce any principal mass of
light at all, and his figures are often too much dispersed, without sufficient
attention to place them in groups.

"The conduct of these two painters is entirely the reverse of what might be
expected from their general style and character; the works of Poussin being as
much distinguished for simplicity, as those of Rembrandt for combination.
Even this conduct of Poussin might proceed from too great an affection to sim-

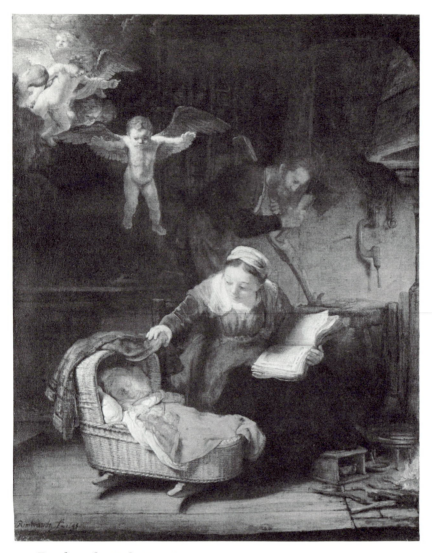

47 Rembrandt: *Holy Family*

plicity of *another kind;* too great a desire to avoid that ostentation of art, with regard to light and shadow, on which Rembrandt so much wished to draw the attention: however, each of them ran into contrary extremes, and it is difficult to determine which is the most reprehensible, both being equally distant from the demands of nature, and the purposes of art."[6]

In the *Journey to Flanders and Holland* we meet with another passage on Rembrandt that shows the limitations of Reynolds' judgment, in spite of his occasional enthusiasm. When Reynolds visited the City Hall of Amsterdam

in 1781, he found van der Helst's large group portrait of Captain Bicker's Company [49], painted in 1643, far superior to Rembrandt's *Night Watch* [50], painted in 1642, which hung in the same building. (The two pictures are still under one roof, but now in the Rijksmuseum, Amsterdam.) Reynolds said of the *Company of Captain Bicker:*

"[It] is, perhaps, the first picture of portraits in the world, comprehending more of those qualities which made a perfect portrait than any other I have seen . . . Of this picture I had before heard great commendations; but it as far exceeded my expectation, as that of Rembrandt [the *Night Watch*] fell below it. So far, indeed, am I from thinking that this last picture deserves its great reputation, that it was with difficulty I could persuade myself that it was painted by Rembrandt . . ."[7]

48 Poussin: *Triumph of Neptune and Amphitrite*

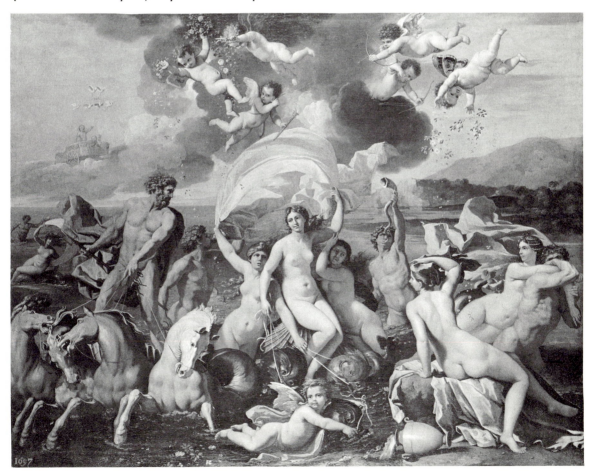

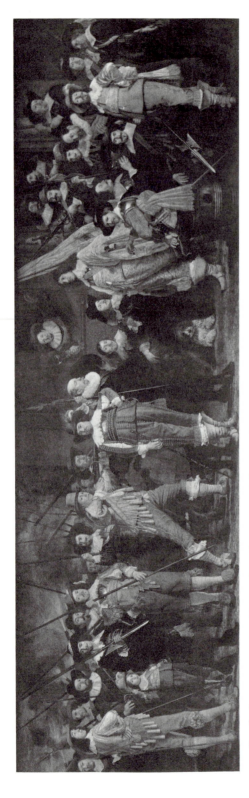

49 Bartholomeus van der Helst: *The Company of Captain Bicker*

50 Rembrandt: *The Night Watch*

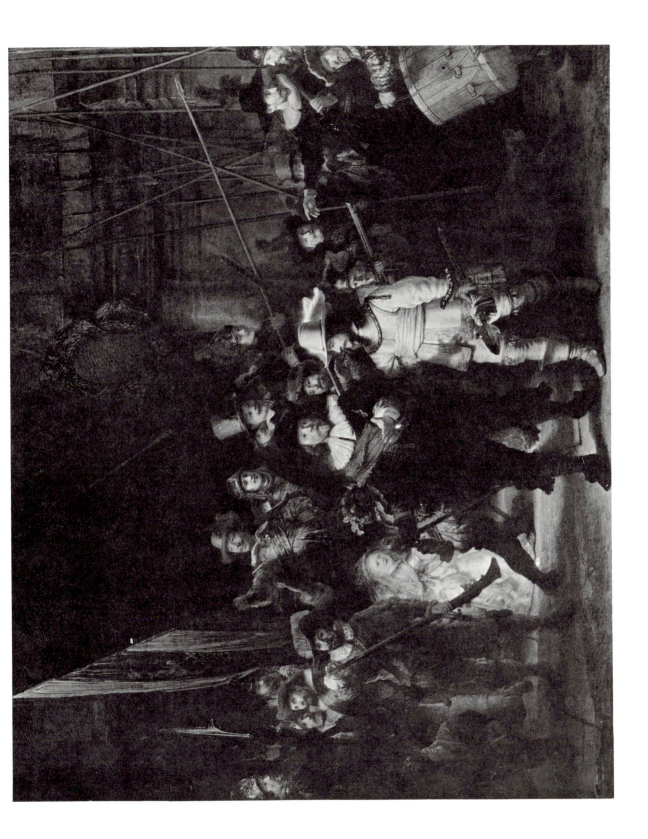

Like many others, Reynolds was impressed by the swagger, the bright coloring, and the clarity with which each of the thirty-two figures in the van der Helst group is depicted. In these respects van der Helst came close to Reynolds' adored model: Van Dyck. It should be noted that the *Night Watch* was probably in a bad state and disfigured by dirty varnish when Reynolds saw it. He writes: ". . . it seemed to me to have more of the yellow manner of Boll. . . . It appears to have been much damaged." But he insists, "what remains seems to be painted in a poor manner."[8]

51 Gainsborough:
Mrs. Robinson
("Perdita")

52 Gainsborough: *Landscape with Bridge*

Thus we see Sir Joshua Reynolds on the one hand genuinely perceptive with regard to substantial qualities of the Dutch School (Frans Hals, Jan Steen, Rembrandt, van der Helst), but on the other hand consistently maintaining his classicistic taste and value-scale, which forced him to relegate all those masters to a lower rank than the Italians. A most striking example of this kind of comparatively "free" judgment that is perceptive but still forced into the straitjacket of classicism is evident in Reynolds' remarkable Fourteenth Discourse, on Gainsborough (it was also, in effect, an obituary). Here he grasps the artistic merits of the great portraitist and landscape painter [51, 52] and points out explicitly how Gainsborough succeeds, with his free and irregular technique, in giving brilliance, coloristic harmony, and unity to his pictures, and how he catches the character of his subjects. Yet Reynolds has to classify Gainsborough as an artist who is active only in the lower category of the "ornamental" style, and who has no access to the higher level of

the "grand" manner which is exemplified by history painting alone. At least Reynolds concedes that an artist like Gainsborough, who is first-class in the "ornamental" style, is superior to second-rate artists of the "grand" style, such as the contemporaries Raphael Mengs and Pompeo Battoni, who he thinks profit too much from the age-old reputation of the Roman School. This was, for Reynolds' period, a considerable achievement in critical judgment. He says:

"I am well aware how much I lay myself open to the censure and ridicule of the academical professors of other nations, in preferring the humble attempts of Gainsborough to the works of those regular graduates in the great historical style. But we have the sanction of all mankind in preferring genius in a lower rank of art, to feebleness and insipidity in the highest."[9]

In this Discourse, Reynolds stretched his classicism to praise the work of his late colleague, who had been his rival and who had never been responsive to the classical tradition. In doing so, Reynolds exhibited his generosity of mind and his ability to recognize genius even when it departed from the established rules of greatness.

CHAPTER IV

The Nineteenth Century

THÉOPHILE THORÉ
(W. BÜRGER) [1807–1869]

G REAT cultural currents do not subside at once; only very gradually do they exhaust their vitality. Classicism still lived on into the nineteenth century, in the diluted form of Neoclassicism, though Romanticism was undermining and transforming its age-old tenets. In 1851 the leader of the French Romantic School, Eugène Delacroix, confided to his journal: "Perhaps one day it will be discovered that Rembrandt is a far greater painter than Raphael. I write this blasphemy—one that will make every schoolman's hair stand on end—without coming to an absolute decision in the matter." [1]

But another Frenchman, Théophile Thoré [53]—one of the outstanding art critics of the time—had by the end of the 1850's formed a more resolute opinion. Under the pseudonym W. Bürger, he wrote in the Introduction to the second volume of his *Musées de la Hollande:*

"By a curious phenomenon, every time I think of Rembrandt and the Dutch, Raphael and the Italians immediately appear to me, in contrast to the artists of the North. For years, therefore, I have lived almost constantly half with the Italians and Raphael, half with our Dutch and Rembrandt, who never leaves me. These illustrious dead, my sole companions in solitude, have tormented me day and night, ceaselessly proposing their divergent enigmas.

53 Leopold Flameng: *Portrait of Thoré-Bürger*

"One morning, having found in a picture shop portraits of Raphael and Rembrandt, I sat down to cut them out mechanically, in order to hang them with a pin on the wall, as the common folk, children, and artists do. Raphael was turned to the left, Rembrandt to the right. Impossible to juxtapose them face to face: that would have the air of a double irony. Naïvely I placed them back to back, and above the two heads joined the wrong way I wrote: JANUS . . .

"Such was the instinctive resumé of all my midnight meditations on these two great geniuses.

"For are not these two, in effect, the Janus of art? Raphael looks backward, Rembrandt looks forward. One saw humanity in the abstract, under the symbols of Venus and the Virgin, Apollo and Christ; the other saw directly, and with his own eyes, a humanity real and living. One is the past, the other is the future.

"I would even readily say that the great Italian art is the supreme blossoming of a completely developed society and is bound to fade, that the little Dutch art is the germ of a society still latent, and must sprout and grow green,—that Raphael is a flower and Rembrandt is a root."[2]

Thoré-Bürger was not the only writer of his generation who had the courage to break radically with the tenets of classicism and to raise the banner of Realism—as his contemporaries Millet, Courbet, and Théodore Rousseau did in their paintings—but he was perhaps Realism's most perceptive critic. He was certainly one of the founders of art history in the modern sense, through his penetrating studies of Dutch painting of the seventeenth century.

Political idealism marked the life of this fiery personality. As an ardent believer in democracy and even socialism, he took part in the revolution of 1830, and his subsequent journalistic efforts lent strong support to the democratic movement. Following his participation in an abortive insurrection, he fled France in 1849, a few months prior to being sentenced to imprisonment in absentia, and did not return until the general amnesty of 1859. From the 1830's on, in his Salon reviews,[3] he had functioned as a critic of contemporary art, but it was during the years of his exile—which he spent in Switzerland and England, in Belgium and Holland—that he adopted the pseudonym W. Bürger and developed into an art historian of no small stature, as is evident from his studies of Dutch painting.

Joseph C. Sloane in his thorough analysis of art theory in France from 1848 to 1870[4] classifies Thoré-Bürger as a "humanitarian" because of Thoré's ardent belief that art "must make people love that which is true, that which is just, that which is fruitful for the development of man. . . . Formerly art was made for gods and princes . . . the time has come to make 'art for man.' "[5]

It is not so much for his humanitarianism that we have singled out Thoré here, but rather for his remarkable contributions to valid criticism. It is true that without his political ideals of freedom and democracy, and accordingly of the independence of the great individual, he may not easily have caught fire in the still-neglected field of Dutch painting and chosen Rembrandt as his hero. On the other hand, without his perceptiveness as a critic, he would not have attained such remarkable results in his evaluation of the Dutch masters, an evaluation which has withstood the test of time for over a hundred years.

The two volumes of the *Musées de la Hollande* were presented in 1858 and 1860, in catalogue form.[6]* But what catalogues they were—ones that transcend by far the range and the character of museum catalogues in our day and that are equaled in importance only by Jacob Burckhardt's *Cicerone,* on the works of art in Italy, which appeared about the same time. The conditions under which Thoré had to work were unbelievably primitive by today's standards. Photographs were still scarce and, for a scholar with limited means, far too expensive. Older catalogues were of little help, being no more than inaccurate lists of artists and subjects. The pictures he saw were poorly exhibited, often inadequately lighted, and in bad condition. In addition, it was no easy task to search in the archives of those days for accurate information about the lives and works of the Old Masters, a search which Thoré felt obliged to make, in his desire for historical accuracy (fortunately, he could rely on the competent help of a contemporary, the learned Dutch archivist

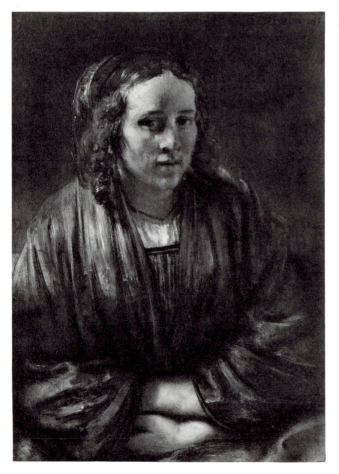

54 Rembrandt: *Hendrickje Stoffels*

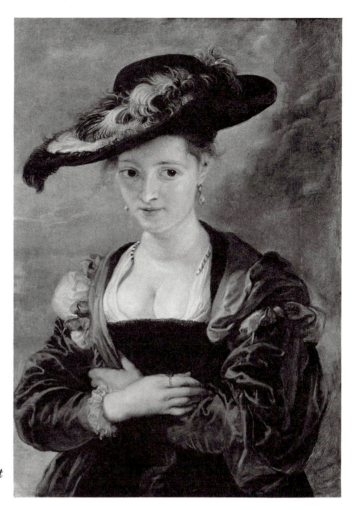

55 Rubens: *Susanne Fourment*
 (*"Chapeau de paille"*)

Pieter Scheltema). Thoré's boundless energy met all such obstacles with un-
diminished enthusiasm. Naturally he could not fully attain his goal. A good
many of his attributions and historical conclusions had to be corrected by
later research. However, his literary performance has preserved its freshness
and sparkle and his critical judgment its validity, to an amazing degree. It is
to the latter that we turn with special attention.

As we have stated earlier, the eighteenth century had already taken a con-
siderable interest in Flemish and Dutch painting, but the two schools were
regarded as a unit. They were praised for their realism, their color, or techni-
cal refinement, but criticized for the lack of grandeur and beauty at which
the great Italians excelled. It is true that Reynolds had admitted Rubens and
even Van Dyck, with only slight reservations, to the ranks of the great because

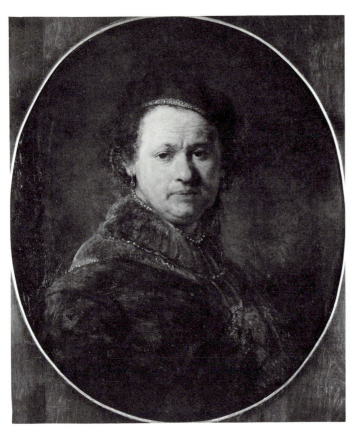

56 Rembrandt: *Self-Portrait*

of their Italian training, and also true that he had a real appreciation of Rembrandt as a colorist, a composer in light and dark, and as a naturalist. But on the whole the eighteenth century considered Rembrandt on the same level as such minor artists as Teniers, Dou, Wouwerman, as well as Jan van Huysum and Adriaen van der Werff, who were equally in demand and amply represented in the princely galleries of that period, such as those at Kassel and Dresden. Thoré substantially corrected these errors of evaluation. He stressed the basic differences between the Flemish and the Dutch schools of the seventeenth century, giving political, sociological, and artistic reasons. He recognized Rembrandt [54] as the towering figure in Dutch painting and profoundly contrasted his characteristics with those of Rubens [55]. He also defined the qualities by which Rembrandt surpassed all other Dutch masters and gave much thought to Rembrandt's development, grasping its three basic phases. Finally he explored the Rembrandt School and tried to trace the great artist's influence on his compatriots, an influence that was, however, exaggerated by Thoré's overflowing enthusiasm and limited historical knowledge. His

intense admiration of Rembrandt did not dampen his appreciation of the many remarkable painters in the Dutch School, and his critical judgment of them was equally penetrating. He was the rediscoverer of Vermeer, Carel Fabritius, Thomas de Keyser, and others, and he gave more or less adequate credit to each of the artists he undertook to study.

We shall now quote from Thoré's writings a few striking passages which are of special interest for our discussion of quality in art. These passages will also—as the Vasari text did for the Renaissance—enable us to touch on some of the highlights of Dutch painting. In comparing Rembrandt and Rubens, Thoré wrote:

". . . one is completely turned inward, the other completely outward. One is mysterious, profound, elusive, and makes you turn your thoughts toward yourself: every painting of Rembrandt, even if known beforehand from descriptions or prints, causes an indefinable surprise when seen for the first time; it is never what one expected; the viewer does not know what to say; he is silent and ponders. The other is expansive, captivating, irresistible, and makes you brighten up: every painting by Rubens communicates joy, health,

57 Gerard Dou: *Self-Portrait*

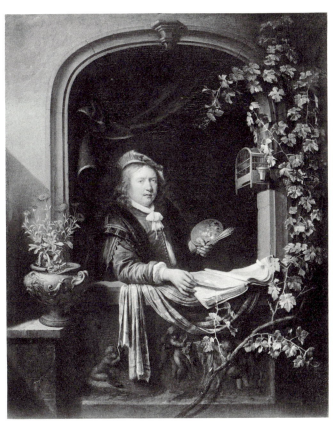

an outward exuberance of life. Before Rembrandt one meditates; before Rubens one is exalted.

"Great magicians both of them, but by absolutely opposite means."[7]

It is worth noting that Thoré does not at all minimize Rubens' greatness in comparing him with Rembrandt, in spite of his greater sympathy for the Dutch master; appropriately, he merely stresses their differences in character.

The towering greatness of Rembrandt [56] within the Dutch School and as a universal figure is recognized by Thoré in many passages of interest. In his comparison of Rembrandt and Gerard Dou [57]—who still, as in the eighteenth century, enjoyed the highest reputation because of his technical refinement—Thoré's concise arguments bring Dou down to a more appropriate level.

"Gerard Dou passes for the first of the *little* Dutch painters, as his master Rembrandt for the greatest artist of Holland.

"It is true of Rembrandt, who in fact immeasurably towers above all his

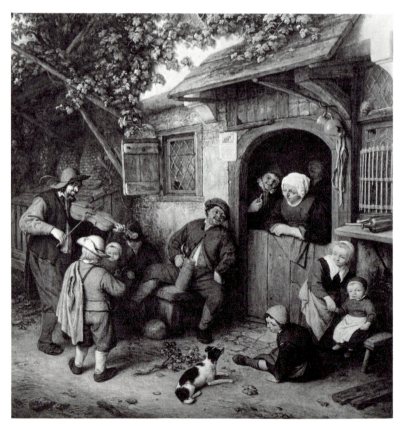

58 Adriaen van Ostade:
The Village Fiddler

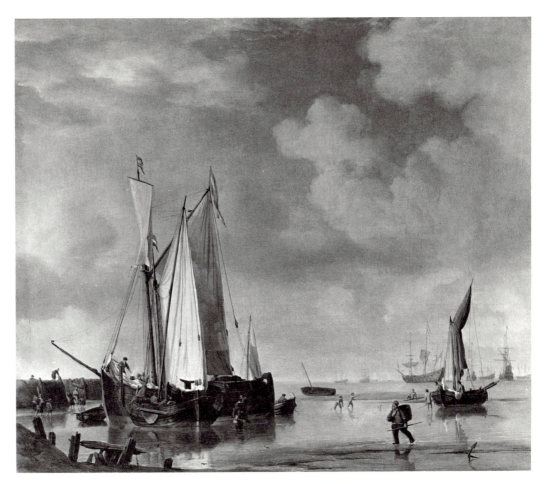

59 Willem van de Velde the Younger: *Coast Scene, a Calm*

compatriots, that he has taken a place in the supreme, hallowed Pleiad that
is above the diverse nationalities, for all humanity. Da Vinci, Michelangelo,
Raphael, Correggio, Titian, Velázquez—Jan van Eyck, Albrecht Dürer, Ru-
bens, Rembrandt—like Dante, Cervantes, Molière, Shakespeare, Goethe—
belong to all peoples."[8]

Thus we discover which of the artists and poets Thoré considered the most
illustrious in European history. The passage that immediately follows is also
revealing, indicating which of the Dutch masters came most easily to his
mind as great, though less exalted than Rembrandt.

"Rembrandt is without equal in his country—and in the world. Gerard Dou
has many equals in his country, although he has no counterpart anywhere.
The three Adriaens (the name is a lucky one!)—van Ostade [58], Brouwer,
and van de Velde—Aelbert Cuyp, Paulus Potter, Jan Steen, Pieter de Hooch,

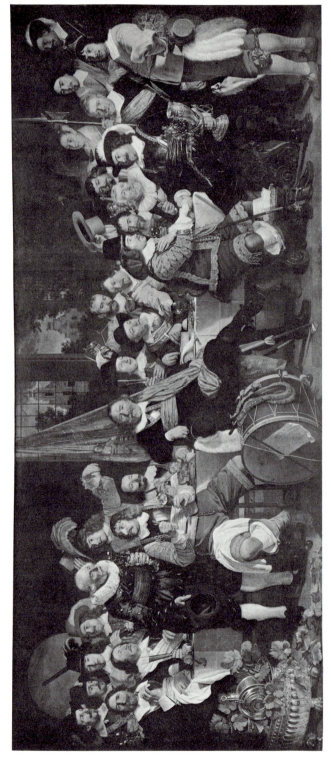

60 Bartholomeus van der Helst: *Banquet of the Civil Guard*

Terborch, Metsu, Philips Wouwerman, Willem van de Velde [59], Ruisdael, Hobbema, are surely as good as Gerard Dou, each in his own genre, and with a different talent."[9]*

The comparison of the *Night Watch* and Bartholomeus van der Helst's famous large *Banquet* [60] may be of special interest. Sir Joshua Reynolds, we will recall, compared the *Night Watch* [50] and van der Helst's *Company of Captain Bicker* [49], and concluded that the van der Helst was "the most beautiful group portrait in existence," while he found the *Night Watch* disappointing. Many critics and writers concurred with his judgment, down to Thoré's time. The latter, however, says:

"It is very curious to pass some hours between these two masterpieces [the *Night Watch* and the *Banquet*] which have always contended for the palm of the great Dutch School and have often aroused fanaticism for one or the other. One goes back and forth from one to the other, one studies them, one questions oneself, seeking to explain the absolute difference of impression which they cause.

"Both of them, each in its own way, push *reality* to the point of *illusion*. But this approximation of words in itself proves that there is nothing less real than reality in painting. What is called so depends upon the *manner of seeing* on the part of the individual. For all the combinations of effect that can produce a body of any sort are in nature, and in these combinations, infinitely diverse, one sees more or less, this or that, according to his own imagination. The artists truly endowed with a poetic faculty have a very particular manner of seeing. What Leonardo saw in La Gioconda, doubtless no one else saw in her. . . . If suddenly, without thinking of the painting, one found oneself face to face with the yellow man of the *Night Watch,* one would move aside to let him pass with his halberd. This is also reality, but as Rembrandt saw it, in a flash of genius.

"Van der Helst's manner of seeing, on the contrary, is more general, or more common—it is the same word. It is better in accord with the sentiment common to the crowd. The scene of the *Banquet* would appear the same, or almost so, to everyone. And that is why van der Helst's picture has always had a more universal success than Rembrandt's."[10]

Though Thoré makes a clear distinction between the gifts of a mere realist

like van der Helst and the more imaginative and poetic genius of a Rembrandt or a Leonardo, he does not fall into the error of considering all of Rembrandt's work to be on the same level, but recognizes differences of quality and style in the master's work and development. Thus again, in contrast to Reynolds and many of his own contemporaries, he gives preference to the *Night Watch* over the *Anatomy Lesson of Dr. Tulp* [61] with the following argument:

"I do not believe that in any school there is a painting that represents nature more sincerely or more intimately.

"Thus perfect, would not the *Anatomy Lesson* be a masterpiece of the first rank? Perhaps. Cultivated persons very much prefer several other paintings by Rembrandt, and the *Night Watch* incomparably. This *Anatomy Lesson* is nature, but a bit as everyone sees it (is this the supreme merit in the arts?) and as a good photograph would render it. The particular genius which seizes an unexpected aspect of life has not passed that way, and the 'lion's claw' has not left its imprint. The mysterious sign which flashes in the *Night Watch* and amazes everyone at first glance is not there at all. Rembrandt at that moment, though he had the vigor of an early master, had not yet, however, completely found himself."[11]

We realize now, with Thoré, that the *Night Watch* is a landmark in Rembrandt's art and in the transition to his more weighty mature style, and that it has greater qualities of imagination and pictorial power than the *Anatomy Lesson*. Thoré also felt that these qualities increase in Rembrandt's late work; but it was not until some time after Thoré's death that the true value of the expressive power and bold technique of the late Rembrandt was fully recognized.

It is worth reading what Thoré has to say about the *Jewish Bride* [62]. Here again we are provided with an example of his lively description of subject matter and technique.

"The entire figure of the bride, head, hands—the right is particularly admirable—garments and jewels, is completely finished, with love and with an extreme felicity of execution. The head of the man is also worked to the last accents of modeling. It recalls a little, in its ampleness of treatment, certain heads of the *Syndics,* and completely, in profoundness of physiognomy and in style, the head of Jan Six in the incomparable portrait in the Six van Hille-

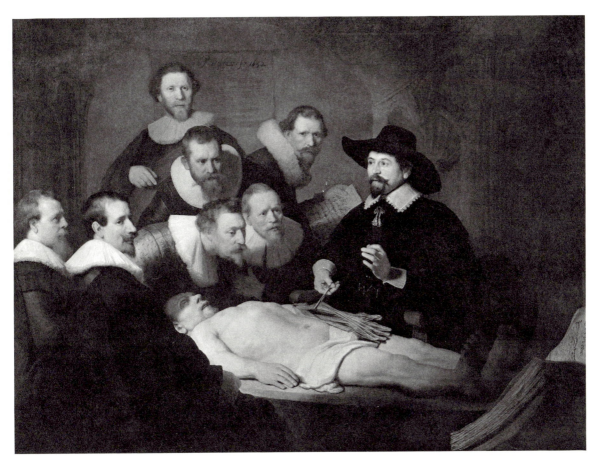

61 Rembrandt: *The Anatomy Lesson of Dr. Tulp*

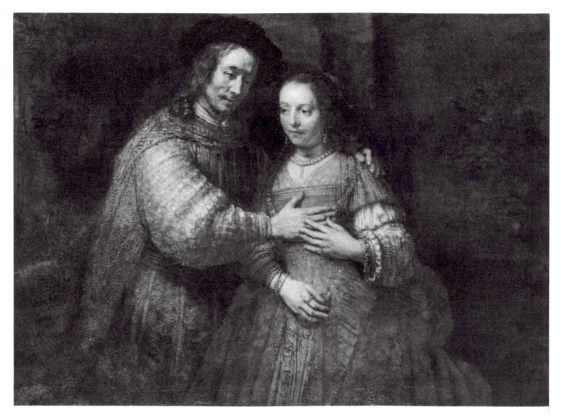

62 Rembrandt: *The Jewish Bride*

gom gallery [63]. But the yellow robe seems to be in the state of a hasty and rough first draft, and the yellow sleeve is heavily loaded with pigment in relief, which Rembrandt doubtless intended to scrape in order to preserve only the vigorous underpainting. For the picture is not finished, and the background has remained in a fantastic state....

"But how interesting for painters is this incomplete state of the picture, and what instruction it offers them! And how well it reveals Rembrandt's method of procedure! First, then, he picked out his figures, made them come out of nothingness, modeled them, brought out their main features, animated them, gave them life. He was occupied solely with his human creation, intending afterward to harmonize with his living beings all the accessories of the surroundings. The undefined background remained like a veil, rubbed with just enough tone to make the heads and the characteristic form of the

ensemble stand out. Next, onto this sort of neutral limbo, the master placed no matter what—masses of trees, a fairy-like castle in the depths—and suddenly air and space were created around the figures. Then the picture was finished and perfect."[12]

While Thoré did not quite grasp the full extent of the expressive power of the late Rembrandt's colorism and bold freedom of brushwork, he came quite close (as did Vasari in the case of the late Titian), offering a very positive and intelligent interpretation of these qualities, which respected the greatness of the performance even though it was somewhat "mysterious" if judged by mid-nineteenth-century concepts. Reynolds would have reproved Rembrandt—as he did Frans Hals—for the "unfinished" character of the works, which was contrary to his notion of perfection.

Though Rembrandt occupied a unique height in Thoré's judgment, most of the other Dutch masters also found, as I have said above, an amazingly just

63 Rembrandt: *Portrait of Jan Six*

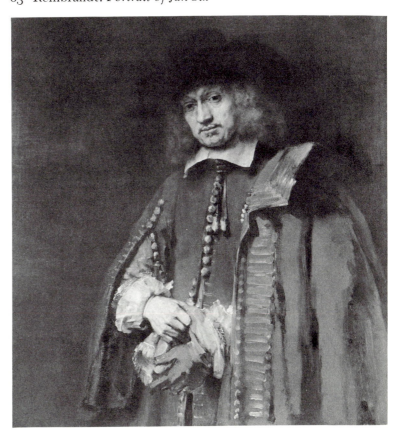

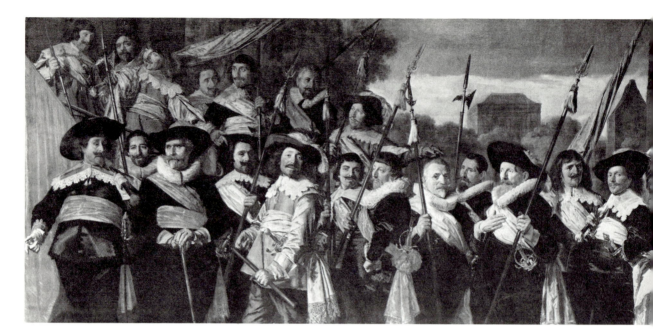

64 Frans Hals: *Officers of the Militia Company of St. George, 1639*

appreciation in his critical remarks. He was well aware of Frans Hals's genius as a portrait painter, but he estimated the later Frans Hals higher than the earlier one, for the characteristic reason that in his second period the Haarlem master had undergone the beneficial influence of Rembrandt. Thoré writes about Hals's large paintings of shooting companies in Haarlem:

"His large pictures in the Town Hall of Haarlem, representing the officers of the Company of St. George . . . are very precious, as definite types of his two manners. One painting is from the same year as the portrait in the van der Hoop museum, 1639 [64]; nineteen figures, lifesize, visible to their knees. They are the arquebusiers of the company of Colonel Johan van Loo, grouped about him. Hals is one of them, second from the left, toward the top. This is indeed one of the masterpieces of the eminent Dutch School. Incomparable mastery, a bold, solid, imposing, and free design, as in Tintoretto, to whom one is often tempted to compare Frans Hals. He knew the painting of Rembrandt at that time, and this new rivalry doubtless incited him to a deeper color, a more intimate expression in the faces, a more harmonious and tranquil effect, while retaining the energetic dash of execution."[13]

Best known of Thoré-Bürger's achievements as an art historian is his amazing discovery of Jan Vermeer. The great Delft master was nearly forgotten or confused with artists of similar manner. Arnold Houbraken's biography of the Dutch painters (published 1718–21) did not even mention him. Thoré's discovery goes back to 1842,[14] when, on his first visit to Holland, he was so impressed by the *View of Delft* [65] in the Mauritshuis that he rated this picture higher than Rembrandt's *Anatomy Lesson*. He steadily continued his search for works of the Delft master and data on him, and almost twenty years later, in the *Musées de la Hollande*, Thoré was able to present a list of a dozen Vermeers, tracing many of them back to the sale of 1696 in Amsterdam (mentioned in Gerard Hoet's 1752 catalogue and rightly called by Thoré "the most

65 Vermeer: *View of Delft*

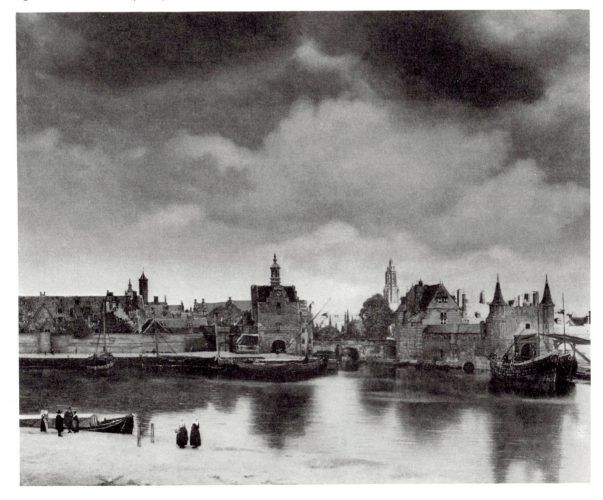

precious document on Vermeer") and to sales of the eighteenth century. In a series of articles in the *Gazette des Beaux-Arts* of 1866,[15] he summed up finally the results of his long research on this favored master, some of whose works he had bought for his own collection.

I quote here some of the observations in the *Musées de la Hollande*, to show not only Thoré's vivid description and keen appreciation, but also his difficulties in understanding Vermeer's very personal style and in clarifying the artist's development. He called Vermeer a "sphinx" because of the different manners of painting and the different influences he observed in the various works. Thoré came to odd conclusions concerning these influences, obviously because of his desire to relate the artist to the better-known masters, particularly to Rembrandt as the dominant figure of that time.

In his chapter on the Mauritshuis in The Hague, he mentions three outstanding Vermeers as follows:

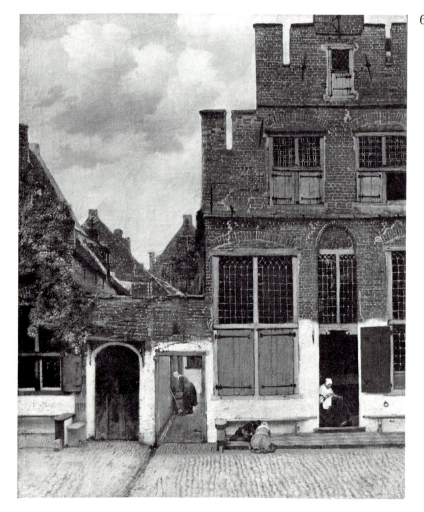

66 Vermeer: *Street in Delft*

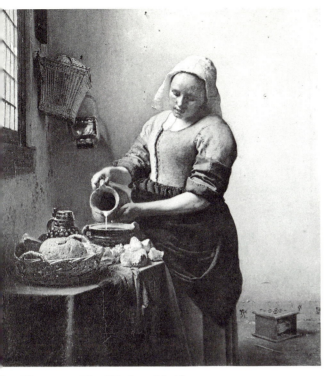

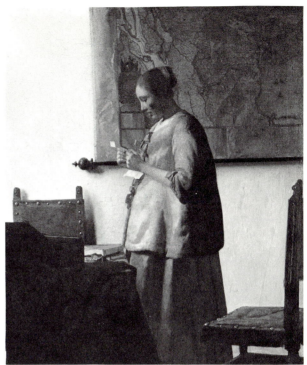

67 Vermeer: *The Kitchen Maid*

68 Vermeer: *Woman Reading a Letter*

"But here is a great painter, whose biography is no more known than that of Hobbema, and whose works are still more rare. One knows only that he was born in Delft about 1632, and that is why, in order to distinguish him from others of the same name, he is called van der Meer of Delft.

"Where to find pictures by him in order to become acquainted with him by studying them? It is only in the Six van Hillegom collection, in two very different paintings, a view of the interior of a Dutch Town [66] and a figure of a woman [67] standing out against a pale wainscoting, that one can gain an idea of this singular artist. He handles pigment like Rembrandt; he makes the light play like Pieter de Hooch, whom he imitates a little; he also has something of Aelbert Cuyp; and he treats his figures with a certain force, very individual and very strange.

"In the picture in The Hague, *View of Delft, Beside a Canal* [65], he has pushed the impasto to a point of exaggeration that one sometimes meets today in M. Decamps. One might say that he wanted to build his town with a trowel and that his walls are of true mortar. Too much is too much. Rembrandt never fell into this excess. If he used impasto in the highlights when a vivid beam

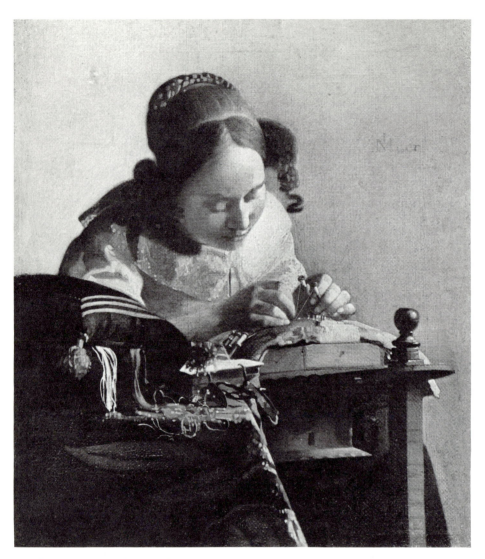

69 Vermeer: *The Lacemaker*

makes a form stand out, he is sparing in the half-tones, and obtains the depth
of the shadows by delicate, transparent glazes.

"The *View of Delft*, in spite of this masonry, is, however, a masterly picture,
and utterly surprising to amateurs unfamiliar with Vermeer. It brought 2,900
florins at the Stinstra sale in 1822."[16]

In the chapter on the van der Hoop museum Thoré deals at length with the
Delft master. He begins with the words: "The Sphinx again!" and goes on to
describe the beautiful picture, *Woman Reading a Letter* [68]. Then he adds:

"The execution of this unusual painting is very delicate, almost overprecise, the pigment very light, the color faint and even a bit dry. It is true that this picture is very much rubbed. Usually, on the contrary, Vermeer of Delft has a free touch, and the paint is thick and abundant, even exaggerated in the *View of Delft* in the museum in The Hague; an incomparable firmness of design and of modeling in the *Milkmaid* [i.e., 67] of the Six van Hillegom gallery; a coloring extremely warm and harmonious in the *Façade of a Dutch House* in the same gallery.

"These differences of treatment made me hesitate for a long time over the originality of the *Reader* of the van der Hoop museum. However, the physiognomy of this woman is of an exquisite delicacy; the bare arms, the hand holding the paper, are wonderfully well drawn; the ensemble has a great deal of strangeness; and then, this pale light, these tender blues, all that points to the Delft van der Meer. This devil of an artist without a doubt had diverse manners.

"This picture even has a signature, on an open book on the table, and although the letters are almost effaced, one can still decipher 'Meer'. Moreover,

70 Vermeer: *The Lacemaker,* detail

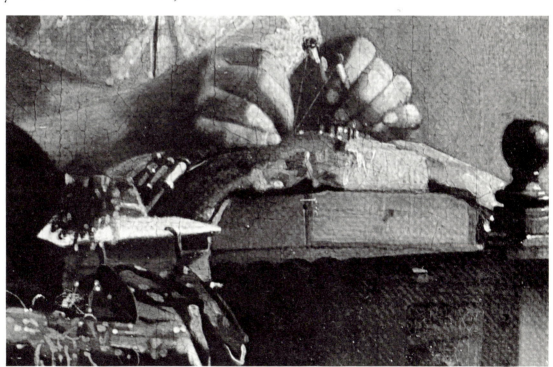

it has a tradition which I discovered . . . in a catalogue of a sale in Paris in 1809 . . ."[17]

Then Thoré lists the paintings of Vermeer thus far known to him, among these the famous *Lacemaker* [69, 70], then in the Blokhuyzen Collection in Rotterdam, analyzing its exquisite colors and praising its superb draftsmanship ("these little hands in action are drawn with a marvelous skill and elegance").[18]

Coming to the *Girl with Suitor* [71] in the museum of Brunswick, he says:

"This Brunswick picture is still different in style, in composition, and in treatment, from the paintings previously mentioned. It contains three persons, in a very elegant interior. . . . The figures have the dimensions of those of Terborch and of Metsu. . . .

"I do not know of a more delightful genre picture in the entire Dutch School of the seventeenth century . . . Here Vermeer is no longer the rough painter of his landscape in the museum of The Hague; what he is seeking is no longer the firmness and the character of the *Milkmaid* of the Six gallery; it is the supreme elegance in this coquette with her delicate and attenuated form, her charming, seductive, and intelligent face. The execution is sober, concise, without impasto, except for little touches to heighten the lights and the accessories. Terborch himself is not lighter of brush or more delicate in coloring."[19]

And finally Thoré comes to the amazing early work of Vermeer in Dresden, *The Procuress* [72, 73], on which he discovered both a signature and a date.

"But here is another masterpiece of Vermeer of Delft—at this same museum of Dresden, so celebrated, and which all artistic Europe must doubtless know —a picture . . . with four figures in life size! And this picture is exhibited in the best place, in the vast gallery of the Dutch painters, exactly above one of the most precious pictures of the whole collection—the portrait of Rembrandt with his wife Saskia on his knee! And it goes wonderfully well there! And nobody, apparently, has been intrigued by this *Jacob* van der Meer, *born in Utrecht*, to whom the painting is attributed in the catalogue! This Jacob of Utrecht has always been confused with Jan de Schoonhaven, and as for me, I do not know his works at all. If he were the author of this picture

in Dresden, he would deserve a place among the first masters of the Dutch School."[20]

Thoré describes the scene, the colors, the characters. About the manner of painting he says:

"The yellow bodice of the courtesan is painted with rich pigment and in thick lumps, without oil, like the lemon peel in pictures by de Heem, and this has become a deep enamel. The force and the harmony of the color, the naturalness of the attitudes, the animation of the faces, the power and strangeness of the effect—all point to Jan Vermeer of Delft."[21]

And he describes how his attribution was confirmed by the discovery of the signature and the date, 1656:

". . . the first that one can point out on a painting by the Delft artist. It allows one to make deductions, and to clarify a little the biography of the 'Sphinx'.

"Let us say that Vermeer was born in 1632, as is supposed. Here he is, in 1656, at the age of twenty-four, as able as the masters. And where does he come from? He comes from Rembrandt. This Dresden picture alone would be sufficient to prove it. The man with the guitar is thoroughly Rembrandt-esque. The boldness of bright tones combined with prodigious gradations of chiaroscuro, the profound sincerity of the expressions, the placing of the firm impasto in the highlights, the transparent touches in the shadows—it was Rembrandt who taught those secrets. —1656! That was also exactly the good period of Nicolaes Maes, with whom Vermeer has much in common. It was also the period when Pieter de Hooch, that counterpart of Vermeer, was beginning. For me there is no longer any doubt that Jan Vermeer of Delft worked with Rembrandt from 1650 to 1655, at the same time as Nicolaes Maes and probably Pieter de Hooch."[22]

These conclusions have subsequently been corrected. They go much too far in assuming Rembrandt's direct influence on Vermeer and Pieter de Hooch. But there is a kernel of truth here. The chiaroscuro, the warm colors, the rich technique in the Dresden *Procuress* may well have come to the early Vermeer through the influence of Rembrandt's pupil Nicolaes Maes, who also painted lifesize genre pictures, not too different in character from this one.

71 Vermeer: *Girl with Suitor*

72 Vermeer: *The Procuress*

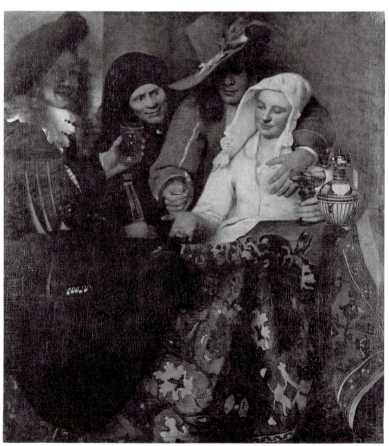

73 Vermeer: *The Procuress,* detail

The above quotations from Thoré's text on the great Dutch masters are sufficient for our purposes, although for the enjoyment of his spirited writing and his astute criticism one may want to read, for instance, those passages in which he speaks of Jacob van Ruisdael and Hobbema as the two greatest landscape painters, yet gives some preference to Ruisdael for his more profound feeling for nature, his poetical mood, and powerful composition;[23] in which he speaks very highly of Terborch and Metsu, yet realizes Terborch's greater

distinction, psychologically and pictorially;[24] in which he points out the fallacy of considering Paulus Potter's lifesize *Young Bull* [74] to be one of the greatest works of art in Holland (as was customary at that time), because, according to Thoré, in this painting the artist has lost his sense of proportion and the consistency of his painterly qualities which were so admirably preserved in his small paintings [75].[25] Thoré was also unwilling to give to the Italianate landscape painters like Nicolaes Pietersz. Berchem and Jan Both— who still ranked very high in the esteem of the collectors—as much artistic credit as he gave to Adriaen and Willem van de Velde and to Philips Wouwerman and Aelbert Cuyp, all of whom he praised for their independence of the Italian landscape, their more naïve and intimate contact with Dutch nature, their originality and pictorial charm; yet he did not fail to see that Cuyp was greater than Wouwerman.[26] It might also be mentioned that he placed Jan van der Heyden [76] high above Frans van Mieris the Younger and Adriaen van der Werff [77]—at the time great popular favorites—because he found in the exquisite architectural painter something of the true Memling and van Eyck tradition. Like the venerable Late Gothic masters, van der Heyden was more than a refined realist. According to Thoré, he "touched the point of mystery."[27]

Thoré was one of the most discriminating critics of all time with regard to quality, in relation both to the art of the past as well as to that of his own period. In applying the same standards of judgment to the Old Masters and to his contemporaries, Thoré was less exposed to the dangers of the day-to-day critic. Also, his democratic political ideals, which kindled his enthusiasm for Rembrandt and the Dutch School, rarely beclouded his sense of quality. In spite of his boundless enthusiasm for Rembrandt, he did not minimize Raphael's or Rubens' artistic greatness, but stressed that Rembrandt was closer to the spirit of his time and a more significant painter for the future. And in judging contemporary art, Thoré did not fall into Baudelaire's error of overestimating Constantin Guys as a great master based on Guys's concern with "dandyism," which for Baudelaire expressed the most essential aspect of his time.

Thoré's adherence to contemporary realism was substantially modified by the high standards he derived from his close study of the old Dutch masters.

In his analysis of Rembrandt in particular, and elsewhere, he stressed that great art requires more than mere description of life and nature, that individuality and originality come into play, that the great artist sees nature according to his inner imagination and inserts poetical feeling and even a sense of mystery. It is true that in the Salon of 1861 Thoré called Millet [78] and Courbet [79] the two master painters of the show and predicted for them a secure place in the future, but he also said that neither of them would ever reach the greatest heights;[28] obviously he felt that their work lacked something essential for the highest level of art.

On the other hand, it might be held against Thoré's critical faculty that he failed to recognize the genius of the young Manet, whose works he saw and reviewed.[29] Here was a case in which he seemed handicapped by his "humanitarianism," which resulted in his opposition to the principle of *l'art pour l'art*. Thoré's great slogan was "Art for man," and he found Manet's content too neutral. He demanded deeper participation in life and nature, not "pure painting" alone. Shall we really blame him for this attitude, or say that it inhibited his critical faculty? It all depends. We shall discuss at a later point whether "content" comes into play as a necessary component of the judgment on quality.

There are, of course, failures and omissions in Thoré's evaluation of Dutch painting. As we have said, he did not fully recognize the unique height of the late Rembrandt, although he came close to it. As for Vermeer, his attributions did not all prove to be correct. He overextended the Delft master's work, perhaps because of his eagerness for discovery, but also because of an insufficient knowledge of the artists in Vermeer's circle, such as Jacobus Vrel, Esaias Boursse, and others. Also, his occasional confusion of Vermeer and Pieter de Hooch—whose work for a while had many similarities—had to be corrected by later research based on a broader knowledge. Furthermore, one may say that from our point of view Thoré ranked certain artists too high— for example, his placement of van der Helst, Thomas de Keyser, and Gerard Dou in the same class as Terborch and Pieter de Hooch, Ruisdael and Hobbema, or his placement of Adriaen van Ostade on the level of Brouwer. But these are minor lapses, in view of Thoré's total achievement.

The beneficial influence on his artistic judgment of an intensified scholarly

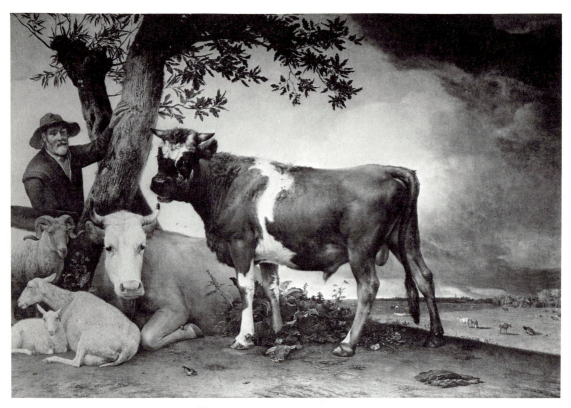

74 Paulus Potter: *The Young Bull*

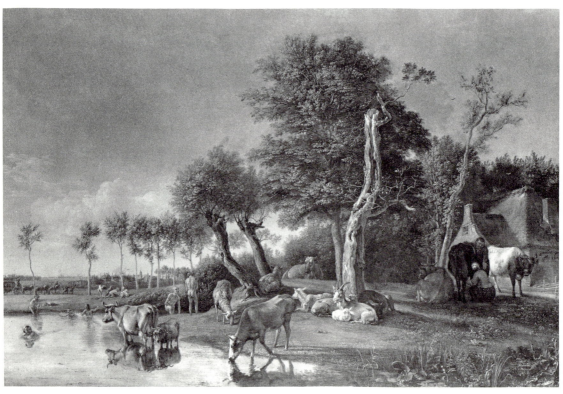

75 Potter: *Landscape with Cattle and Bathers*

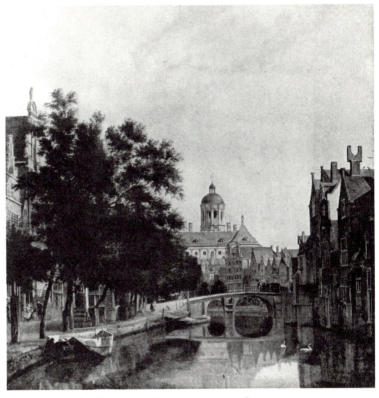

76 Jan van der Heyden: *View of Amsterdam*

77 Adriaen van de Werff:
 Man in a Quilted Gown, 1685

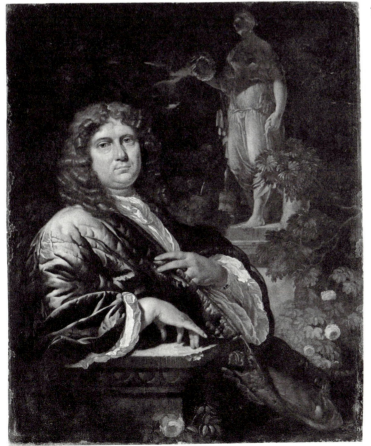

attitude and an historical approach and method is of great interest for our discussion and indicates an important turning point in the history of art and art appreciation. Thoré himself clearly states how this came about:

"I have been studying painting for a long time, but it was not very long ago that I realized that I knew almost nothing about it. I had always, however, had an extreme passion for it, an eye keen and sure, an instinct almost infallible, and nevertheless I had hardly any assurance other than that instinct. Why? Because ordinarily I had studied each picture only for its own particular qualities, without bothering about the circumstances under which it had been painted, or its chronological classification in the work of the master, or the biography of the master himself.

"When long journeys permitted me to examine at leisure the majority of the collections of Europe, and to study deeply those of certain countries, I perceived vaguely the series of works of each master who was the object of my special consideration. I understood that, in order to penetrate the character of an artist, it was necessary to reconstruct his entire *œuvre*, and that it was in the painting itself that one would find the elements missing in the painter's biography.

"I then proceeded anew, like a man knowing nothing at all and forgetting what others believed they knew; and 'going with simplicity from the known to the unknown,' as I said in the Preface to the *Musées d'Amsterdam et de La Haye,* I reapproached successively, one by one, the pictures according to the way I was seeing them. Little by little the light dawned, and today I know my principal Dutchmen, from their beginning to their end—some of them, year by year without interruption from their first student efforts, under the influence of this or that master, to their ultimate productions. If I recount these personal things, it is to recommend the same procedure to lovers of art, to scholars, critics, or collectors."[30]

By combining his keen critical judgment with this new scholarly and historical attitude, Thoré set the path for the following generation of great connoisseurs in this field, for Wilhelm von Bode, Cornelis Hofstede de Groot and Abraham Bredius, to whom we owe the foundation of our knowledge of Dutch painting. But the new value accents and the proper method had already been set by the great French critic, and only minor adjustments had to be made.

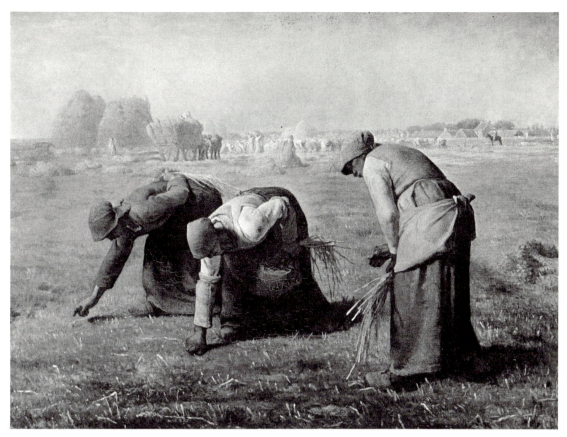

78 Millet: *The Gleaners*

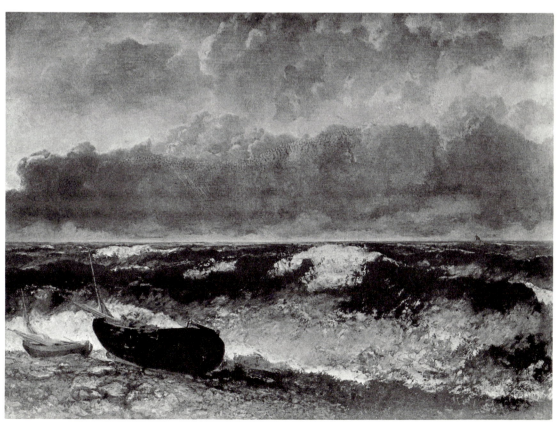

79 Courbet: *Stormy Sea*

This younger generation was fully aware of Thoré's pioneering work. Bode, for example, said in his memoirs that as a young art historian he knew the works of Thoré-Bürger *beinahe auswendig* (almost by heart).[31] And in his obituary of Thoré, Bode declared: "He established for the first time a scientific treatment of Dutch art, and thereby laid the foundation for its general recognition."[32]

CHAPTER V

The Early Twentieth Century

ROGER FRY [1866–1934]

I T is not easy to make a choice of an instructive and somewhat important
figure in the history of value judgment for the first decades of the turbu-
lent twentieth century. If I have finally settled on Roger Fry, although there
were greater art historians and connoisseurs in his generation, it is for various
reasons. According to Sir Kenneth Clark,[1] Fry was the best-known English
writer on art and the most influential figure since Ruskin. But we have also
chosen him as a representative—in fact an extreme—example of the so-called
"formal" approach to art that seems so characteristic of our century. It is the
approach which evaluates works of art primarily in terms of the qualities of
form and formal organization and too easily neglects or denies all other as-
pects, particularly subject matter or content. This kind of modern criticism
seems the ultimate consequence of the principle of *l'art pour l'art*, which origi-
nated in the mid-nineteenth century and which has since risen in importance.

Roger Fry [80] was born in 1866, the scion of a distinguished Quaker
family.[2]* His father, Sir Edward Fry, was first a successful lawyer and then
a judge. He supported his son for a long while after Roger left Cambridge
University to start the uncertain career of an artist. It seems that the young
man's strict Victorian upbringing drove him to the other extreme—the most

99

80 Roger Fry: *Self-Portrait*

independent individualism. Roger Fry's life was rather restless, and his travels almost endless. He felt equally at home in Paris and London, in Italy and southern France. Even the United States, New York in particular, was not beyond his reach. While he never gave up painting as a profession, he gained a greater reputation as an art critic, connoisseur, and lecturer. For a short period he was called to the Metropolitan Museum of Art in New York as an adviser—he declined a longer engagement—and the president of that institution, J. Pierpont Morgan, also employed him as a consultant for his private collection, traveling with him through Italy. In England, Fry tried various enterprises with the financial aid of friends, among these an arts-and-crafts shop, the Omega, which opened in 1913. Like many other of his attempts, this was a financial failure, but it helped to create in England a more modern taste in the decorative arts.

His boldest and most consequential deed had been the organization of a Post-Impressionist show, as early as 1910, at the Grafton Galleries in London—

a show that acquainted the English public for the first time with the art of
Cézanne, van Gogh, and Gauguin, as well as with that of the early Picasso and
Matisse and other Cubists and Fauves. The reaction was at least as violent
and antagonistic as the later response to the notorious Armory Show in New
York, which may have been inspired by Fry's pioneer venture. It was in these
years that he conceived his art theory, which is largely drawn from experience
of Cézanne's works. With his growing reputation as an art critic, writer, and,
equally important, lecturer, he became one of the most respected figures in
the art world—so much so that ultimately Cambridge University, although
thoroughly conservative in matters of art, could not help extending to him
an appointment as Slade Professor of Fine Arts. This academic recognition,
for which Fry had so often longed, came too late. He was by then sixty-seven,
and had only one more year to live. At the time of his Cambridge appoint-
ment, his spirits were still high, and he undertook to reinterpret and re-
evaluate the history of art within the framework of his hard-won theory. His
unfinished lectures were never revised for publication, but on the basis of his
notes they were published by devoted friends under the title *Last Lectures*.
Sir Kenneth Clark helped to prepare the edition, and wrote a perceptive Intro-
duction to the posthumous publication.

One of Fry's early and lasting experiences was his contact with the great
Italians. Giotto,[3] Masaccio, and Raphael remained for him summits of West-
ern art, and it was from them that he derived much of his basic notion of
plastic values. But his art theory was brought to full flower only by the excit-
ing experience of Cézanne, to whom he finally devoted a special monograph.[4]
Since this opus represents the very best of Fry's critical work and has hardly
been surpassed in perceptiveness and penetrating observations, we quote here
some characteristic passages on the various periods of Cézanne. These will
enable us to focus on several outstanding works by this great artist and on the
successive steps of his development. We shall see that Fry is particularly
brilliant in his observation of the master's technique and all features that per-
tain to formal organization. But in this case Fry is also remarkable in sensing
the psychological motives behind the artist's style and development.

First a passage about Cézanne's early period:

"The other portraits [of the 1860's] have all more or less the same charac-

teristics. In all, black is largely used to heighten the luminosity of the flesh tones. The volumes are firmly established and defined with broad, sweeping strokes of the palette knife in a thick paste. . . .

"One of the best of the series is that which represents an *Advocate in his Robes* [81] in the act of pleading. The dramatic idea is not perhaps subtly conceived or very strikingly expressed; one could never compare it in this respect to a Daumier. But then, in spite of his youthful ambition to excell in expressive dramatic design, Cézanne was always more plastic than psychological. But here at least the forms are interpreted with a more curious, more alert sensibility. He has evidently forgotten to be impressive and to impose his own personality, and here the colour is even more remarkable than in most, with its rich olive flesh tones against a background of white paint plastered heavily on the canvas. Even in the reproduction one can guess at something of the reckless vehemence of the handling of this period, of that celebrated *peinture couillarde* which he was destined to abandon so entirely later on.

"These portraits are perhaps of more interest as revelations of Cézanne's state of mind at this period than of value for any decisive achievement."[5]

For a view of Cézanne's middle period—which lasts through the 1870's and the first half of the eighties, and is marked by his contact with Impressionism and in particular by the influence of his friend Pissarro—we select some paragraphs that include Fry's analysis of the *Compotier* [82]. Before discussing that painting, he comments on still lifes in general:

"One may take as typical works of the period we are about to consider . . . a series of still-lifes. Before certain portraits and landscapes of Cézanne's maturity, before so impressive a masterpiece of genre painting as the *Cardplayers,* it would sound blasphemous to speak of our artist as a painter of still-life pictures, but none the less it is noteworthy that he is distinguished among artists of the highest rank by the fact that he devoted so large a part of his time to this class of picture, that he achieved in still-life the expression of the most exalted feelings and the deepest intuitions of his nature. Rembrandt alone, and that only in the rarest examples, or in accessories, can be compared to him in this respect. For one cannot deny that Cézanne gave a new character to his still-lifes. Nothing else but still-life allowed him sufficient calm and

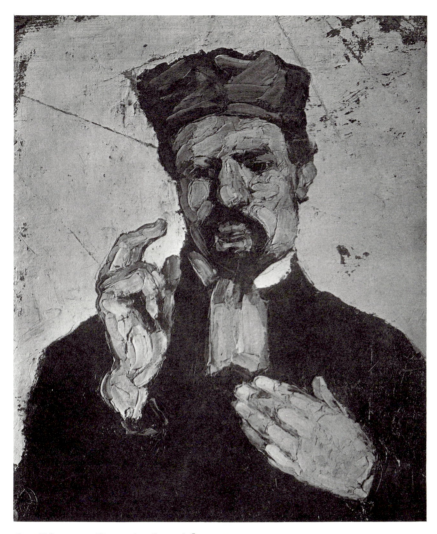

81 Cézanne: *Portrait of an Advocate*

leisure, and admitted all the delays which were necessary to him for plumbing the depths of his idea. But there, before the still-life, put together not with too ephemeral flowers, but with onions, apples, or other robust and long-enduring fruits, he could pursue till it was exhausted his probing analysis of the chromatic whole. But during the bewildering labyrinth of this analysis he held always, like Ariadne's thread, the notion that changes of colour correspond to movements of planes. He sought always to trace this correspondence throughout all the diverse modifications which changes of local colour introduced into the observed resultant."[6]

He then turns his attention to the *Compotier:*

"We may take as typical of this series and as one of the most completely achieved, the celebrated still-life of the *Compotier*. It dates, no doubt, from well on into the period under consideration, from a time when Cézanne had completely established his personal method. The sensual energy which had led him from early days to knead a dense paste into shape upon his canvas persists still. But his method of handling it has become far more circumspect. Instead of those brave swashing strokes of the brush or palette knife, we find him here proceeding by the accumulation of small touches of a full brush. These small touches had become a necessity from the moment he undertook the careful analysis of coloured surfaces. To the immediate and preconceived synthesis which in the past he had imposed upon appearance, there now succeeds a long research for an ultimate synthesis which unveils itself little by little from the contemplation of the things seen. Not that he fumbles: each touch is laid on with deliberate frankness, as a challenge to nature, as it were, and, from time to time, he confirms the conviction which he has won by a fierce accent, an almost brutal contour, which as often as not he will overlay later on, under stress of fresh discoveries and yet again reaffirm. These successive attacks on the final position leave their traces in the substance of the pigment, which becomes of an extreme richness and density. The paste under his hands grows to the quality of a sort of lacquer, saturated with colour and of an almost vitreous hardness. . . .

"Hitherto we have considered this picture solely from the point of view of the surface it offers to the eye. It is true that this surface has already yielded us certain important facts about Cézanne's emotional reactions at this period.

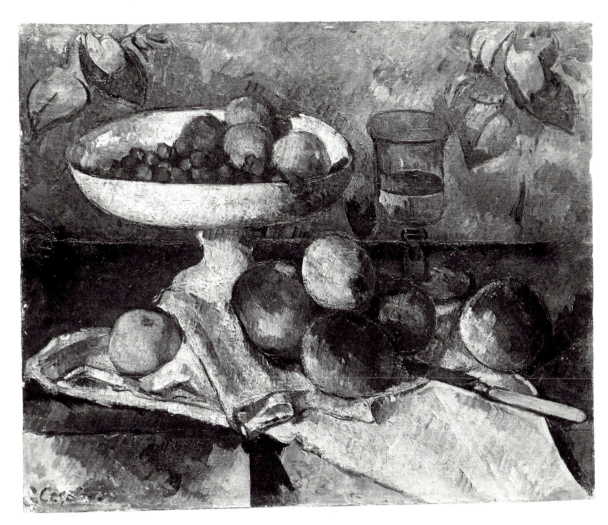

82 Cézanne: *Compotier, verre et pommes*

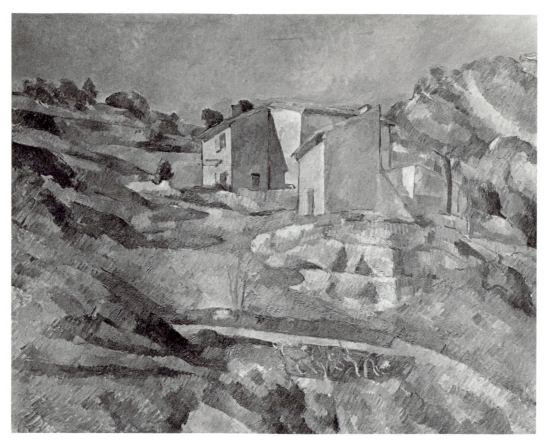

83 Cézanne: *House in Provence (Provençal Mas)*

But we must also consider it from the more fundamental point of view of the organization of the forms and the ordering of the volumes. We have already guessed, behind the exuberances of Cézanne's Baroque [early] designs, a constant tendency towards the most simple and logical relations. Here that simplicity becomes fully evident. One has the impression that each of these objects is infallibly in its place, and that its place was ordained for it from the beginning of all things, so majestically and serenely does it repose there. Such phrases are, of course, rather fantastic, but one has to make use of figurative expressions to render at all the extraordinary feeling of gravity and solemnity which the artist has found how to evoke from the presentment of these commonplace objects. One suspects a strange complicity between these objects, as though they insinuated mysterious meanings by the way they are extended on the plane of the table and occupy the imagined picture space.

Each form seems to have a surprising amplitude, to permit of our apprehending it with an ease which surprises us, and yet they admit a free circulation in the surrounding space. It is above all the main directions given by the rectilinear lines of the napkin and the knife that make us feel so vividly this horizontal extension. And this horizontal supports the spherical volumes, which enforce, far more than real apples could, the sense of their density and mass."[7]

From the landscapes of the middle period Fry chooses the *House in Provence* [83] as typical and gives an equally striking analysis of it. To this he adds a paragraph which shows how his own art theory has crystallized in the interpretation of Cézanne's pictures. He says:

"We may describe the process by which such a picture is arrived at in some such way as this:—the actual objects presented to the artist's vision are first deprived of all those specific characters by which we ordinarily apprehend their concrete existence—they are reduced to pure elements of space and volume. In this abstract world these elements are perfectly co-ordinated and organized by the artist's sensual intelligence, they attain logical consistency.

84 Cézanne: *House and Trees*

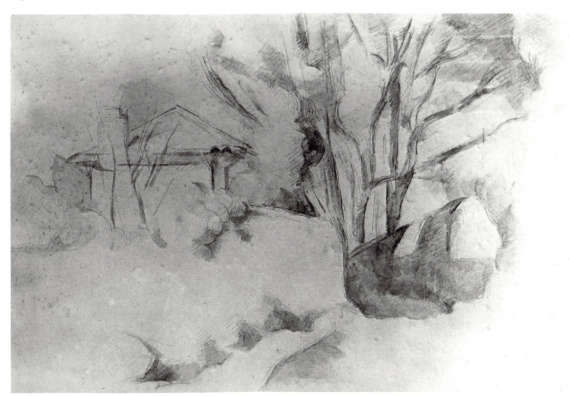

These abstractions are then brought back into the concrete world of real things, not by giving them back their specific peculiarities, but by expressing them in an incessantly varying and shifting texture. They retain their abstract intelligibility, their amenity to the human mind, and regain that reality of actual things which is absent from all abstractions."[8]

In discussing Cézanne's mature period, Fry gives some prominence to Cézanne's watercolors [84] and to their loosening effect on his style of painting—a fact which is now generally recognized but which Fry saw earlier than others. He says:

"And water-colour was developed by Cézanne in a very new and personal way. He recognized that this medium allows of certain reticences which are much less admissible in oil-painting. In that the smallest statement is definitive. The smallest touch tends to deny the surface of the canvas and to impose on the imagination a plane situated in the picture-space. In water-colour we never can lose the sense of the material, which is a wash upon the paper. The colour may stand for a plane in the picture-space, but it is only, as it were, by a tacit convention with the spectator that it does so. It never denies its actual existence on the surface of the paper. In oil, then, one is almost forced to unite together in an unbroken sequence all the separate statements of colour of the various planes. In water-colour the touches are indications rather than definite affirmations, so that the paper itself may serve as a connecting link between disparate touches of colour."[9]

Finally, two examples of Fry's analysis of Cézanne's mature style. About the *Cardplayers* [85], he says:

"Here, too, the subject is a group of cardplayers which [the artist] evidently studied in some humble café in Aix. Here perhaps was the only opportunity possible to so nervous and irritable a man as Cézanne, so easily put off by the least distraction. He could rely no doubt on the fact that these peasants took no notice of him—he was just an 'original', an odd old man whom most people thought rather mad but harmless. It was always Cézanne's great ambition to do figure pieces, but the conditions for it were too trying. Portraits were possible no doubt, but only when he could get an entirely humble and submissive sitter. But in this *cabaret* Cézanne seems for once to have found the necessary conditions and he did no less than four pictures of this subject . . .

85 Cézanne: *The Cardplayers*

"Here he seems to have carried the elimination of all but the essentials to the furthest point attainable. The simplicity of disposition is such as might even have made Giotto hesitate to adopt it. For not only is everything seen in strict parallelism to the picture plane, not only are the figures seen in almost as strict a profile as in an Egyptian relief, but they are symmetrically disposed about the central axis. And this again is, as it were wilfully, emphasized by the bottle on the table. It is true that having once accepted this Cézanne employs every ruse to render it less crushing. The axis is very slightly displaced and the balance redressed by the slight inclination of the chair back and the gestures of the two men are slightly, but sufficiently varied. But it is above all by the constant variation of the movements of planes within the main volumes, the changing relief of the contours, the complexity of the colour, in which Cézanne's bluish, purplish and greenish greys are played against oranges and coppery reds, and finally by the delightful freedom of the handwriting that he avoids all suggestion of rigidity and monotony. The feeling of life is no less intense than that of eternal stillness and repose. The hands for instance have the weight of matter because they are relaxed in complete repose, but they have the unmistakable potentiality of life.

"These figures have indeed the gravity, the reserve and the weighty solemnity of some monument of antiquity. This little café becomes for us, in Cézanne's transmutation, an epic scene in which gestures and events take on a Homeric ease and amplitude.

". . . Cézanne's purely plastic expression reaches to depths of the imaginative life to which consciously poetical painting has scarcely ever attained."[10]

The *Cardplayers*, a late painting, is dated about 1890–2; Fry, however, observes a further development in other of Cézanne's works of this period, which we illustrate with the *Pool Overhung with Foliage* [86].

"It is more difficult to be precise about this [very last phase] than about the previous [ones]. . . . in some ways it shows a continuance of the watercolour technique, an even extended use of pure transparent glazes of colour; in other examples there is a return to impasto laid on to the preparation directly, in loaded brush strokes. . . .

"But whatever the technique we find in this last phase a tendency to break up the volumes, to arrive almost at a refusal to accept the unity of each object,

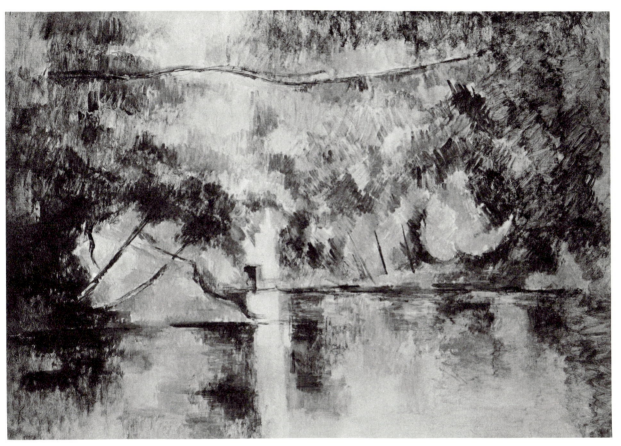

86 Cézanne: *Pool Overhung with Foliage* (*"Les Reflets dans l'eau"*)

to allow the planes to move freely in space. We get, in fact, a kind of abstract system of plastic rhythms, from which we can no doubt build up the separate volumes for ourselves, but in which these are not clearly enforced on us. But in contradistinction to the earlier work, where the articulations were heavily emphasized, we are almost invited to articulate the weft of movements for ourselves. . . .

"The landscape of a pool overhung with foliage gives an idea of the disintegration of volumes of which I have spoken. It is quite true that in nature such a scene gives an effect of a confused interweft, but in earlier days Cézanne either would not have accepted it as a motive or would have established certain definitely articulated masses. Here the flux of small movements is continuous and unbroken. We seem almost back to the attitude of the pure Impressionists. But this is illusory, for there will be found to emerge from this a far more definite and coherent plastic construction than theirs. It is no mere impression of a natural effect, but a re-creation which has a similar dazzling multiplicity and involution."[11]

Now let us consider what art theory Fry has built out of this experience and what new evaluation of the history of art he has undertaken on that basis. It is true that the Cézanne experience was not the only influence, although it was the most decisive one. Heinrich Wölfflin's *Principles of Art History* also made an impression on him,[12] as did Denman Ross's *Theory of Pure Design*. Yet they did not do much more than strengthen Fry's own inclination toward a radical "formal" approach in his criticism.

Roger Fry's art theory is not easy to define, not only because it suffers from inconsistencies, but also because he kept moving on from experience to experience, insisting that the actual confrontation with the work of art matters more than any theory. However, he did not really abandon his basic ideas, which are roughly the following: There is the world of reality and there is the world of "pure art." The two are basically different, and we have access to "pure art" and to the "pure aesthetic effect" only through the aesthetic sense, which is a kind of sixth sense and should not be distracted by non-artistic associations, whether they are literary, psychological, social, or political ones. Even the representational aspect distracts from the pure aesthetic effect.

A chief concern of "pure" art is the clear expression of volume and the plastic continuity and coherence in space. Unity and order are of course indispensable for every design; rhythm, texture, and color are essential elements of animation along with the all-important plastic expression.

In his eagerness to purify the aesthetic effect, Fry comes close to rejecting "illustrative" and "decorative" values as irrelevant. Furthermore, his enthusiasm for Primitive art led him to assume that the intellectual approach, if it dominates the intuitive and subconscious impulses—as he believed it did in Egyptian art and even more so in Greek—interferes with the purely artistic character of the work. Also, too much "finish"—which he thought was always due to nonartistic influences, such as social ambition or absolutism—prohibits free artistic expression.

In the *Last Lectures,* Fry singled out two primary qualities by which he undertook to re-evaluate the history of art. They are "sensibility" and "vitality," and their definition implies a curious mixture of biological, psychological, and artistic consideration. He defines his use of the word sensibility in the following passage:

"I am going to use the word 'sensibility' for the sensibility to texture, the sensibility of execution, which we found to be most bound up with the unconscious nature."[13]

He distinguishes the execution from the organization or design, which, he feels, is more bound up with our conscious nature. In defining the quality of vitality, Fry is still less specific, yet it obviously means something important to him. He says that this quality is "the quality of vitality in artistic images. Some images give us a strong illusion that they possess a life of their own, others may appear to us exact likenesses of living things and are yet themselves devoid of life."[14]

He continues:

"In the *Niobid* [87], there is not only strong action but also violent emotion freely depicted; yet it is more like a statement about the state than a representation of the state itself. . . .

"The *Niobid,* for example, is a very complete rendering of a living human figure; the likeness to the human being is very close. But these Negro figures [88] which are extremely incomplete with barely enough likeness for us to

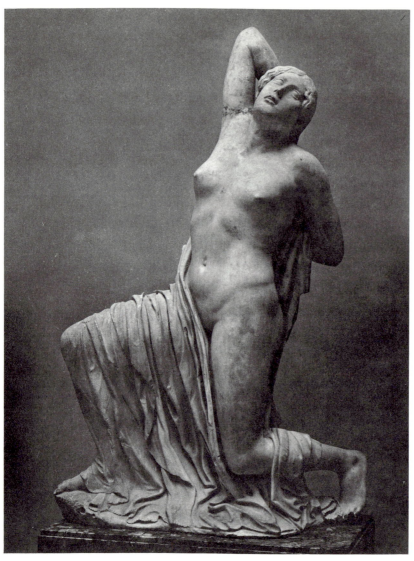

87 Greek sculpture, 5th century B.C.: *Niobid*

recognize what they represent, are yet vividly alive. We may suspect that it is only by suppressing every other aspect of the figure but those which suggest vitality that the artist can arouse in us the conviction of life."[15]

 This quality of vitality Fry sees also in Giotto and his contemporaries, but not in Greek art or in the artists of the High Renaissance, for instance, Raphael and Fra Bartolommeo, because, he says, in all of these "a peculiarly conscious and deliberate pursuit of ideal beauty"[16] prohibits the expression of vital life.

While he does not insist that this quality of vitality is always bound up with artistic value—after all, he admired Raphael—he says that "if we find aesthetic satisfaction in a work of art it is probable that our satisfaction will be heightened if the images which arouse it suggest vital energy."[17]

What, then, are the results of his art theory and of the application of the criteria of sensibility and vitality in Fry's great effort to re-evaluate the whole history of art? We have already outlined some of them: his elevation of Primitive art, in the case of Negro sculpture, to a very high plane in contrast to Greek art, which he more or less debunks as overintellectual or conceptual and as lacking in sensibility and vitality. One striking instance of this is his startling comparative judgment of Chinese bronze vessels of the Chou period [89], on the one hand, and of the Olympia sculptures [90], on the other. He raves about the former throughout many pages; for the latter he has severe criticism and hardly a word of praise. Note what he says:

88 Negro sculpture:
 Two wood figures from
 Gabon, West Africa

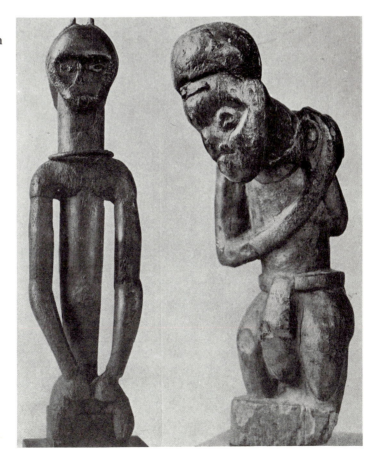

"These bronzes well illustrate the peculiar aesthetic quality of Chou art; the rigorous co-ordination of the parts in a single unity and the full sensibility of the handling. It is this tense equilibrium between sensibility and controlling intelligence which is so fascinating to us. I find the essentials of plastic harmony in almost their purest most elemental expression in these bronzes. The imposed condition of making a vessel is so slight that the plastic imagination of the artist is left almost entirely free."[18]

Regarding the Olympia sculptures, he has first to admit that "there is none of the tight, decorative pattern-work of the folds which we saw in the archaic. Nor are the muscles used as patterns. There is much less tight precision everywhere."[19] But he adds that "the absence of this tight patterned linear treatment has left the modelling rather shapeless in its bland rounding off of every form. There are no accents to mark the division of planes . . . no trace of inner tension. Nor again is there any rhythmic idea uniting one figure with another, nor, in spite of the full relief, any suggestion of spatial relations."[20] About the particular metope *Herakles and the Augean Stables,* Fry remarks that "there is the same curious want of composition, of balance, of direction. Even if we complete the movement it is strange to note how no attempt has been made to unite the rigid perpendicular of the goddess with the diagonal system; her extended arm even increases the difficulty. It would have been well within the resources of this sculptor to establish some diagonals in the

89 Chinese bronzes, Chou Dynasty:
 a) Bowl with elephant-trunk handles b) Diamond-patterned bowl

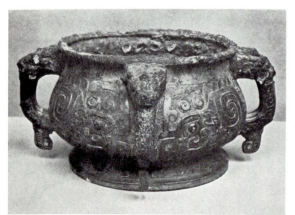
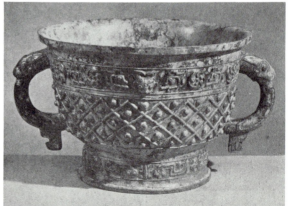

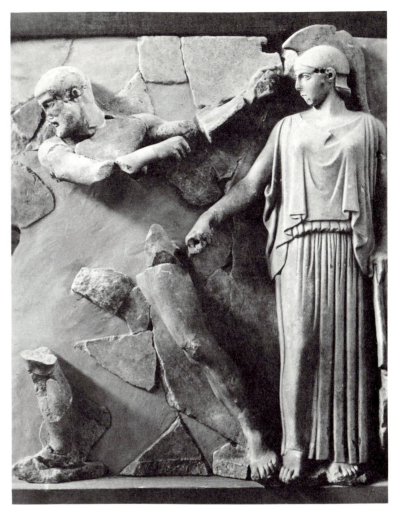

90 Greek sculpture, 5th century B.C.: *Herakles and the Augean Stables*. Metope, Temple of Zeus, Olympia

figure of Athena, and one notes once more how little it occurred to the Greek mind to consider a more extended whole than the single figure."[21] While Fry admits that "the movement of the Heracles is admirably observed," he turns this praise into censure by adding, "only again the sense of tension of the spirit is strangely absent."[22]

On the other hand, in his criticism of Greek art finer distinctions are not lacking, as is evident from the previous quotations. He finds in particular the Archaic sculpture [91] overestimated and sees in it primarily a rigid and purely decorative character with little vital animation. He admits only a few

91 Greek sculpture,
6th century B.C.:
Hera of Samos

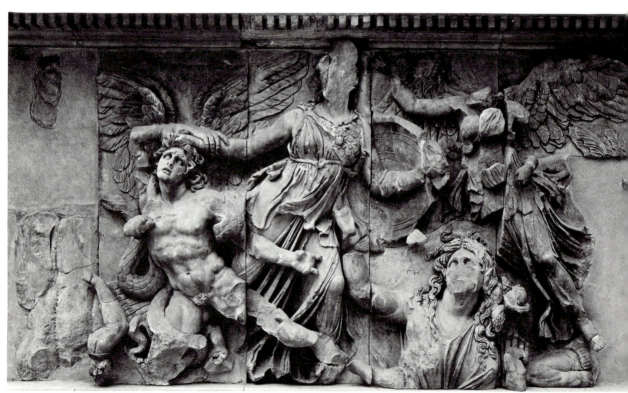

92 Greek sculpture, Hellenistic: *Athena group*. Detail, Pergamon Altar

exceptions, such as the sixth-century *Lion* in the Berlin Museum. Even the Elgin marbles of the Classical period do not escape his derogatory criticism, except for the so-called *Three Sisters*. He has praise, however, for the baroque animation of Hellenistic art, as represented by the Pergamon frieze [92]. Here he finds vitality and rhythm. Roman art is completely dismissed as purely realistic and overdecorative.

Fry also has a low opinion of the art of the Middle Ages,[23] as we may expect from his theory that the merely formal relationships matter more than other relationships and that the content matters least of all. He could not tolerate the fact that art at that time was at the service of religion, and he tried to explain the relatively high quality of the portals at Chartres [93] and Reims [94] by the curious assumption that the Church at that phase had not yet fully understood how to corrupt art for its own purposes.

Why, then, did a critic as successful and penetrating in his judgment on the art of Cézanne fail so badly in the evaluation of whole periods and great works of art? What was wrong with Fry's theory and with the criteria that led him to such aberrations? There are a number of reasons for these failures, which we shall trace. (That they were failures has already been clearly though subtly indicated by Kenneth Clark in his Introduction to Fry's *Last Lectures*.) Above all, we must acknowledge his overestimation of Primitive art and his underestimation of classical Greek and medieval art. Moreover, the criteria with which Fry approached the re-evaluation of the history of art, namely, "sensibility" and "vitality," are vaguely or too narrowly defined, and are certainly insufficient for such an ambitious undertaking. An artist's sensibility penetrates the organization of his designs, not only their execution or texture. Sensibility and vitality are not exclusively bound up with the unconscious and the intuitive. There is a kind of homespun character to the whole of Fry's terminology and to the limited, often too negative meaning he gives to his terms (such as "finish" and "decorative," "conceptual" versus "intuitive," "free" versus "alienated" art). These limited and often too negative meanings do not withstand the hard test of the history of art and its manifold character.

Another primary reason for his failures can be found in the fact that the inspiring experience of the art of Cézanne and of Post-Impressionism—which formed the basis of Fry's criticism—is insufficient for an all-embracing art

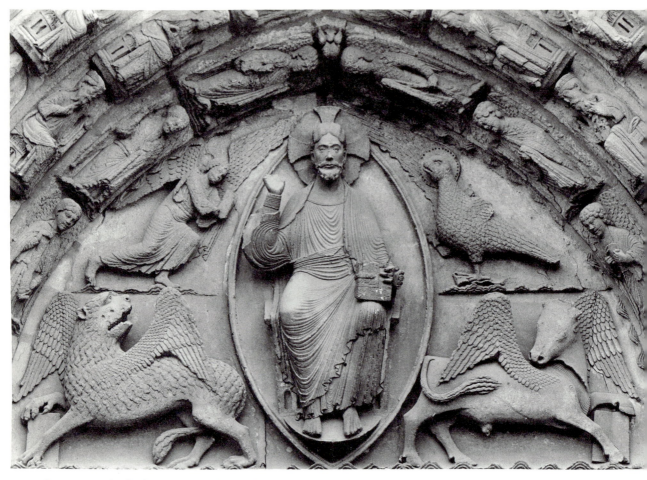

93 Chartres Cathedral, west central portal, tympanum: *Christ in Majesty*

theory and critical evaluation. In this regard, even Roger de Piles was more circumspect when he demanded that we learn from as many great masters as possible in order to validate our critical judgment. Still another serious reason for Fry's failures lies in the extremism of his purely formal approach, which he drove *ad absurdum* by ignoring, as being artistically irrelevant, the original intention of a work of art and its historical circumstances, its cultural function, and its content. A major example of this is his overenthusiasm for Negro art which is—as Clark rightly points out—"the art of a people with whom he [Fry] can have had no single idea or association in common. The very existence of these sculptures depended on beliefs and emotions which he must have regarded as mere madness."[24]

Fry, then, did not generally use history or historical information as an indispensable source of knowledge for the proper understanding and, therefore, evaluation of works of art. In this respect, Thoré-Bürger was superior and less prone to error because of his basic realization that full exploitation of all documentary sources as well as an historical approach is indispensable to the

94 Reims Cathedral, west central portal: *Annunciation and Visitation*

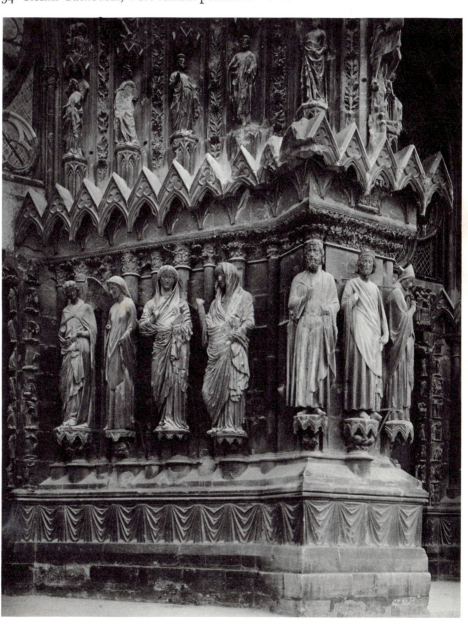

stability of our attribution and our critical judgment. In passing quality judgments on periods and masters other than those he really loved, Thoré was much less overreaching and more restrained. We may recall that in spite of his aversion to classicism he did not minimize Raphael's greatness; he merely stressed the contrast of character between the art of Raphael and Rembrandt.

We must say, on the other hand, that in his analysis of Cézanne's work and development Fry has provided a fine example of the process of proper evaluation of a work of art and of a great master. In the case of Cézanne, he did understand and take into consideration the important circumstances of the artist's life, his intentions, and his reaction to contemporary trends. But above all, Fry's analysis of formal organization and technical execution is incisive and perceptive. In this respect he is more articulate than Thoré-Bürger and, certainly, than any of the earlier critics.

Conclusions

WHAT, then, have we learned from the merits and the failures of outstanding critics of the past, from the Renaissance to the first decades of our century?

Let us begin with the merits:

It was Vasari [1] who made us realize that our judgment should not be too rigidly restricted by the dominant art theory of our period or by dogmatic historical concepts, but that we should give some leeway to our instinct or intuitive reaction. We have seen instances of this in his estimate of Donatello and the late Titian.

It was Roger de Piles [22] who taught us to derive our standards not only from one great master or one period, but from several, and to do so by analysis based on a sufficiently broad theory, and by comparison. In this way, de Piles came to appreciate Rubens as being on the same level as Raphael, and to see value in Rembrandt.

It was Sir Joshua Reynolds [38] who, in spite of his still-persistent classicism and the typical attitude of the Academician, provided remarkable glimpses into such unclassical fields as Flemish and Dutch painting. His appreciation of a contemporary like Gainsborough was also high. In addition, he had a

vivid feeling for the charm of drawings and sketches and their appeal to the imagination.

It was Thoré-Bürger [53] who not only definitely broke through the restrictions of the classicistic judgment, but who also taught us to back up our critical judgment by a scholarly attitude, by documentary evidence, and by an historical approach that considers the work of art in its larger context and places it within the artist's development as well as within his local and national school. Thoré was primarily concerned with the problem of proper attribution, but for us the sound attribution to a great master is also a safeguard for quality judgment.

Finally, it was Roger Fry [80] who gave us an instructive example of how to penetrate into a deeper understanding of works of art through an incisive and perceptive analysis of the formal organization and the technical means employed. In this way he was able to reveal to us the full stature of Cézanne and to extend our understanding of modern art.

In order to avoid the failures of the critics whom we have considered, we list the following warnings, which may keep us from falling into the same traps, or which may at least make us aware of our limitations when we ourselves set out to establish criteria of quality.

We should avoid quality judgments on whole periods unless we are really informed and unless we consider adequately the cultural purposes and artistic intentions of the period, keeping ourselves as free as possible from the prejudices of our time. In this respect, all the critics failed, from Vasari to Reynolds, as a result of their classicistic devaluation of medieval art.

We should, in general, avoid judgment based on too narrow a set of principles or on vaguely or ill-defined criteria. In the latter respect Fry failed when attempting to re-evaluate the history of art. And his too exclusively "formal" approach turned out to be misleading for art with a cultural purpose and content.

Finally, we should avoid overrating the celebrated figures of our own time or Old Masters who happen to be fashionable. De Piles failed in both respects. He estimated Charles Le Brun almost as high as the greatest artists of the past and he accepted little masters like Teniers as being on almost the same level as Rembrandt.

Equipped with these warnings and encouraged by the achievements of critics of the past, have we any chance to do better? Is our time really in a more favorable position than theirs to judge more objectively? Are we not also subject to prejudices and limitations? We are indeed, but we can modify these limitations because we have certain advantages over the critics of the past:

We can build on such of their judgments as have been validated by the test of time. In addition, time has provided us with the advantages of wider experience and a broader perspective. We have enlarged our knowledge by having access to more examples of great masters and to periods not known to the older critics.

Furthermore, the proper analysis of a work of art—by which one gains a fuller understanding—has become, step by step, more intensive and successful. Fry set an excellent example in his treatment of Cézanne's art, and there have been many more such achievements since.

Finally, our scholarly standards and our historical knowledge have greatly increased and have helped to clarify the attributions to the great and to the minor masters, and this, in turn, supports our value judgment.

What, then, would be the best procedure to follow in order to gain criteria of excellence that are as sound as possible? We must go more slowly, more cautiously, armed with more information than Roger Fry, and we must therefore restrict our ambition—at least at first—to the discrimination of quality in works of art of a single period and of similar style and technique. If, for instance, we compare a portrait by Rembrandt with a portrait by a pupil of his—let us say Gerbrand van den Eeckhout or Ferdinand Bol—we have an excellent opportunity to define the characteristics of higher and lesser quality, to see the difference between a great and a minor artist. Naturally, we would judge not only by comparison, but also by an analysis of each work in itself; the comparison, however, will fortify our conclusions. If we extend this experience to other examples from various periods, we will gradually evolve criteria of excellence of a more general validity. Whether we can or should go further and compare the quality of whole periods, or of works of art of very different styles and techniques, is not our immediate concern. Past examples of this endeavor, particularly Roger Fry's unsuccessful comparison of Greek

and Negro art, have cautioned us against going too far, and we may well be satisfied with establishing valid criteria within comprehensive limits. After all, we cannot hope to gain absolute, but only relative, certainty about our quality judgment.

As for a systematic approach, there remains one big question: Do we not move in a vicious circle in assuming that a great master *is* a great master because his fame is tested by the approval of centuries? We certainly ought to test and to experience again this value judgment. But I think it does no harm if, in our choice of examples, we go first on the generally accepted assumption that Rembrandt and Raphael, Rubens and Watteau, Cézanne and Manet are great masters, and then prove it again by our analysis and comparison. In this way the *circulus vitiosus* will be broken.

The following chapters, therefore, will deal with our own search for criteria of excellence along the lines which I have indicated.

Quality Judgment Today

CHAPTER VI

Master Drawings of the Fifteenth and Sixteenth Centuries

A FTER dealing in the previous chapters with the criteria of excellence in the past and learning something about the problem of quality judgment from the achievements and failures of eminent critics, we turn now to the task of establishing criteria for ourselves. We came to the conclusion that a good approach to this task would be to compare the works of great masters with those of minor artists who follow them or who work in a similar style. In this way the degrees of quality would be best distinguishable, while the greatness of the great would be reconfirmed by a fresh analysis. And it is helpful if we compare works that show similarities not only of style, but also of subject matter and technique, so that our attention is primarily directed toward differences in quality, allowing a more complete concentration on our problem.

We have chosen master drawings as the best possible material for our purpose. Drawings are more satisfactorily reproduced than paintings, in which the exact rendering of colors presents great difficulty. In this chapter we shall focus on some leading artists of the fifteenth and sixteenth centuries, that is, of the Late Gothic and the Renaissance. In the chapter that follows we shall turn to the later periods, through the end of the nineteenth century. The

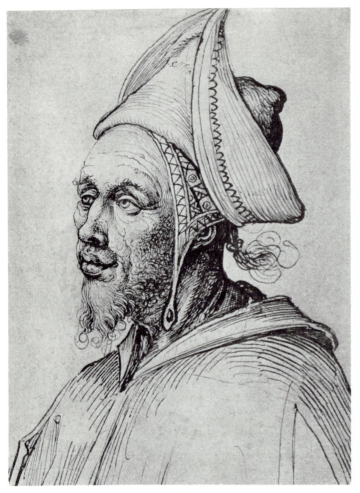

95 Martin Schongauer: *Head of an Oriental*

twentieth century, because of its decisive break with representational art, will be dealt with in a separate chapter.

We begin by comparing a pen drawing by Martin Schongauer [95]—one of the greatest German artists in the second half of the fifteenth century, who exerted a strong influence on the young Albrecht Dürer—with a drawing by a Schongauer pupil [96], also in pen and representing a similar subject: the head of an Oriental. I doubt that an untrained eye will easily realize the inferior quality of the follower's drawing. It may appeal at first by its more forceful accents and rather daring breadth. Closer observation, however, will reveal that this drawing lacks the finer as well as the fundamental qualities

by which the master's drawing is distinguished. In this, as in the comparisons that follow, the distinctions to be made do not offer themselves too readily. As we well know, subtle intellectual and visual discrimination cannot be attained in a moment; it requires a concentrated study of the objects concerned. In Schongauer's work the line is finer, more sensitive, and more graded in its accents. It models with a sure feeling for roundness, for texture, for organic structure. Look at the mouth, the side of the nose, the eyes and the eye sockets, the beard, the wrinkles on the forehead and the sweeping form of the turban. Schongauer's line is also marked by a calligraphic quality, by an extraordinary graphic charm. A small detail like the pigtail of the Oriental makes us aware of that. Furthermore the linear vocabulary which the artist

96 School of Schongauer: *Head of an Oriental*

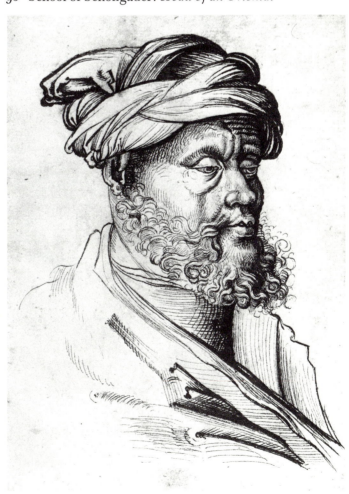

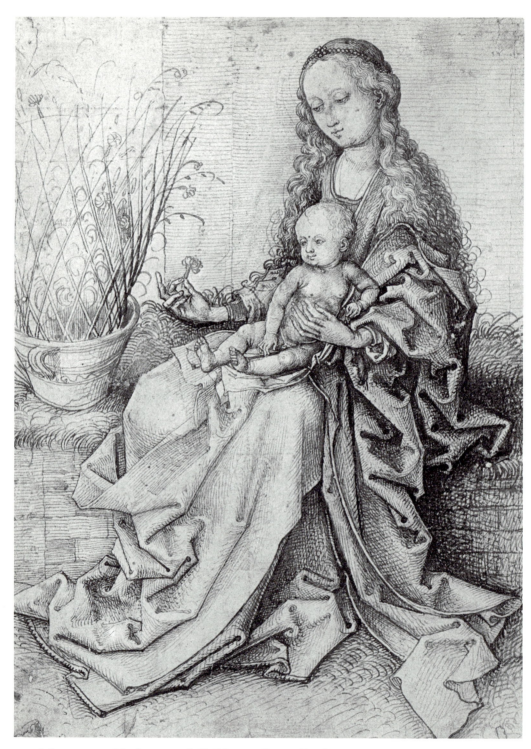

97 Schongauer: *Madonna and Child on a Grassy Bank*

has created—the various types of stroke and shading, such as simple parallels, little hooks, dense crosshatching—smoothly and completely fulfills its complex function, which is to model the figure and to give texture as well as to build up a coherent graphic design.

There is no doubt that the Schongauer head has more plastic life, more surface animation and organic coherence than the other drawing. The whole and the parts are better related. There is a clearer distinction of planes throughout, with more gradual transitions from light to dark. And, ultimately, a sensitive human characterization is achieved with a convincing momentary expression.

The follower's drawing seems in comparison harsh and unrelated in its parts. The overdone accents in certain areas have a disruptive effect on the whole. The bulk of the form is not brought out in the bust, the head, or the turban. This last remains flat, whereas in the master's drawing the eye is effectively guided around the complicated form of the fantastic headdress. Altogether, we miss the graphic charm, the decorative coherence of the design, and the human animation that Schongauer achieves. In the work of the follower, the expression is masklike and rigid, and lacks the palpitating life of the other. Whether this drawing was done after a Schongauer original with some willful deviations and omissions, or whether it was this follower's own invention in the Schongauer manner, the performance is conspicuously inferior to that of the master.

In another comparison between one of the rare original Schongauer drawings [97] and a similar one by a follower [98], both in pen, it may be still harder to perceive the difference in quality, at least at first sight. Here a greater closeness exists between master and pupil; yet, we can distinguish the superior quality of the first. We need such finer distinctions as well as more obvious ones for the clarification of our problem.

The Schongauer Madonna with a pink, holding the Child and seated near a pot of pinks on a grassy bank, shows the characteristic Late Gothic taste of Northern, and in particular German, art for slender, overdelicate figures as well as for emphasis on the display of drapery. Also distinctly Late Gothic is the animation of the drapery by sweeping turns and a cascade of angular folds that almost bury the forms of the Madonna underneath. In the elaboration,

vividness, and clarity of this motif Schongauer shows his superiority to his follower.

Under the Madonna's left hand the mantle is divided by two contrasting curves, both containing a cluster of angular folds. Most vivid are those on the right—we called them a cascade. The smaller folds under the Madonna's right knee also have a plastic and rhythmic quality. The whole layout of the drapery, although complicated, is nevertheless clear and animated by a continuous rhythm, with larger and smaller accents well related and with a distinct indication of recession in space. Also a sensitive control of light and shade is evident, a convincing distinction between the delicately accentuated folds at the lower left, where the figure is exposed to full light, and the deeply shadowed drapery at the right. Even here, in the darkest areas, we note a clear tonal gradation in the interest of modeling, and a vivid graphic pattern. The lines are swift and delicate in the delineation of the organic forms, the hands, the face, the hair of the Madonna; also in the contours of the Christ Child, with its Gothic meagerness; finally, in the spirited sketching of the flower pot.

After observing the master's drawing, we are prepared to recognize definite weaknesses in the pupil's performance [98]. In the drapery, first of all, we miss the spirited, clear, and fluid rhythm, within a well-controlled organization. Here the drapery moves aimlessly, for the sake of movement, rather than to build up an expressive, animated design. There is only a superficial adaptation of Schongauer's manner and style, but not his conciseness, his meaningful variety of forms and accents, his sure and sensitive stroke. The arms and hands, the hair, the face of the saint seem feebly and loosely drawn when compared to the master's tighter draftsmanship. The folds on the shadowed side of the mantle are neither as convincingly molded nor as interestingly arranged to produce a continuous rhythmical effect. The knees of the figure are not "felt" under the drapery—as they are in the Schongauer—nor does the drapery spread convincingly on the ground and the grassy bank. In spite of these deficiencies, the School drawing retains a good deal of the charm of Schongauer's style and sentiment. But incisive analysis will reveal the master's superiority and the aspects of higher quality in his work.

From the Northern Late Gothic—about 1480, which is the approximate

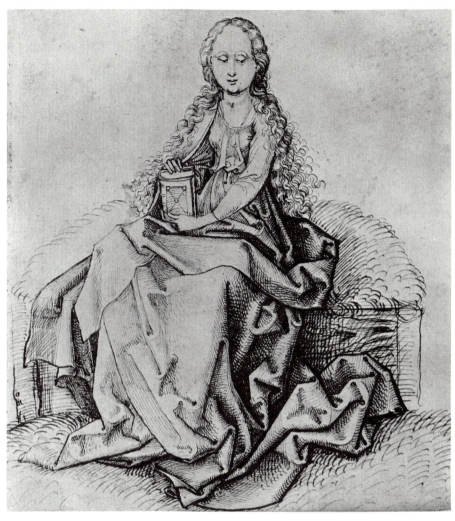

98 School of Schongauer: *Saint with Book*

date of the Schongauer Madonna—we turn to the late Quattrocento in Italy, and here, in two comparable drawings by Leonardo [99] and by Lorenzo di Credi [100], a lesser artist in the young Leonardo's circle, we encounter the more monumental character of Italian Renaissance art. The drawings date from about the same time as the Schongauer, and both are done with the brush, the Credi on paper, the Leonardo on a fine linen. Drapery studies were practiced in Florentine workshops like that of Verrocchio, who was the teacher of both artists.

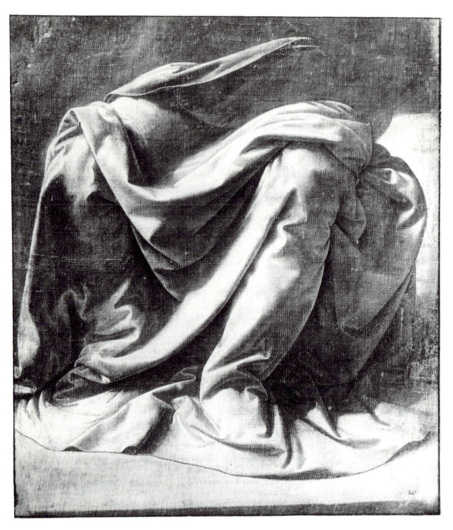

99 Leonardo da Vinci: *Study of Drapery*

The Lorenzo di Credi drawing has certain appealing qualities. It seems
clearly composed, with definite plastic accents, and one can easily read how
the drapery covers the lower part of a seated figure. The shading has some
subtlety and the whole motif is not without a certain grandeur.

Yet when we become familiar with the Leonardo drawing, we realize the
limitations and deficiencies in the Credi. To begin with, there is in the Leo-
nardo a much clearer expression of the body's form and movement under the
drapery—for instance, in the leg on the right—and also a clearer recession of
the forms into space as a result of proper foreshortening. This we notice first

136

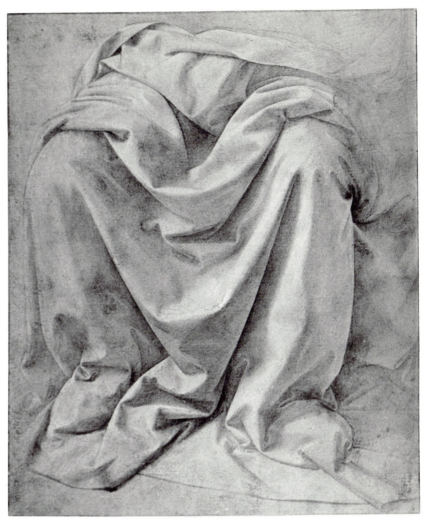

100 Lorenzo di Credi: *Study of Drapery*

in the foreground, then in the shadowed parts of the drapery, and definitely
above the knees along the thighs; whereas in the Credi the drapery clings
more or less to the front plane.

We are immediately aware of the greater subtlety and power in the Leo-
nardo, with its deeper contrasts of light and shade, and also its sensitive
transitions into the darks without loss of clarity. The design shows a grand
sweep as well as finer variations, for example, above the knees, in the fore-
ground around the left foot, and elsewhere. But these finer movements are
well subordinated to the larger rhythms which, while somewhat linear in

137

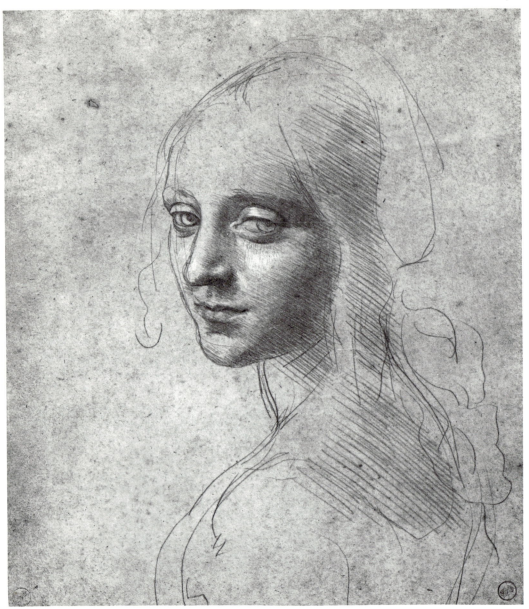

101 Leonardo da Vinci: *Study for the Angel of The Virgin of the Rocks*

effect, are essentially brought out by Leonardo's clear and soft lighting. Thus a symphonic breadth is attained, with many minor intermediary melodies, each of them interesting and playing its part within the whole design. Nowhere is there a passage without an original turn. Thus the unity, the richness, and the integration of this drapery composition are on a much higher plane than in the Credi, which now seems a bit dry and monotonous—note, for

138

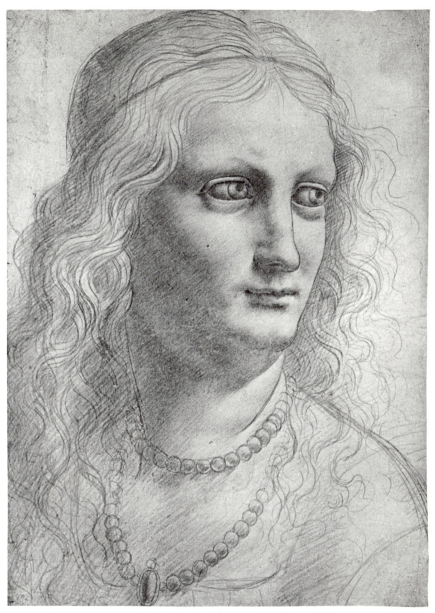

102 School of Leonardo da Vinci: *Portrait of a Young Woman*

instance, the sameness of the position of the legs and the lack of variation in the drapery's fall between the knees.

For the next comparison, we juxtapose a Leonardo drawing of the bust of a girl, in silverpoint [101], and a drawing in the same technique of a young woman by a Leonardo pupil [102]. The Leonardo sketch was used by the master for the kneeling angel of the *Virgin of the Rocks*, now in the Louvre.

139

Thus it belongs to the early 1480's, when Leonardo was in Milan in the service of Lodovico Sforza. The author of the other drawing is unknown, but is obviously one of the master's Milanese pupils.

The Leonardo is carried to completion only in the face; the rest is very lightly sketched, but clearly suggests the hair and the position of the bust. While the pupil's drawing is more finished, its expression of form, particularly in the neck and shoulders, is much weaker. We are fascinated in the Leonardo by the intensity and clarity of the modeling, by the free and searching character of his outlines, and not least by the depth of expression in this head. How moving are these eyes, the sensitive mouth, the fine contours of the nose and the cheek. The co-ordination of the features shows an unfailing surety; the face has that inscrutable charm that transcends earthly beauty, befitting the character of an angel.

The follower's drawing falls far behind in many ways. It shows by no means the same control over the co-ordination of the features. The eyes are over-done and protrude as in a poor piece of sculpture. The mouth is without life, the nose shapeless. The line in general lacks that springy quality of the master —not only his searching freshness and modeling power, but also his rhythmi-cal charm. Moreover, the head of the woman does not relate properly to the bust, which seems to recede and is somewhat stunted. On the other hand, how clearly and beautifully brought out is the contrasting movement of head and shoulder in the Leonardo. Here the master's greater brevity—we may call it artistic economy—is far more telling than the pupil's completeness of execution.

One more comparison of heads by Leonardo [103] and a Leonardo pupil [104] may be of interest. Here the master's study belongs to a more advanced phase of his art. Both drawings represent a characteristic type of old man often used by Leonardo—in this case, for the horseman at the top of the composition in the *Battle of Anghiari*, which he created for the Town Hall of Florence in 1504–5. The drawing, in black chalk, is now in Budapest. Like the sketch of the head of an angel [101], it shows full execution only in the face, but the position and action of the rest of the figure are again clearly suggested by forceful summary outlines which leave no uncertainty as to the fullness of form and recession into space. Motion and emotion are wonderfully

well expressed. The intensity, clarity, and subtlety of the modeling are un-matched by any of Leonardo's contemporaries, and the expression of fury mixed with horror dramatically reflects the man's crucial situation. Observe the action of the muscles in this face, on the forehead and around the open mouth, and the frantic expression of the shadowed eyes.

It is true that in the pupil's drawing the elderly man is not in action, but rather quietly gazes to the left. Also the technique is slightly different, that is, silverpoint rather than black chalk. In spite of these differences, a comparison of quality is quite possible. The form here is much weaker in its expression of bulk and also in its surface modeling. There is only a low-relief effect, with little suggestion of roundness or of existence in space. The outline of the man's profile appears hard and monotonous, and shows no signs of the master's modeling power. One may compare the region around the neck and along the shoulder, a critical passage for any draftsman. How sure and telling are these parts in the Leonardo, for all his brevity; in the follower's drawing they are flat and lack organic tension. There is in the Leonardo face a continuous re-cession from plane to plane, while in the pupil's drawing only a few passages stand out somewhat harshly from the flat-relief effect of the whole, such as the bulge on the forehead, the bony edge of the cheek, the muscle extending downward from the chin to the throat. The isolated character of these details hinders an effect of organic coherence. The pupil has learned a certain swift-ness of stroke from his master, but achieves little more than a faint reflection of Leonardo's heroic type and style.

Leonardo leads into the High Renaissance; Raphael is the most perfect representative of that fully classical phase, and by no means least in his draftsmanship. We present a study of four nude warriors [105], a pen draw-ing that dates from Raphael's Florentine period, about 1505–8, when he was still young. He was born in 1483. The impression made on Raphael by Dona-tello's Orsanmichele *St. George* is reflected in the central figure, and the youth on the right approximates a figure in an ancient Roman terra-cotta relief. These derivations do not detract from the originality and freshness of Raph-ael's sketch. It belongs to the Ashmolean Museum at Oxford, which owns the richest treasure of Raphael drawings in the world. The drawing is here con-trasted with one of three standing nudes and a child, from the so-called

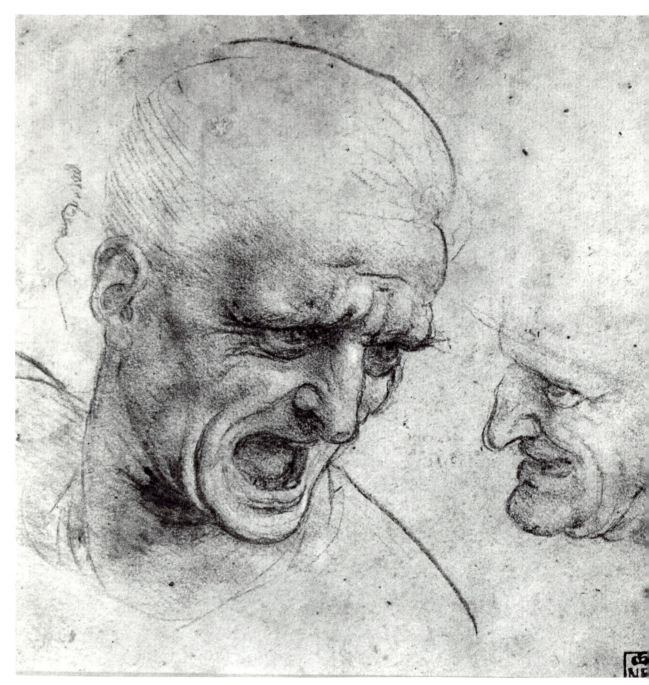

103 Leonardo da Vinci: *Study for The Battle of Anghiari*

Venetian Sketchbook in the Accademia in Venice [106]. This sketchbook was once attributed to Raphael, but O. Fischel rightly pointed out that its author was a minor artist who copied various Umbrian masters, among them Raphael. Fischel assumes our drawing is a copy after Raphael or Signorelli and believes that the subject represents the crowning of the shepherd David by the high priest.[1]

Raphael's drawings have often been spoiled by additions by later hands which sought to improve their effect by giving them a more finished char-

104 School of Leonardo da Vinci: *Head of an Old Man*

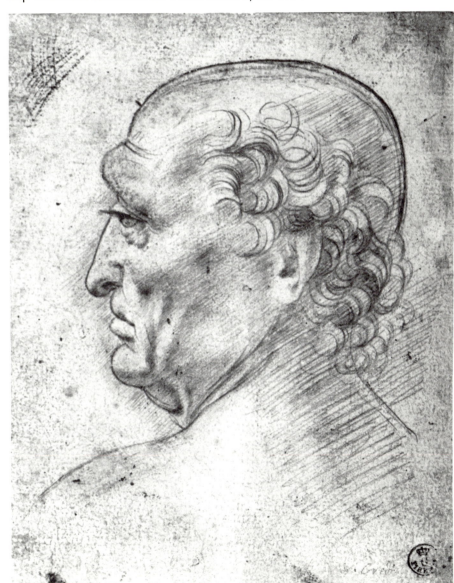

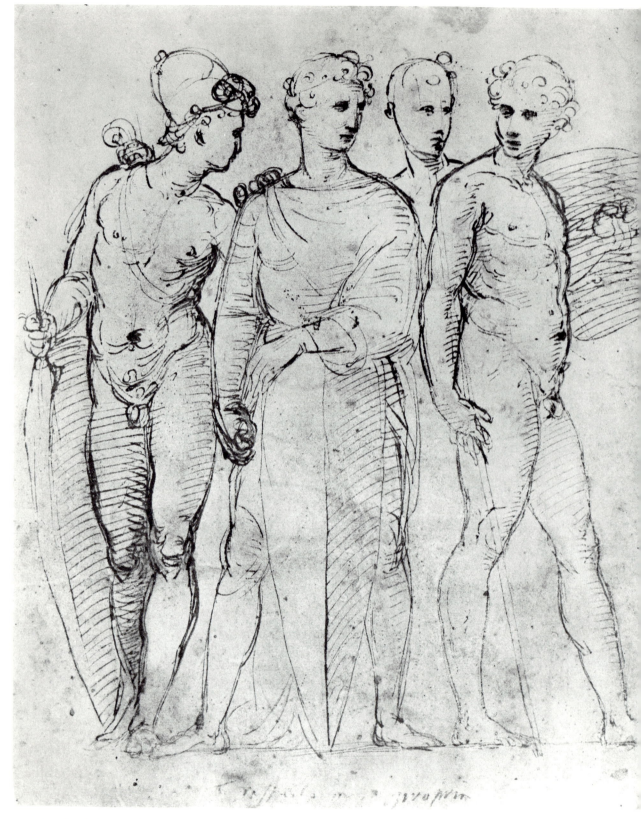

105 Raphael: *Four Warriors*

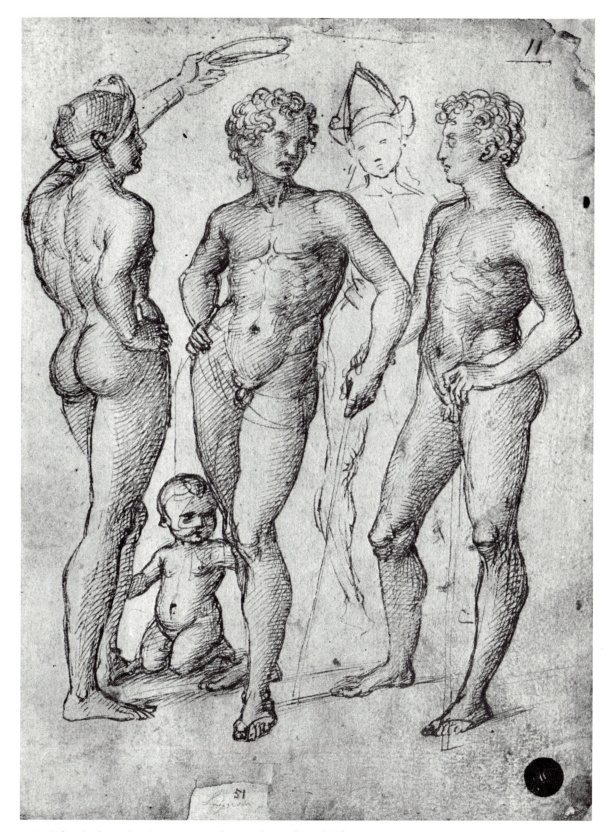

106 School of Raphael: *Three Nude Youths and a Child*

acter. In so doing, these later draftsmen reveal their lack of understanding of a great artist's brevity and suggestiveness. The sketch of the four nude warriors [105], however, is an untouched original in which we can enjoy the full charm of the master's own hand. The ease and surety of line are here remarkable, coupled with an amazing simplicity and elegance—all earmarks of great draftsmanship. As in the work of Leonardo and of Dürer, whom we shall discuss below, the Raphael figures have power in their plastic accentuation and in their definition of form; their rhythmical swing is vigorous as well as subtle. Utmost economy is paired with great clarity and expressiveness. The position of the figures within a limited space—this drawing seems to be a draft for a relief—is unmistakable. The movements are free and poised, in spite of their closeness to the front plane. There is no uncertainty concerning the forward or back position in any part of their bodies. A summary and light parallel shading lends unity and atmosphere to the design. It also helps to distinguish planes by light tonal contrasts. The subtle emphasis on the central axis of the composition and the formal relationship of the contrasting movements on either side reveal Raphael's extraordinary sense of balance.

All these qualities are lacking in the contemporary's pedestrian drawing [106], where we feel nothing of the master's sensitiveness of tonal variation, his wonderful grasp of organic forms, or the fluid rhythm of his lines. Here the meticulous execution, the mechanical shading, the hardness of contours create isolated forms, and these remain without weight and tension, without convincing ponderation and poise. Last but not least, the trivial expression of the faces compares poorly with the heroic spirit emanating from Raphael's figures.

In the next examples we see a Raphael study of fighting nudes [107] from his Roman period—some five years later—and a School drawing that shows two nudes in action, one large and one very small [108]. In addition, there are in the School drawing some studies of legs, one overlapping the principal figure. For our purposes, we shall concentrate on the principal figure. This sheet is done in pen, while the master's drawing is carried out in dark-red chalk over a leadpoint sketch. We can date the Raphael around 1511 because it served as a model for the relief under the Apollo figure which stands in a niche in the architectural background of the *School of Athens*. During his

Roman period Raphael had come under the influence of Michelangelo after seeing the nudes in the Sistine ceiling. He derives from the older master the intensified anatomical treatment of his nudes. Michelangelo, in his drawings, seems to chisel out the muscles with the pen. His close crosshatching produces the same effect as the intense plastic elaboration in his sculptured figures. Raphael follows, but only to a certain degree. He leaves the main emphasis to the contours, which have in turn gained in power and incisiveness compared with his Florentine nudes. His lines swing with a remarkable swiftness, inward and outward according to the course of the form, and are animated with a still richer accentuation than before.

The Raphael School drawing, while also showing Michelangelo's influence in the close shading and the effort at anatomical thoroughness, fails to bring coherence into the organic form. The outlines here have little modeling function, nor do they flow with such rhythmic beauty. While there is a reflection of both Michelangelo and Raphael, this artist falls far short of the great masters and lacks such fundamental qualities as structural clarity and convincing projection of form into space. He grasps only some aspects of both artists, but is unable to unite and integrate these features in his dry performance.

We follow with two chalk studies of heads of young women, one by Raphael [109] and one by a Raphael follower [110]. The Raphael can be dated in 1510–11, since the master used this study for one of the muses in the *Parnassus* fresco in the Vatican. The drawing of the Raphael School has had various attributions, but there is no disagreement that the work is by a follower of Raphael. It belongs to the Fogg Museum, and it is attributed there to Sodoma in his Raphaelesque phase.

The qualities we admired in the nudes of the great Umbrian master we find also in the head shown here: grandeur and ease, a magnificent grasp of form and of movement in space created by outlines of great beauty and of utmost simplicity, and by sparse but effective shading. There is a wonderful co-ordination of the features within the well-rounded head. The outward beauty and the inner spirit seem in perfect harmony. Here again it may be worth noticing how subtly the master uses light and dark contrasts to achieve clarity of form and spatial recession, in the accents around the forehead, in the nose, the

107 Raphael: *Study for The School of Athens*

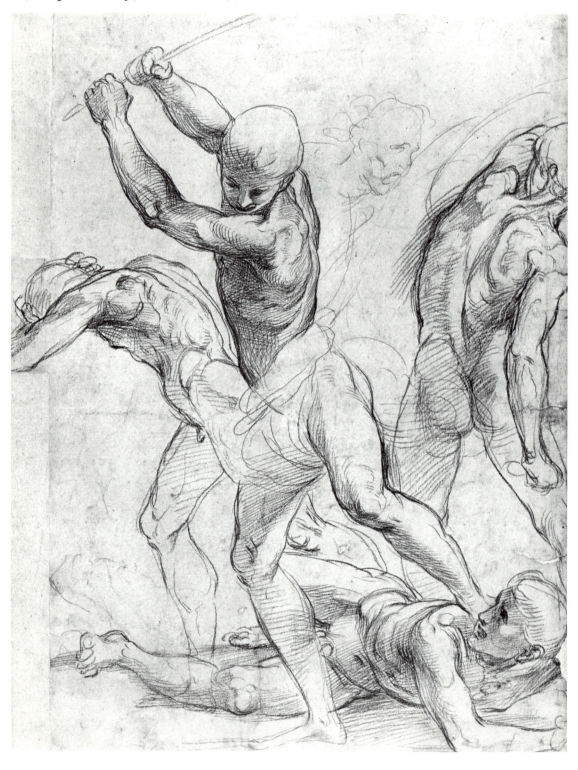

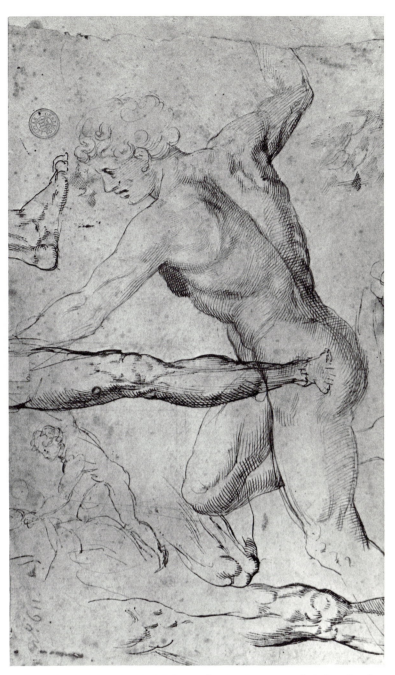

108 School of Raphael: *Male Nudes in Action, and Other Studies*

mouth, the chin—and how he uses a narrow strip of reflected light along the contour of the cheek to loosen the form from the background.

The follower's drawing is far from achieving such clarity of form with equal subtlety and strength. The face is less successfully modeled. Line and

149

tone are not as effectively co-ordinated. It is true the artist works more with tone than line, yet the shading does not, as in Raphael's drawing, reveal selective use and finer accentuation. Something of Raphael's style, however, is reflected, but on a lower level of quality.

We bring forth two more pen drawings by Raphael and a follower or imitator to give some idea of the range of Raphael's draftsmanship and the variations of quality among the artists working in his manner. The Raphael shows a draped and a nude figure [111]; the draped figure seems to represent

109 Raphael: *Head of a Muse.* Study for *Parnassus*

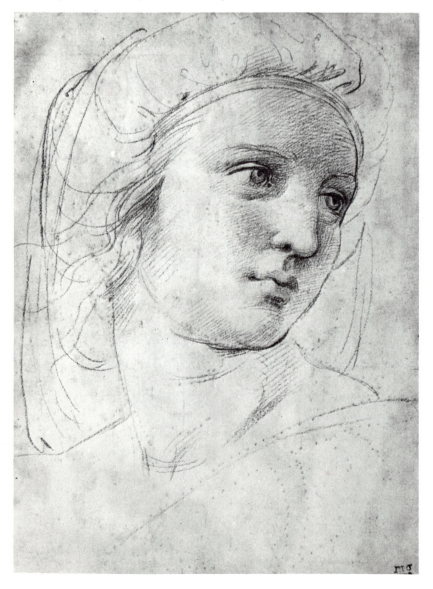

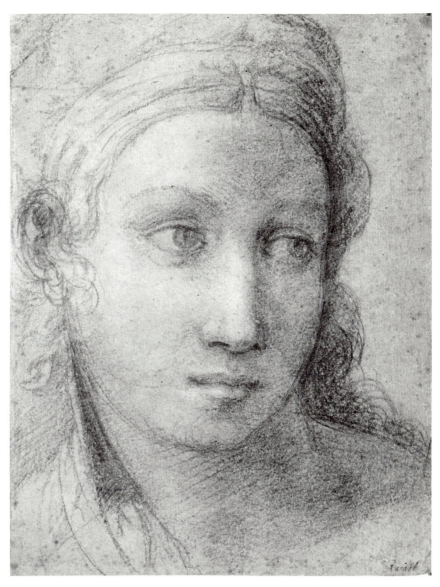

110 School of Raphael: *Head of a Woman*

a poet—he holds a book and wears a wreath—the nude, an Apollo with the lyre. For comparison we reproduce a drawing [112] formerly attributed to the Raphael pupil G. F. Penni, but recently to a seventeenth-century imitator of Raphael and Timoteo Viti, who was very close to Raphael.[2] It represents a mythological subject: Mercury and Aglauros. Aglauros was jealous of her beautiful sister Herse who was beloved by Mercury. Thus she refuses him

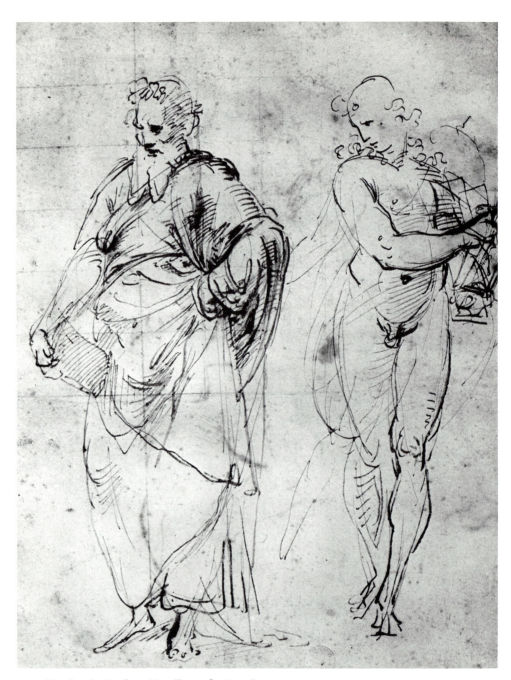

111 Raphael: *Studies (Apollo and a Poet)*

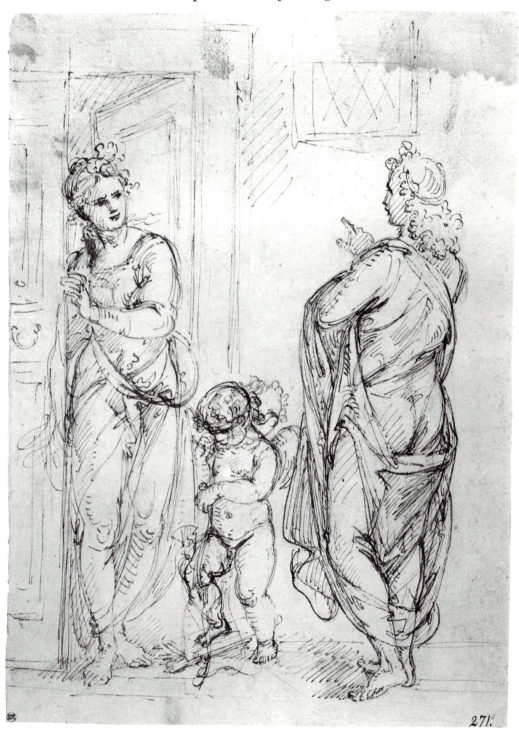

271.

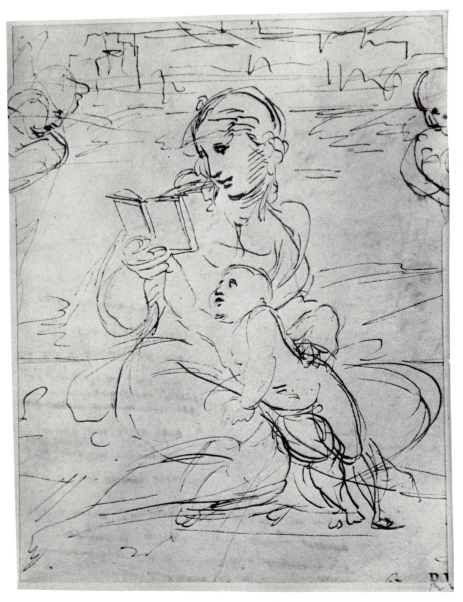

113 Raphael: *Madonna and Child with a Book*

entrance to their father's palace. Cupid stands between the two, crying. This
story is told by Raphael's follower with a certain liveliness. One realizes that
an argument is going on, and one may even speak of a psychological tension
between the figures. But when held against a genuine Raphael—even though
the latter is without action and represents studies of single figures—we are
made aware of the shortcomings in the work of the follower. It lacks the

master's striking economy, the articulateness and beauty of his line, his clear expression of bodily structure and movement, and his sensitive suggestion of light and air.

If we try to distinguish planes in the figures of the follower we run into difficulties. We are aware of a multitude of strokes, but they are repetitious and ineffective. One may follow the outline of Mercury's figure, as well as its inner shading, and compare it with Raphael's corresponding figure of Apollo.

114 School of Raphael: *Marriage of St. Catherine*

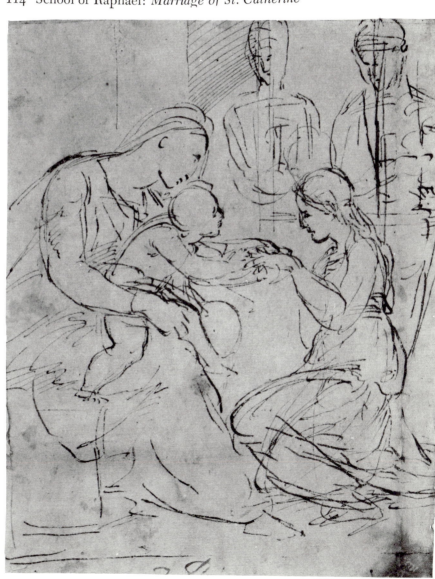

Few words are needed to make clear the tremendous difference in articulation, in richness and economy of accents, in animation.

At least one of Raphael's Madonna drawings should be shown. We choose a seated Madonna, reading with the Child beside her [113], and compare it with a School drawing representing the marriage of St. Catherine [114]. The Madonna shows the freest type of pen sketch from Raphael's Roman period, about 1510–15. The School drawing seems at first very similar in the sketchy penmanship, yet on closer study it reveals weaknesses. It is true that the background of Raphael's drawing is most fugitively hinted at, but the group of the Madonna and Child is clearly formulated and placed into the landscape; the action, movement, and the mood of the two figures are distinctly brought out by Raphael's free-swinging strokes. The outlines of the forms are here effectively suggested, rather than defined with any rigidity. The body's position under the garment is unmistakable. In a superb way, light and air envelop the group, and the accents of the pen are wisely reserved for the major points of interest, such as the two heads, and also the Child's legs, to indicate His position between Mary's knees. One easily notices how continuous the recession is from the Madonna's book to her head and left shoulder, or from her forward leg, over the Christ Child, to her rear knee. With the barest minimum of lines and ever so lightly—in order not to interfere with the major accents—is the complicated attitude of the Christ Child clarified.

If we turn after this experience to the pupil's drawing, we feel at once a lack of spatial articulation. The outlines do not really loosen the forms from the front plane, but rather force them into a narrow relief style. The inner design is poorly adjusted to these contours and fails to clarify the positions and the garments. Compare the lower half of the Madonna figures in each work, or the seated position of the Raphael Madonna with that of the kneeling St. Catherine. And it is not only the lack of control over the three-dimensional aspect of the figures and their actions that betrays the minor hand. The faces are without expression and the lines are often repetitious or meaningless, unrelated to the total rhythm of the composition.

From Raphael we turn to Dürer as the greatest draftsman of the Northern Renaissance, and show a portrait drawing of 1503 representing his friend and patron, the humanist Willibald Pirkheimer [115]. We compare it with a por-

trait drawing of a man by a Dürer contemporary, the Monogrammist B.B., who is known to us only by his initials which are found in the lower left corner [116]. In the upper left is the date 1504. The Monogrammist B.B. cannot be called a Dürer pupil; he probably belongs to the School of Augsburg, a city not far from Nuremberg and the influence of Dürer. In any case, the two drawings are similar enough in style and technique—both are done in charcoal—to be profitably compared.

In viewing the Dürer we are perhaps first impressed by its monumentality. This is achieved by a great power of abstraction and simplification, as well as by a tight compositional order. Dürer's ability to subordinate the parts to the whole is here most remarkable. With a few vigorous accents and an extraordinary sense of the significant, he expresses the character of his subject, the full-blooded temperament, the boldness and keenness of this Pirkheimer, whose adventurous life and intellectual sophistication are known to us from his own writings and his correspondence with Dürer. There is not only solidity of form, but also a striking decorative quality to the design, with a firm and sensitive balance. All the details—the bony forehead, the massive cheek, the ear, the mouth, the nose, and the eye—are modeled with both strength and delicacy.

Set beside this drawing, the work of the Monogrammist B.B. suffers considerably. His contours are dull and monotonous, their modeling function poor. The portrait seems lifeless and flat. The composition shows no significant formal relationships, and is weak in the integration of the two- and three-dimensional aspects. The head could easily be turned in any direction without spoiling the loose organization of the whole. And to repeat: we miss not only Dürer's lively accentuation, but also his profound grasp of character.

The next works to be compared show a portrait drawing of Dürer's mature period [117]—it is dated 1521—and a portrait drawing by the contemporary, Leonhard Beck [118]. The latter represents a German nobleman, Count Moritz von Ertingen. The technique of the two is not exactly the same, but similar enough to allow an easy quality comparison. The Dürer is done in charcoal, like many of his large portrait drawings; the Beck in black, red, and yellow chalk with the addition of some wash. Here the Augsburg artist's drawing comes closer to Dürer in quality. It shows freshness and a vivid characteri-

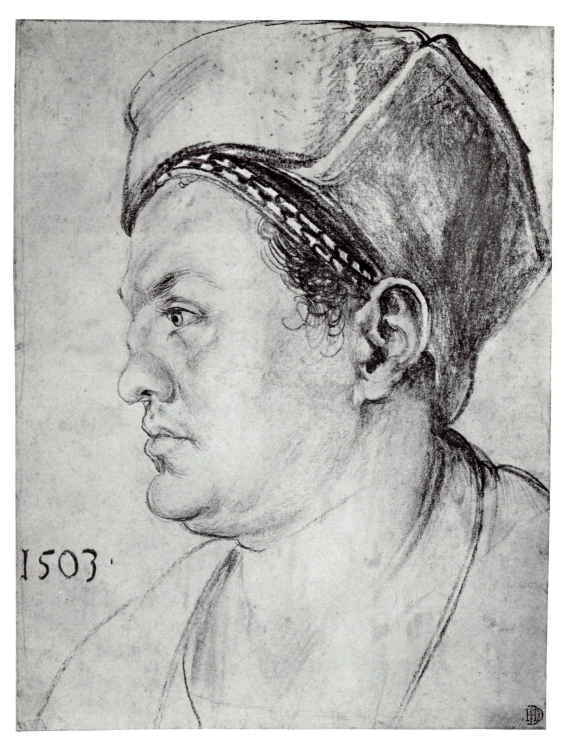

115 Dürer: *Willibald Pirkheimer*

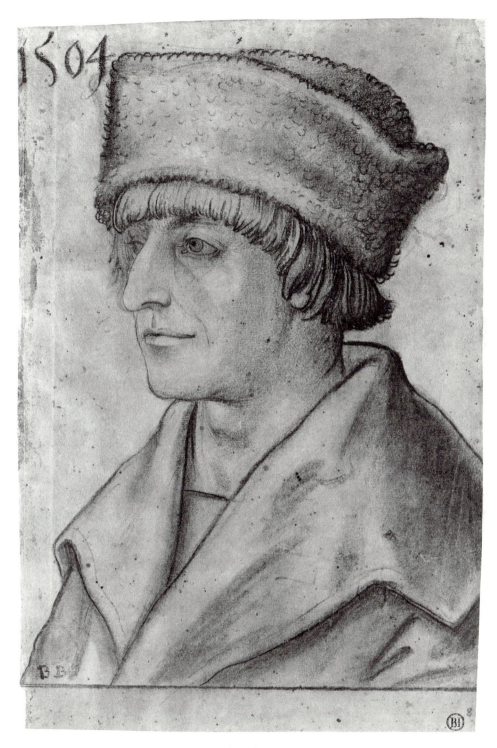

116 Monogrammist B.B.: *Portrait of a Man*

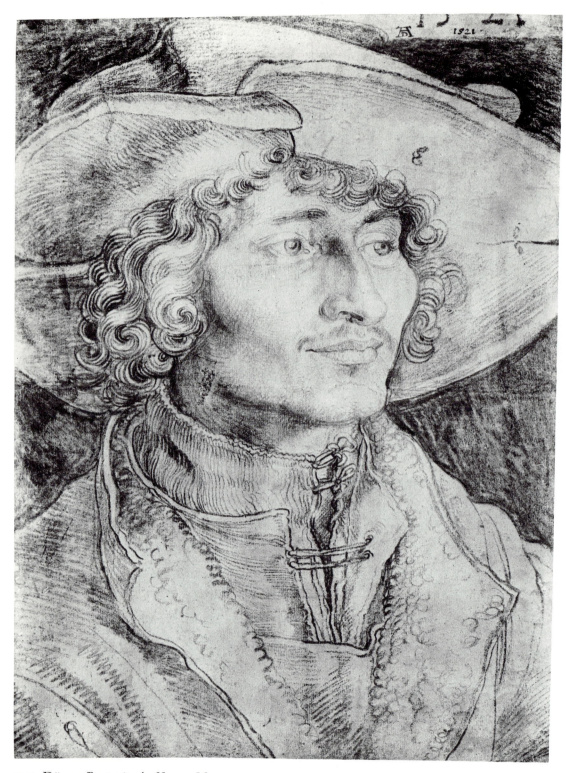

117 Dürer: *Portrait of a Young Man*

118 Leonhard Beck: *Count Moritz von Ertingen*

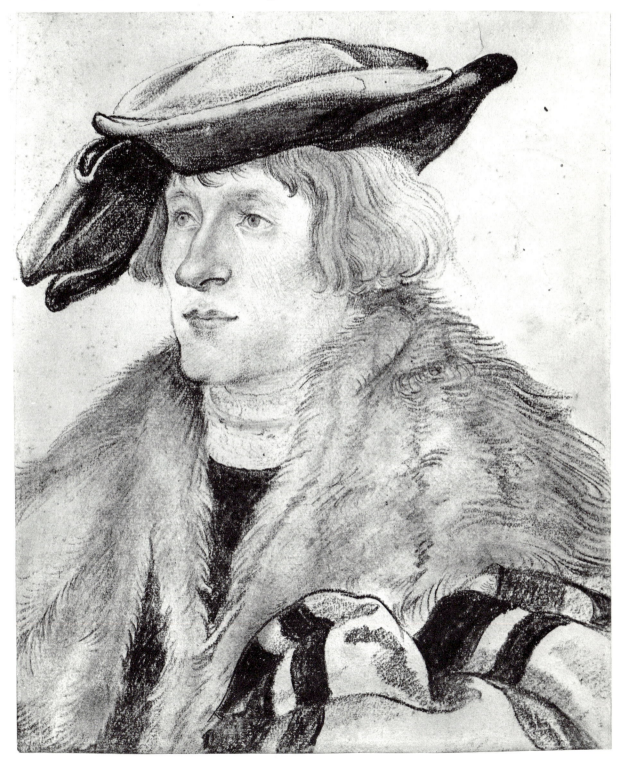

zation; it has an attractive decorative charm, and is well composed. Yet it does not attain the grandeur of Dürer's composition. To appreciate the latter fully, we must take into account that the drawing was originally larger—it is cut on either side and on top—and showed the round form of the hat more completely than we see it now. (We know this effect from similar drawings of the period.) In addition, Dürer's line is ever so much more sensitive. Each detail shows a fine modeling, and there is a greater plastic effect to the bust and to the head. How Dürer sets off the cheek against the hair, the chin against the throat, or how he clarifies the complicated opening of the fur coat and the shirt at the neck—there are no equivalents in the Beck drawing. And another important distinction, the incisive characterization of Dürer's subject is not attained by the contemporary, who altogether lacks the intensity and the sensibility of the great master.

As a truly Renaissance artist, Dürer was as much concerned with the study and representation of the nude as Raphael and the Italian masters. The spirited sketch of six nude figures [119] dates from 1515. Dürer had by then well absorbed the impressions of Italian art which he had received on his second trip to Venice in 1506–7. In his draftsmanship he adopted the Italian manner of uniform shading with open parallels, and the emphasis on the organic structure of the human body based on anatomical knowledge. Dürer, however, remains a Northerner in his more vivid lighting and the intensified plastic elaboration of detail, an inheritance from the Late Gothic. One should notice that the interior shading of the nudes—more than in Raphael—tends to rounding strokes instead of straight parallels. In this way Dürer produces the more bulging effect of the muscles. Thus parts of the body become more lively, but at the same time the total effect loses in monumentality, compared to the Italians. Yet in his Northern manner Dürer was one of the greatest draftsmen of all time, and unmatched in the charm, inventiveness, and fluidity of his penmanship.

When we compare his drawing with one on a similar subject attributed to the Dürer pupil Hans von Kulmbach [120], and possibly only a copy after him, we easily recognize the latter's inferiority in various ways. His contours lack the springy and calligraphic quality of Dürer's line. The lighting is overdone and leads to emptiness or spotty accentuation of the form; the interior

shading is too scattered and rhythmically unrelated to the outlines. We note a general thinness and dryness which hardly bring these nudes to life; whereas Dürer animates every figure and binds them together into an interesting composition, although there is probably no special meaning to his representation here, other than the study of various positions and attitudes of nudes.

While treating Dürer we should also bring in at least one of his lovely drawings of the Madonna. This one—in pen—[121], with an angel playing a viol at her feet, is dated 1519. We compare it with a pen drawing, an *Adoration of the Kings* [122] by Hans Schäufelein, a Dürer pupil of considerable individulity and, like his master, quite productive as a draftsman. Schäufelein's line has ease and an ornamental playfulness, but it is less sensitive to the expression of form, less interesting and varied. It will easily be seen that Schäufelein lacks the master's higher economy, structural clarity, and animating accents of light and shade. One may compare the Madonna and Child group in the two drawings as well as the layout of the drapery over the Madonna's knees and elsewhere in the works. In the Schäufelein the folds are repetitiously piled up; in the Dürer they are delightfully varied and everywhere clearly defined. Light and shade are here more subtly contrasted, and wherever we look they serve the expression of form, even in the most intricate passages. Once one has grasped this superb quality of the Dürer, the limitations of the Schäufelein drawing become apparent in spite of its dash and virtuosity.

Now we may try to sum up what criteria of high quality we have found, not forgetting that thus far they relate only to master drawings of the fifteenth and sixteenth centuries, the Late Gothic and the Renaissance. But these criteria will be tested further for their validity by examples from later periods, from the Baroque to the nineteenth century. We shall be concerned with this task in our next chapter.

As for line, we observed that sensitivity, flexibility, rhythmical quality, decorative charm, modeling power, descriptive quality, suggestiveness, ease and surety, and spontaneity and articulateness are all good criteria. It will be interesting to see whether these terms can be applied to tone and to touch—and not only to line—when we come in later centuries to a more painterly than linear style.

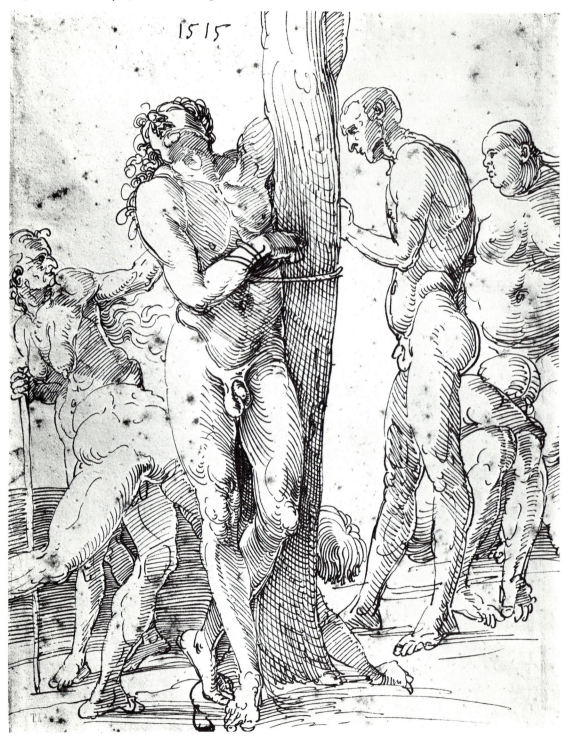

119 Dürer: *Group of Six Nude Figures*

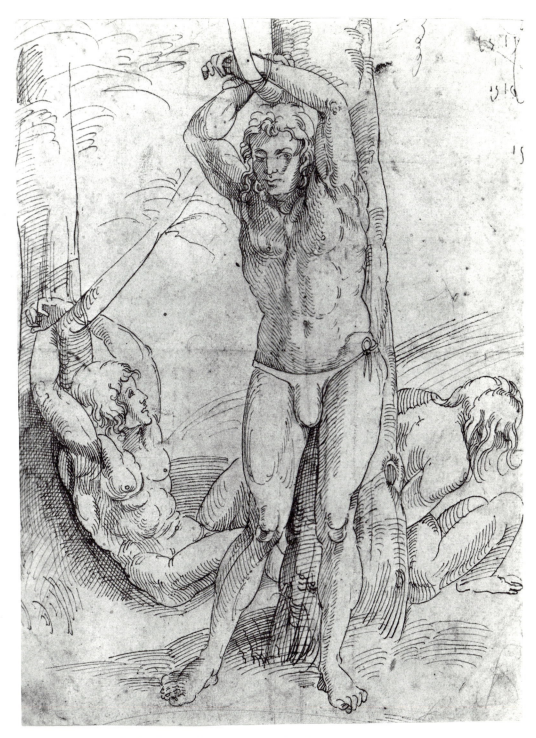

120 Hans von Kulmbach: *Studies of Men in Bondage*

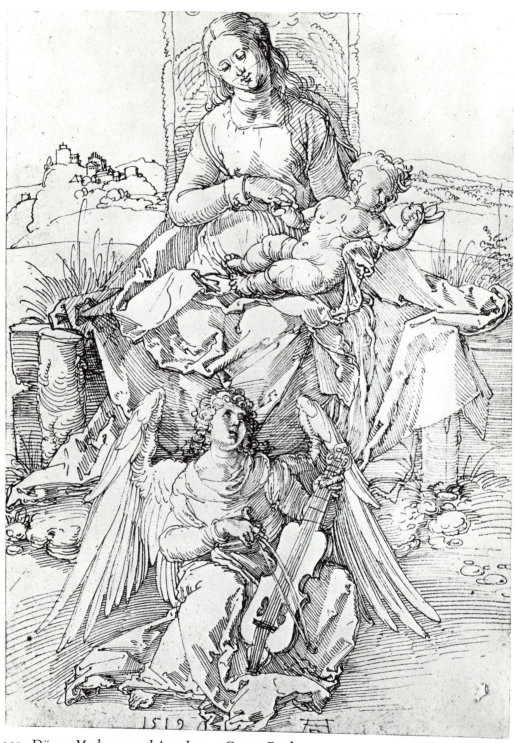

121 Dürer: *Madonna and Angels on a Grassy Bank*

As for form, the works of high quality were distinguished by solidity, structural clarity, organic character, and clear distinction of planes. For plastic clarity, one can also speak of a clear expression of the three-dimensional aspect of the form, or of a clear projection of form into space—and conclude accordingly that the treatment of space should be articulate and continuous.

As for composition or design, for which we had perhaps best use the broad

122 Hans Schäufelein: *Adoration of the Kings*

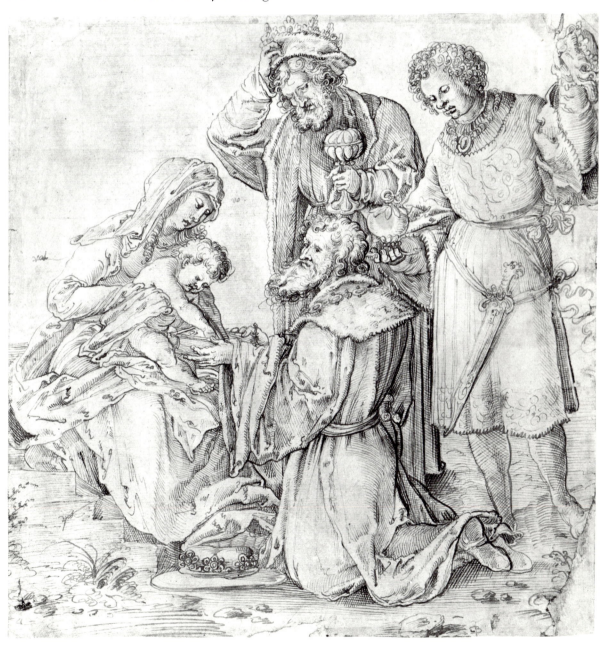

term formal organization of the total image, we have seen that integration and coherence are of great importance—for the latter one may also speak of unity—and that a certain richness of formal interrelationships, a striking decorative quality as well as expressiveness are indispensable for high-quality design.

Other characteristics we found are a wide range of accents, artistic economy, a sense of balance, a sense of the significant, and inventiveness and originality. The combination of subtlety and power, or clarity and articulateness, or in general the combination of many of the above qualities, rather than the exclusive appearance of one or a few, is an important feature.

Naturally, our definition of such criteria is far from exhaustive, but I believe we have made a real start on our way to determine the characteristics of high quality.

CHAPTER VII

Master Drawings of the Seventeenth to Nineteenth Century

IN our search for valid criteria of high quality we come now to the Baroque period and begin with examples of Rubens and his pupils or followers. Along with Bernini, Rubens was the mightiest creator and representative of the Baroque style, and also a draftsman of the highest rank. His drawing of the head of a woman [123], which served as a study for the Madonna of the St. Ildefonso altar, is done in red and black chalk. We shall compare it with the study of a head of a girl [124] attributed to Jacob Jordaens. This drawing is done in black chalk and charcoal.

As we saw in earlier examples by great masters, the Rubens shows an admirable lightness of touch. The mode of representation is now different from that of the Renaissance. The lines seem to melt into tones. Light and atmosphere flow around the form. The treatment is more painterly, with soft tonal transitions. Yet there is no lack of clarity in the expression of form and its movement. On the contrary, we discover as full a suggestion of mass and as sensitive a modeling of surfaces as we ever found in great Renaissance examples. Rubens' mastery manifests itself also in the exalted mood which the Madonna's head conveys. This mood still reflects a heroic concept, such as prevailed in Renaissance art, but also a sensuous graciousness that is Baroque

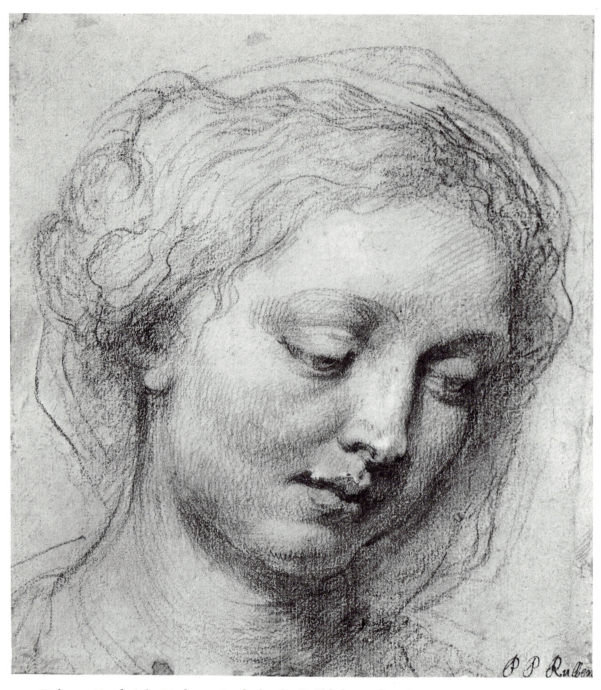

123 Rubens: *Head of the Madonna.* Study for the St. Ildefonso altarpiece

124 Jacob Jordaens (?): *Head of a Girl*

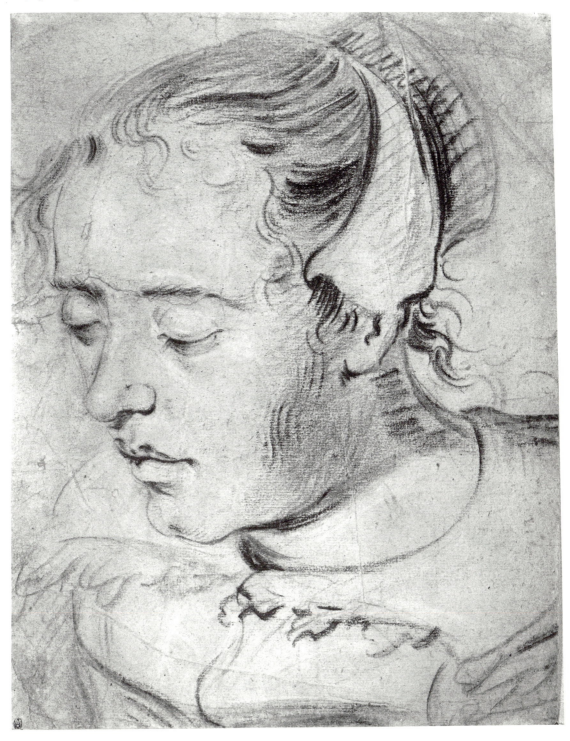

and Rubensesque. We are inclined to call the Madonna's head an ideal type, rather than an individual face. Such high universal significance can be expressed only when the artistic concept is sufficiently profound and comprehensive.[1]*

The drawing attributed to Jordaens looks almost vulgar in comparison. It exhibits a certain force of accents—and a Baroque quality of florid movement. But the contrasts are overdone and there is a lack of gradation, with the result that roundness of form and richness of surface modeling fall far below Rubens' superior achievement. Our eyes are not led around the head. The cheeks and the neck seem flat. Finer accents are totally missing in line and tone, and the features remain unanimated. It is not because the person represented is of a humbler type or because the style of this artist is more robust that the treatment of the subject, of form and character, is considerably inferior to the Rubens drawing.

The next examples show a Rubens study [125], for the woman with an ostrich fan in the *Garden of Love* in the Prado, done in colored chalk—black, red, and white—and a portrait of a seated woman, also in rich costume, by Cornelis de Vos [126]. The latter artist, like all Flemish painters at that time, came under the great master's influence. Even in a mere costume study—as the Rubens drawing can be called—his vitality and originality are clearly evident. The brilliance of the pictorial animation finds no match in the equally elaborate costume in the de Vos charcoal drawing. The follower does not achieve the master's fullness of form, or the splendid rhythm in the movement of his drapery, with large and smaller folds well co-ordinated and brought to a high pitch of pictorial life by a brilliant and varied lighting. One may argue in defense of the de Vos drawing that his is largely a portrait study, whereas Rubens concentrates more on the costume. That is true only to a certain extent. De Vos gives a full account of the costume as well, but in general he is weaker, drier, and emptier, and less capable of such a rich plastic and pictorial expression. His touch is far less spirited and his design more diffused in small accents.

From Rubens' rare landscape drawings we show a farmyard in winter [127], done in pen and watercolor, juxtaposed with a landscape, also in pen and watercolor, attributed to Paulus van Hillegaert [128], a minor contempo-

rary whom we know from only a few works. He is Dutch, but the drawing has a Flemish touch in the Jan Brueghel tradition, and is close enough to the Rubens in technique, subject matter, and style to allow a quality comparison.

In the Rubens landscape we are impressed by various features: the powerful spatial effect and the dynamic animation of the composition by the sense of movement in the trees, the road, the clouds, and the atmosphere itself. The road swings sharply in a curve to the left, from the foreground into the far distance. Vigorous yet graded contrasts of light and dark establish clear spatial relationships from the front to the rear and lend plasticity to the forms, such as the thatched barns and the bare trees. The composition has larger and smaller accents that are woven into a higher unity.

Van Hillegaert's drawing has its merits in a modest prettiness and delicacy of detail. However, it lacks Rubens' vitality, the range of his accents, and, indeed, the intensity of his mood. The expression of form in space is indistinct in the van Hillegaert; his lighting is even and dull; the perspective is rather faulty; the sky is empty and plays no part in the spatial effect. The one diagonal thrust of the road into the distance is not sufficient to create a comprehensive space. The composition drops off on either side. On the whole, the drawing teaches us that delicacy of touch alone, if not enriched with stronger accents, rarely results in a design of high quality.

The contrast of a great master with a respectable minor one is also quite striking in the following examples of Rubens and a Flemish artist who was a contemporary, but a generation younger. The sketch in black chalk [129] is a study by Rubens[2] for figures in his large landscape in the Pitti Gallery in Florence called *The Return from the Fields*. The drawing in pencil [130] shows hunters with their dogs and a peasant who points the way. It is from the hand of David Teniers the Younger, the well-known genre painter who became particularly popular in the eighteenth century for his gay scenes of rustic life. Today we rank him as a minor master, and the reason becomes quite obvious when we compare the two drawings.

Rubens' greater vitality strikingly manifests itself here. These peasant women really stride along in full sunshine, and one feels the swift and lively movement of their bodies. They seem to be enveloped by a brisk and airy atmosphere. Again Rubens expresses the visual image with great economy

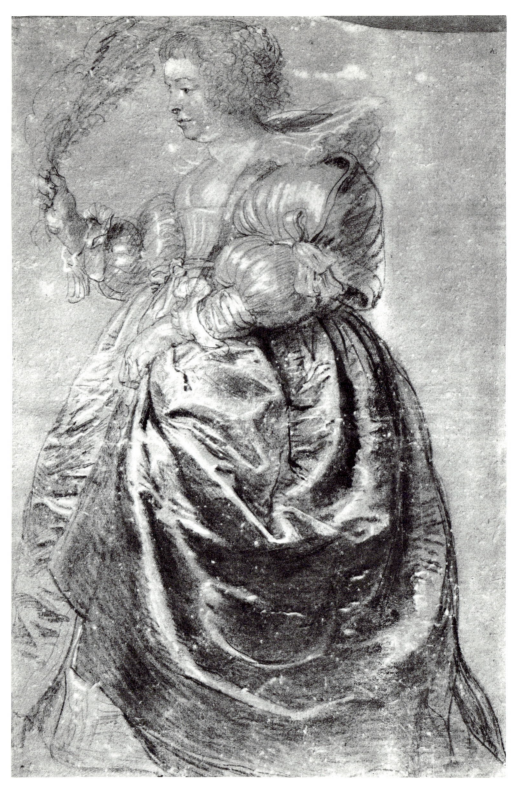

125 Rubens: *Lady with a Fan*. Study for *The Garden of Love*

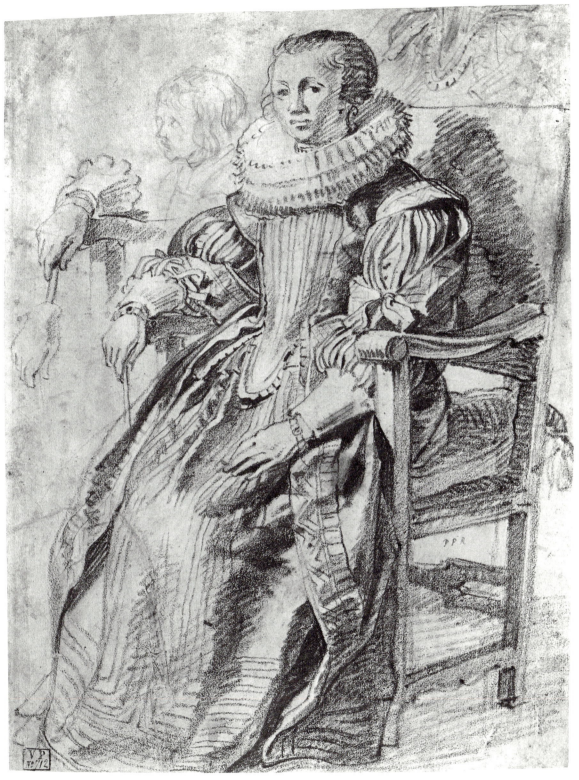

126 Cornelis de Vos: *Seated Lady*

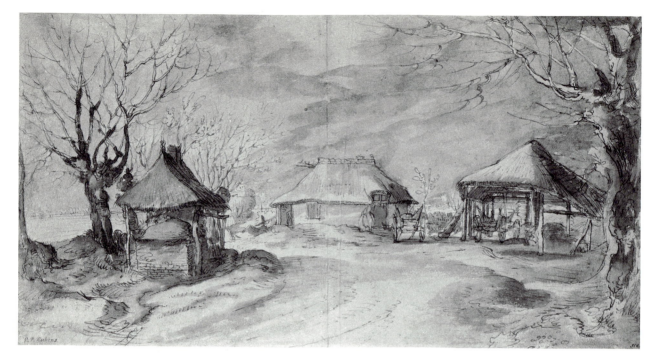

127 Rubens: *Farmyard*

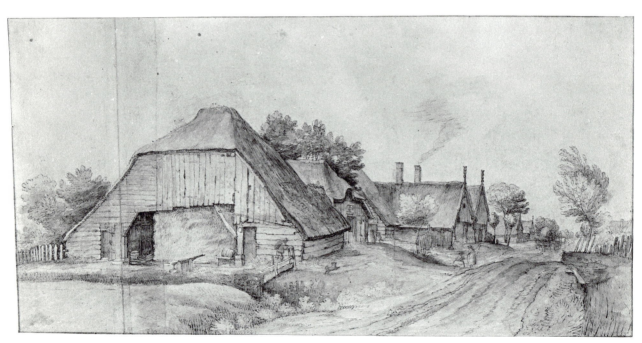

128 Paulus van Hillegaert: *Village Street*

129 Rubens: *Studies for The Return from the Fields*

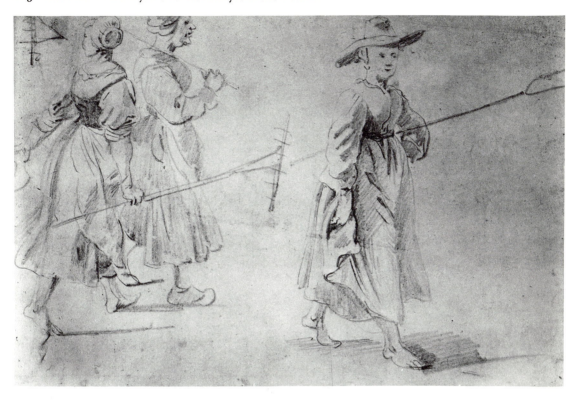

130 David Teniers the Younger: *Study of Hunters with Dogs*

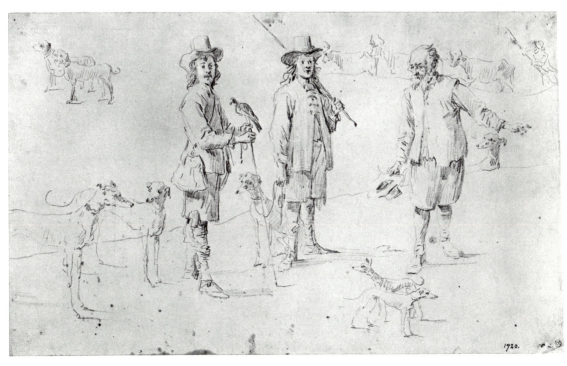

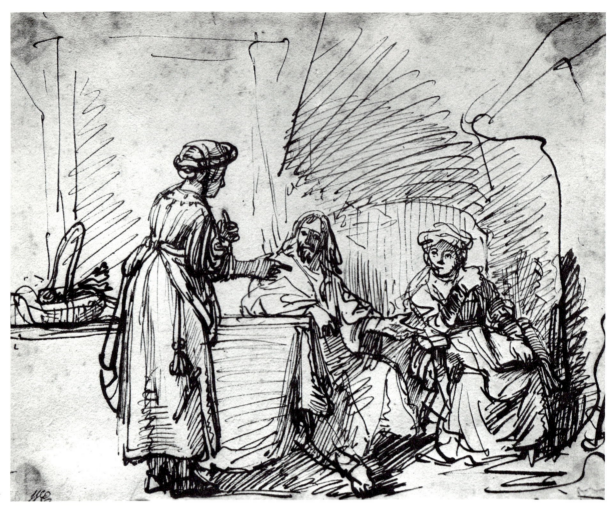

131 Rembrandt: *Christ in the House of Mary and Martha*

and vigor. Full force is given to the forms by the Baroque device of light and dark contrast. Yet the light darts over their figures and the tones ease to full brightness through the omission of lines and shading. There is a broad rhythmical flow to his draftsmanship.

Teniers' figures, it is true, are not moving at the moment he depicts them, but this is not what makes them less animated than Rubens' figures. Essentially, Teniers lacks the great master's force in bringing out the volume of the figures and in endowing them with vigor and vitality. He works with small, sketchy strokes, carefully describing details. He is also sensitive to light and

air, but, like van Hillegaert in comparison with Rubens, his delicacy and relative freshness are not enough to raise the drawing to the level of great art. Rubens' draftsmanship comprehends many more aspects than mere surface description, and his selectiveness and range of accents are very much greater.

For Rembrandt, we show first a drawing from his early period, about 1633, representing a biblical subject, Christ in the house of Mary and Martha [131], and beside it a drawing by the Rembrandt pupil Gerbrand van den Eeckhout, also illustrating a biblical subject: Judah and Tamar [132]. Both drawings are done with the pen.

Superficially there is a great similarity in the swirling lines and the intense graphic elaboration of the compositions. It does not take very long, however,

132 Gerbrand van den Eeckhout: *Judah and Tamar*

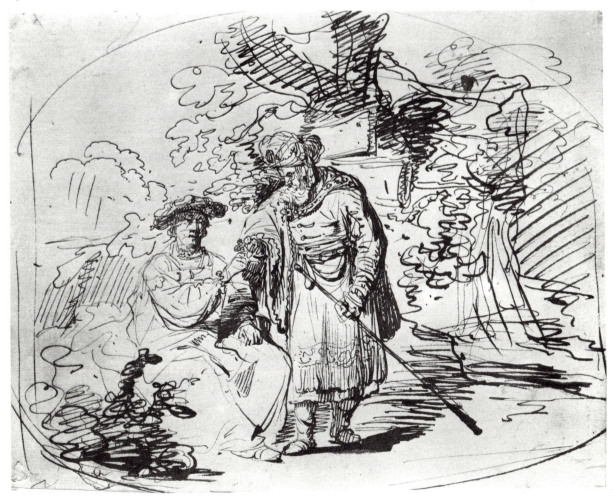

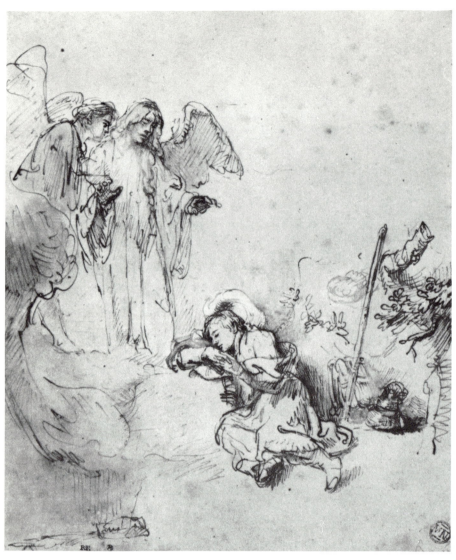

133 Rembrandt: *Jacob's Dream*

to discover a higher discipline in Rembrandt's control over his multiple lines, even though he drew them speedily. One sees that the directions and the density of his shading work more effectively for the articulation of his figures, for the expression of their form and action and, finally, for the dramatic concentration of the composition on Christ's central role between the two sisters. As we learn from the text of the Bible, He defends Mary, the contemplative one, seated with a book, against Martha, the busy housewife who complained that her sister "left her to serve alone." Christ counters with the famous words:

180

134 Ferdinand Bol: *Jacob's Dream*

"Martha, Martha, thou art careful and troubled about many things: But one thing is needful: and Mary hath chosen that good part, which shall not be taken away from her."

In the *Judah and Tamar*, the group is placed in the open air, before a house whose roof and chimney are indicated, surrounded by sprouting vegetation. Eeckhout's line is swift and curly. He tells us the story of Judah unknowingly approaching his widowed daughter-in-law who sits by the wayside like a harlot. But the artist is successful only to a certain degree. A slight vagueness

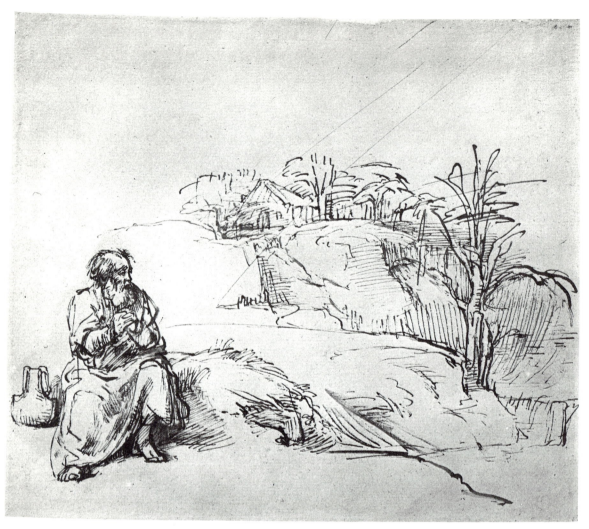

135 Rembrandt: *Elijah in the Desert*

prevails in all parts, particularly when we compare the drawing with Rembrandt's clarity and the more meaningful accentuation. This vagueness is evident in the vegetation as well as in the figures, and in the spatial accents, which should determine the position of the figures in relation to their environment. It is not a bad drawing; it is, however, inferior to Rembrandt's.

From Rembrandt's middle period, that is, the 1640's, we show the drawing *Jacob's Dream* [133], which belongs to the Louvre, juxtaposed with the same subject done by Rembrandt's pupil, Ferdinand Bol [134]. In his middle period, Rembrandt turned from a graphic sharpness, expressed with an abun-

dance of lines or strokes, to a greater tonal softness and a higher economy of touch. This drawing shows Jacob asleep on the stone which served him as a pillow, and two angels coming down from heaven and looking on tenderly. The delicate tonal treatment with pen and brush helps to create a transcendental atmosphere and relieves the scene of any kind of obtrusive realism.

In the pupil's drawing of the same subject, the sketchiness is overdone. Lights and darks are massed in dramatic contrast, but lose all the finer points of Rembrandt's draftsmanship, with its sensitiveness and economy. The comparison of Bol's angel with those in the master's drawing needs no further explanation. Even the lightest touch of the pen or the brush by Rembrandt has significance, while the pupil wastes an abundance of strokes and heavy tones on a much less articulate suggestion of the messenger from heaven. This also applies if we compare the sleeping Jacob in the two drawings, or the environmental details.

From Rembrandt's mature period—about 1655—we show the beautiful drawing of the Prophet Elijah seated by the Brook Cherith [135], and a *Judah and Tamar* [136] done by a follower—a similar composition, inspired by Rem-

136 School of Rembrandt: *Landscape with Judah and Tamar*

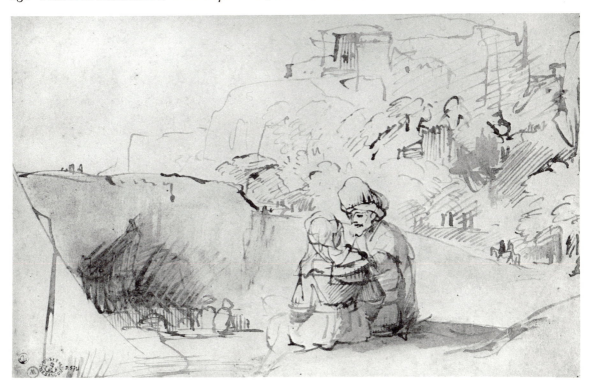

brandt's style of the 1650's. Both are done in pen and wash. In the *Elijah* drawing rays coming from heaven indicate that this is the moment when the prophet hears the voice of the Lord telling him to move on to Zarephath after the brook had dried up through lack of rain. There a widow woman would sustain him (I Kings, 17:9). Elijah raises his hands in prayer as he sits in this desert landscape, facing a distant hill. We again admire Rembrandt's mastery in creating a highly expressive scene with a minimum of articulate strokes that build up—even more firmly than before—the composition, the contrast of figure with distant view, and the structure of this sandy, rugged landscape. His line combines brevity with suggestiveness, and the lightest tonal accents or omissions count in creating spaciousness and a sun-drenched atmosphere.

The spatial relationships are much less certain in the follower's drawing,

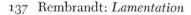

137 Rembrandt: *Lamentation*

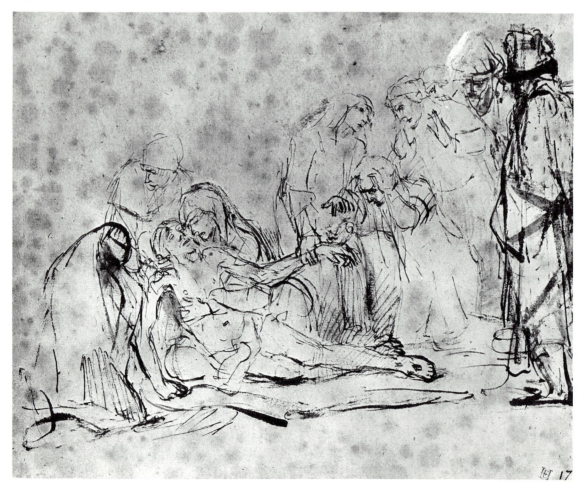

where we also miss Rembrandt's sure construction of the terrain. The hill, with its buildings and trees, does not gain sufficient body, nor the details distinct form. The strokes are vague and wobbly; also, the structure of the bridge leading through the middle distance on the left is hard to understand and cuts off the suggestion of a further distance. The figures of Judah and Tamar are comparatively articulate. Here the follower takes over Rembrandt's sketchy style with a measure of success, but he cannot maintain the effectiveness of the master's line in the elaboration of the landscape.

To indicate the great importance of subtle tonal accents in Rembrandt's mature draftsmanship, we show the drawing *Lamentation* [137], dated in the early 1650's, beside an old copy of this composition belonging to the National-museum in Stockholm [138]. Formerly, such copies were often considered

138 Copy of Rembrandt: *Lamentation*

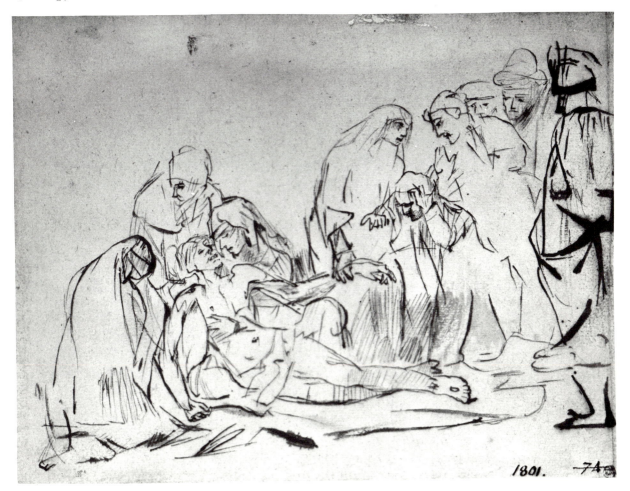

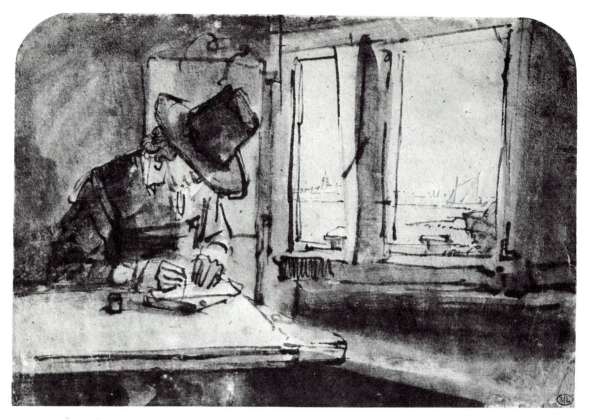

139 Rembrandt: *Man at Desk*

authentic Rembrandt drawings, until the originals were discovered and the differences became evident. One can easily see that the copy, done in pen over pencil, is only a meager skeleton of Rembrandt's pen and wash sketch. What an enormous richness is present in the master's work by means of the variation of tonal accents and their interrelationships. These accents are responsible for the clear suggestion of forms in space and their envelopment by light and air, as well as for the sensitive expression in the faces, the glances, the gestures. How intricate yet how clear is the passage around Christ's left hand which St. John holds with his right, while his left is slightly raised and Mary Magdalen looks on in deep awe and sorrow. And how empty this passage is in the copy, because the finer gradations of line and tone are completely lacking. The same can be said about every other passage and about the overall relationships in these two drawings.

The mature Rembrandt sometimes also used stronger and broader contrasts

of light and dark, as we see in the drawing of a man at his desk [139], done in pen and brush. It can be dated about 1655. The person represented may well be—as Frits Lugt has suggested[3]—the artist's friend and patron Jan Six at his estate IJmond, as the view of the Amstel River seen through the window indicates. We compare this drawing with one of a similar subject, a scholar at his desk, by Rembrandt's pupil Nicolaes Maes [140], done in pen and wash.

Nicolaes Maes derives from his master the bold chiaroscuro treatment which throws dramatic emphasis on lights and darks for the expression of form, space, and mood. However, Rembrandt's means, his graphic and rather painterly vocabulary, are not fully exploited. The contrasts are exaggerated, lacking the finer transitions, and thus breaking, rather than building up, form and spatial coherence. The figure has little solidity compared with the man in the Rembrandt drawing, and we gain, in general, the impression of a spotty rather than well-integrated tonal organization.

140 Nicolaes Maes:
 Scholar at His Desk

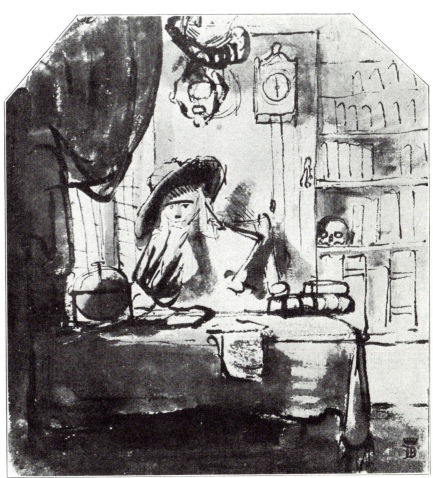

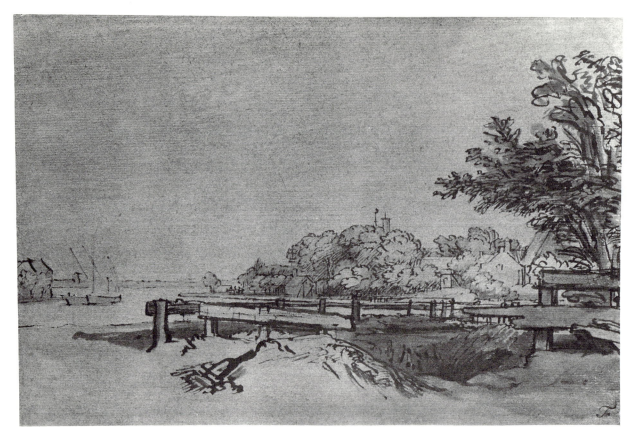

141 Rembrandt: *Bend in the River Amstel*

In the master's drawing there is not only a more coherent expression of form and space; the mood, expressed by the quiet concentration of the man sealing a letter, permeates the room and is successfully evoked by compositional and pictorial devices. Note, for instance, the head of the little boy peeping through the right corner of the window, or the perspective lines of the table and the window as they lead to the figure at its task. The figure itself attracts the eye through rich tonal accents which contrast effectively—without harshness—with the bright areas on the right. The subtle penetration of outdoor brightness with indoor darkness is wonderfully rendered and exploited for the expressiveness and unity of the design. Rembrandt's masterly use of the media, of the pen and the brush and their subtle interaction, is most admirable. Nicolaes Maes remains far behind in all these respects. By the noisy and splashy manipulation of tones and the self-conscious posture of the scholar, Maes fails to express the quiet, contemplative mood which this

subject matter calls for. Such inconsistency in the relationship of form and content is unthinkable with a great master like Rembrandt.

From his landscape drawings, which are rightly among the most treasured works of Rembrandt, we reproduce a view of the Amstel near Amsterdam [141], in which we see the bend in the river near the ruined castle of Kostverloren—the top of the castle is barely visible between trees. In the foreground a fence encloses what seems to be an opening for the foundation of a country house. In the middle distance on the left, a sailing boat is docked. This drawing in pen and brush, part of the famous collection of the Duke of Devonshire, can be dated about 1651–2 and is here compared with a School drawing of about the same time, attributed to Anthonie van Borssom [142], similar in composition and technique. It shows a thatched cottage standing between trees and situated near a canal. As in the case of Nicolaes Maes, this pupil also overdoes the dashiness and breadth of the mature Rembrandt's style, as if to show a superior skill. But, as in the Maes, the result is vagueness and lack of spatial clarity. How much more articulate and clear is Rembrandt's drawing in leading the eye into a vast space, from the foreground through the middle distance to the remote bank of the river along the horizon. How

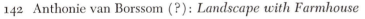

142 Anthonie van Borssom (?): *Landscape with Farmhouse*

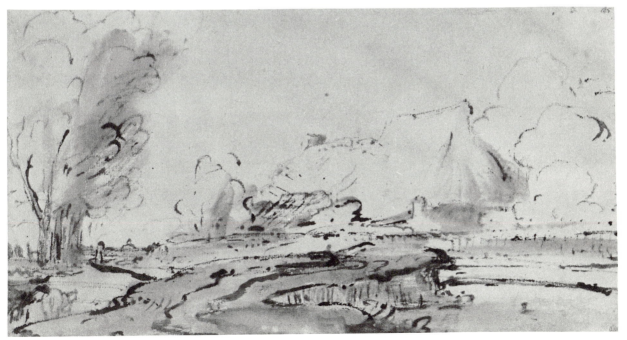

effective with him are the varied contrasts of light against dark and dark against light, creating wide as well as smaller distances, for instance, in the left foreground, where the master sets off the dark edge of the fence against the bright river; but also on the right, where the view is somewhat limited by houses and trees, yet the suggestion of the space beyond is kept alive by various devices such as the direction of the roofs and a sensitive aerial perspective. In the Rembrandt, whether we look at a tree, at the bushes, the houses or fences, at the terrain or the sailboat—everywhere we feel the surer and more incisive touch of the master, in his grasp of the structural features, in his more selective and descriptive brevity. The follower utterly fails to bring the details to life. Also, the structure of the whole is weaker and more nebulous. There is some movement in his composition, but it is not as consistently carried through with major and minor accents. Van Borssom's superficial dashiness lets us down in many ways. His forms are puffed up and his spatial image appears incomplete and vague in the distances.

With the next two drawings we reach the eighteenth century. Watteau's sketch of the actor Philippe Poisson [143] is in red and black chalk. The other study, in red chalk, of a man holding a thin rope [144] is by Nicolas Lancret. Both drawings reflect the charm of eighteenth-century France, where the ponderous Baroque style gave way to a spirited lightness and elegance. In brilliant illumination the graceful figures carry themselves with the ease of dancers. All darker shadows have disappeared. An impressionistic glitter spreads over the surfaces and lends a gay note to this art. The lines are broken open, crisply marking form, texture, and action. Although Lancret must be respected as an artist of more than ordinary attractiveness, his style cannot rival that of Watteau. With Watteau, the illumination is more intense, the quality of the line more exciting, in its crispness and precision, in its sparse, incisive, and rhythmical accents. His figures have both tension and poise, and the articulateness and elegance of his draftsmanship place him beside the foremost representatives of French art, from Callot the Mannerist to Degas and Toulouse-Lautrec, the Impressionists. Compared with Watteau's figure, Lancret's appears stiff, in spite of its movement. The light does not model the form with the same intensity, flexibility, and ease. The accents are less incisive in their modeling function. The over-all brilliance is not attained, nor the finesse of Watteau's articulation in line and tone.

143 Watteau: *M. Poisson*

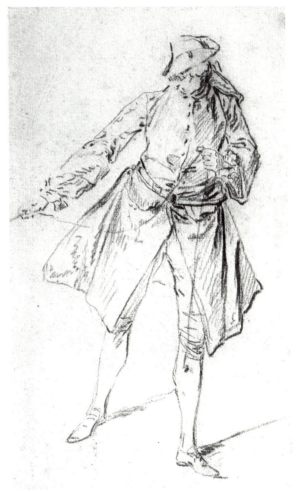

144 Nicolas Lancret: *Study of a Man with a Rope*

When we compare the study of a seated woman by Watteau [145] with a
similar study by Lancret [146]—both are drawings in colored chalk—we
find the same difference of quality. Here Lancret, even more notably than
in the previous work, exhibits considerable charm. There are ease and light-
ness of touch in this costume study, and perhaps if it were not juxtaposed to
a Watteau we would overvalue it. But Watteau's performance teaches us what
real authority in draftsmanship can be when strength is combined with grace
and when a more intense grasp of the forms, a wider range of accents, and a

145 Watteau: *Study of a Woman Seated*

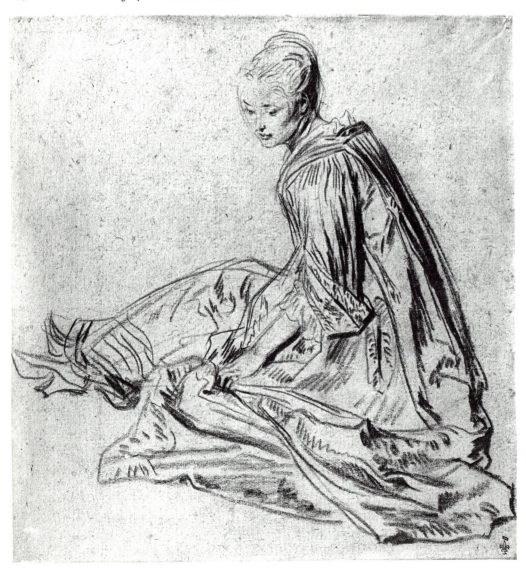

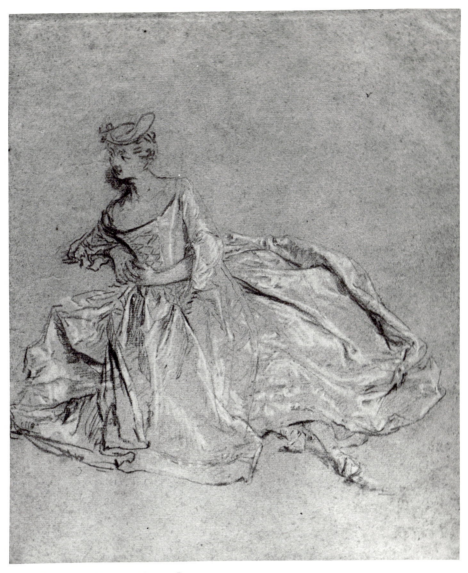

146 Lancret: *Woman Seated*

stronger design coherence are present. Watteau's bold strokes characterize well how the stiff and glittering material of the woman's dress stands out from the body here and there, or breaks into angular folds. Yet figure and costume are an inseparable unit, and the movement of the body is closely felt in this complex design of almost abstract beauty. The formal organization of the various shapes and strokes centers around the point where the figure bends to form an angle, and here the drawing becomes more delicate.

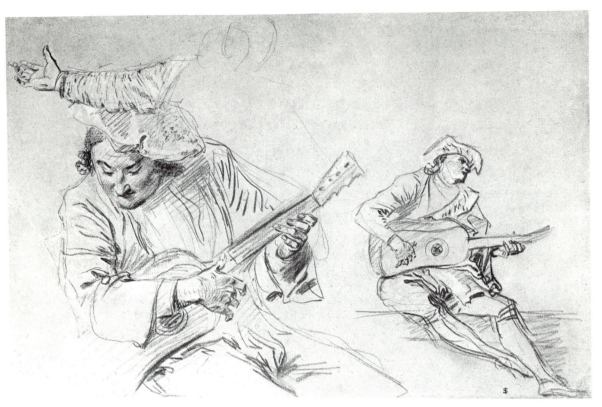

147 Watteau: *Studies of a Guitar Player*

In the Lancret, the coherence of form and of the whole design is much looser—it is largely a surface coherence and there is little structural character. Even if we limit our criticism to the widely spread skirt, its arrangement has less variety and interest. The distinction of planes is weaker, as well as the formation of pattern, which is certainly not as descriptive and ornate as in the Watteau.

When we juxtapose a Watteau drawing of a guitarist in two different positions [147] with one of the same motif by another follower, Jean-Baptiste Pater [148]—both in chalk—the master's draftsmanship is wondrously superior. Watteau sets the accents more succinctly at vital points—look at the marvelous play of the hands and the foreshortened face, with its pensive expression, of the guitarist on the left. Lights and darks produce a sparkling brilliance, and the complicated movement of the player could not be more

194

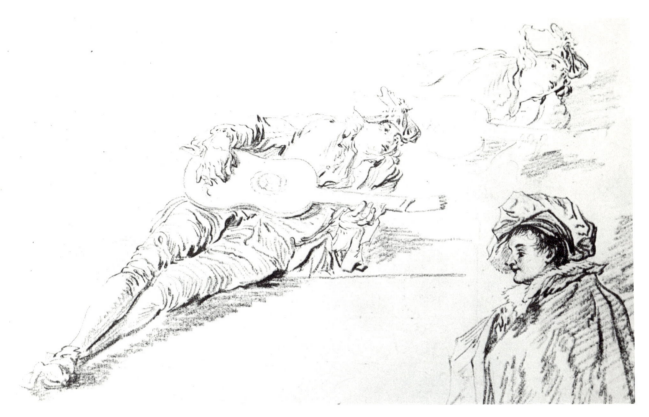

48 Jean-Baptiste Pater: *Studies of a Guitarist*

strikingly expressed. To appreciate the articulateness of Watteau's draftsman-
ship and its superb economy, follow, for instance, the recession from the left
hand of the player over the neck of the guitar to the musician's left upper
arm and shoulder, which are indicated by only a few open strokes. How in-
tensely does the master focus our interest on the action of these fine, nervous
fingers by easing up the passage behind them, and at the same time how dis-
tinctly does he make us aware of the distance from the hand to the arm and
the shoulder.

Such fine articulation, such surety and economy, such pictorial brilliance
are not found in the Pater. He takes over Watteau's vocabulary, his short,
ornamental strokes and his manner of accentuating, but he cannot apply these
means with the same incisiveness, flexibility, and suggestiveness. The strokes
are much more repetitious; they do not give as much form or express the

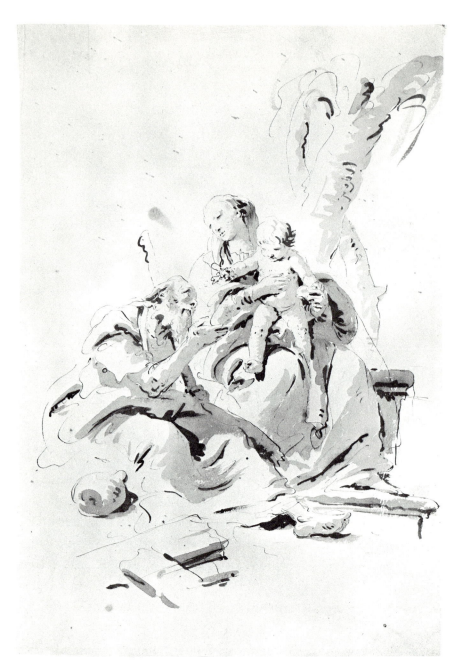

149 G. B. Tiepolo: *Rest on the Flight to Egypt*

movement of the figure with the same clarity and intensity. While there are light and dark accents, the gradation between them is very limited.

Italy's greatest contribution to Rococo draftsmanship is the work of the Venetian Giovanni Battista Tiepolo, whose *Rest on the Flight to Egypt* [149], in pen and wash, is reproduced here. It is compared with a follower's drawing—also in pen and wash—representing a similar subject: a Madonna with a kneeling saint and angels [150]. A study of a male figure in the right foreground seems unrelated to the others.

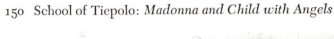

150 School of Tiepolo: *Madonna and Child with Angels*

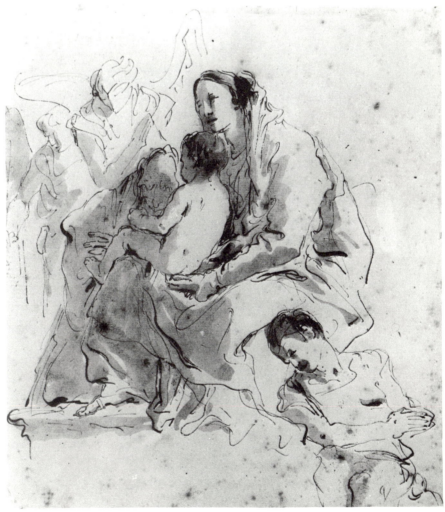

Tiepolo, like Watteau, raises a brilliant light to a dominant position in his draftsmanship, but he does so with a broader sweep and monumentality. He organizes tones in three values: the most intense brightness emanates from the whitness of the paper—against which he sets a middle tone and a few crisp deeper darks. He uses this three-value system with supreme economy of touch, creating a clearly articulated group, full of sweeping movement and bathed in the most brilliant light. The tones, in particular the dark accents, show their rhythmical coherence by forming a *rocaille*-like pattern.

We miss the same clear articulation and spirited organization in the follower's drawing, also the economic and expressive use of Tiepolo's painterly language. Line and tone do not interact with the same control. The forms seem to run into each other. The middle tone has neither a clear modeling function nor does it co-operate with the other values to create an integrated design, which in the master's drawing—as we noticed—has the animated rhythm of a Rococo ornament.

Turning to the nineteenth century, we offer, first, Degas's pencil drawing of Mme Julie Burtin [151] and a drawing by his pupil Mary Cassatt, also in pencil, of a seated young girl [152].

The Degas sketch dates from the early 1860's, when the artist's style still reflected something of Ingres's fine linear draftsmanship. The pencil is here slightly enriched by the use of white chalk in the face and the hair. The drawing goes beyond Ingres in many other ways. Posture, gesture, and facial expression characterize the woman's individuality with utmost delicacy. Tone is added to the line, and envelops the figure with tender light and atmosphere. This play of values seems to veil the sensitive balance in the composition, in which the crossing diagonals in the center have a leading part, and a slight geometrical basis in the triangular build-up of the figure remains almost unnoticed. How subtly and expressively Degas contrasts shapes and accents: notice the rectangular corner of the chair with the oval of the head, or the central vertical on the skirt with the diagonals formed in the center. There are variety and integration. His draftsmanship, in its incisive yet delicate lines and subtle play of tones, preserves a subdued spontaneity and freshness.

Mary Cassatt's nice pencil sketch is much more limited in its graphic means

and range of expression. She cannot bring to life all the parts of the drawing as her master can. Her lines are less descriptive and sensitive, less incisive and meaningful. Except for the head and the legs, there is little articulation in the girl's costume or body. The bright light thrown on her is not exploited with the same fine feeling for the indication of form and texture that is found in the Degas, nor is there inherent any design order of a higher character.

Finally we come to an example of draftsmanship from the end of the nineteenth century, a pen drawing by van Gogh, representing a wheat field with reapers [153]. In the distance one sees the town of Arles. This drawing is here juxtaposed with a forgery [154], which presents a similar subject and imitates van Gogh's style of penmanship.

One ought to be able to recognize a forgery as a work of minor quality. While it cannot be denied that even connoisseurs are once in a while deceived, closer and more competent quality-distinctions should protect them from such deceptions. When we compare the genuine van Gogh drawing with the forgery we immediately miss in the latter such basic features of great draftsmanship as structural quality of form and space, and design coherence and articulation. The drawing is messy and crude in many ways, whether we look at the foreground, with its coarse repetitious strokes and the formless sheaves, or at the hopeless confusion of planes in the distance.

How clear, in contrast, are the master's spatial distinctions, how sensitive his lighting, and how striking his structural accents, even in the remote buildings along the horizon. The whole design shows fine gradations and a firm coherence. Van Gogh's original and rich graphic vocabulary—so coarsely imitated by the forger—serves perfectly to express form, light, atmosphere, and space. With similar success, through gradation in size, direction, and tonal accent, it serves to build up an articulate design, in which the parts are related to the whole with a fine sense of balance and rhythmical order. None of these qualities was the forger able to approach.

If we look back over this chapter to find out whether the criteria of excellence formed from examples of the Late Gothic and the Renaissance were also valid in later centuries, from the seventeenth to the end of the nineteenth, we

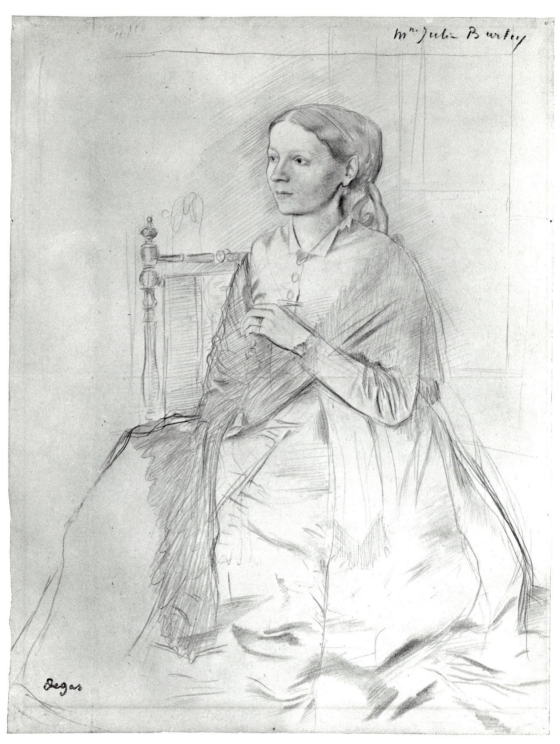

151 Degas: *Mme Julie Burtin*

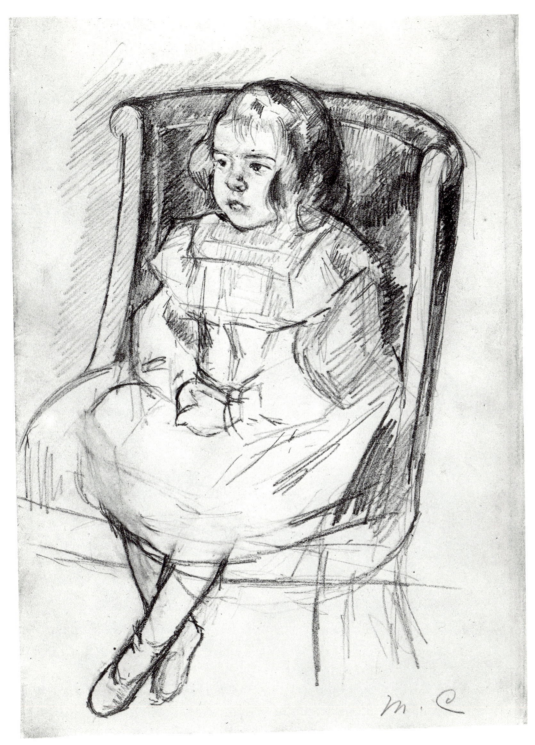

152 Mary Cassatt: *Young Girl Seated*

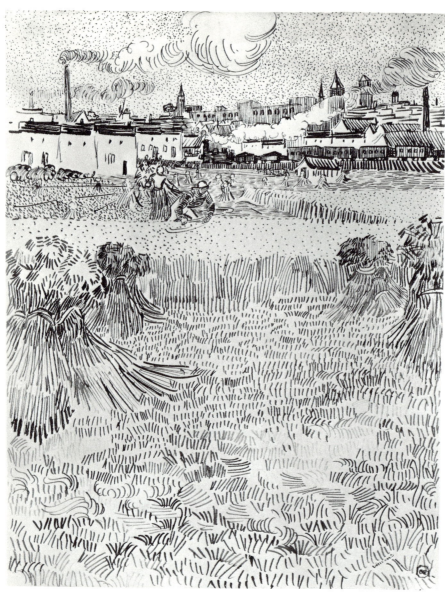

153 van Gogh: *Wheatfield with Reapers, Arles*

can say that this is the case. A few minor adjustments were necessary, as a result of the change of style in the later periods: for instance, the criteria formerly applied to the quality of line are more applicable in the Baroque to the quality of tone or touch, owing to the change from a linear to a more painterly mode of expression. We also added a few general criteria, such as

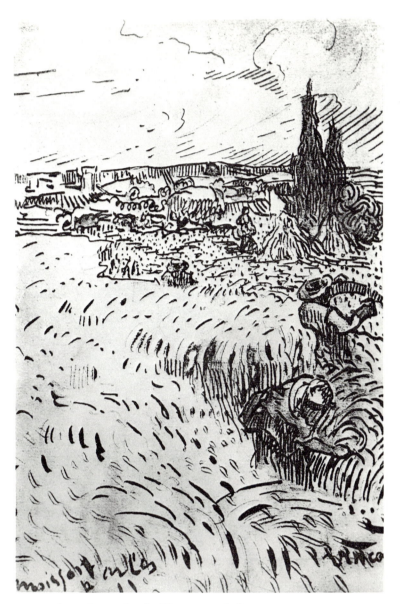

154 A forged van Gogh: *Harvest at Arles*

vitality, intensity, selectiveness, consistency, density, feeling for the media, the combination of depth and comprehensiveness (of concept), and the combination of clarity and richness; finally, originality, which relates to both concept and formal expression. But most of these additional findings are in turn applicable to the earlier centuries. Therefore, to sum up the results of

203

these two chapters, we suggest the following list of criteria of high quality as being more or less valid for the whole field of master drawings from the fifteenth through the nineteenth century:

Line and tone:

sensitivity, articulateness, flexibility, ease, surety, spontaneity, rhythmical quality, suggestiveness

Form:

solidity, organic character, coherence, clear distinction of planes

Space:

an articulate, continuous, and comprehensive treatment ("comprehensive" is a Baroque addition)

Composition, or, perhaps, formal organization:

integration (unification), gradation, density, sense of balance, and richness of formal relationships

Finally the following more general characteristics, which cannot be properly confined to any one of the above categories:

range of accents, artistic economy, selectiveness, feeling for the media, sense for the significant, consistency, vitality, originality, inventiveness, intensity, clarity, expressiveness

This above grouping is not absolutely binding, since some of the criteria are applicable to more than one category: for instance, sensitivity has a bearing not only on line and tone, but also on form, space, and the whole formal organization. But it is most noticeable in relation to line, tone, and touch. Furthermore, there is some overlapping among these criteria: for instance, originality and inventiveness, suggestiveness and expressiveness; while they are close, they are not really identical. Another point to be remembered is that not all of these aspects of high quality are found in every work of art, although many of them will appear. Very often some aspects stand out more than others in a particular work, but it is important that a good number of

them are included. And certain combinations seem mandatory, such as the combination of subtlety and power, clarity and richness, depth and comprehensiveness of concept. Each of these qualities appearing singly, as we have witnessed, is not in itself indicative of high quality.

Our list, while far from complete, covers a great many of the essential criteria of quality. But the big question still unanswered is whether these criteria, which are drawn from periods concerned exclusively with representational art, can be applied as well to contemporary—that is, to largely abstract—art. To this vexing problem—Whether abstract art requires a completely different set of standards for its proper evaluation?—we shall turn in our concluding chapter.

Master Drawings
and Prints of the
Twentieth Century

T HE difficulty of making valid quality distinctions greatly increases when
we come to the art of the present. There are good reasons for this. We lack
perspective and we do not have the benefit of time-tested judgments. Further-
more, the art of today is largely abstract and differs so basically from the repre-
sentational art of the past—which relied on natural vision and had a definite
content—that the standards of excellence of the past seem questionable or no
longer applicable.

Early in 1964 at the National Gallery in Washington there was an unusual
opportunity to become fully aware of the embarrassing range and diversity
of the art of our century, through the comprehensive loan exhibition of paint-
ings from the Museum of Modern Art in New York. One saw every phase of
twentieth-century painting, and even its forerunners were well represented.
There were strong examples of the art of Cézanne, van Gogh, and Gauguin;
there were outstanding works by Matisse and the Fauves, by Picasso and the
Cubists, by the German Expressionists and by Kandinsky and Mondrian, the
founders of Abstract art; there were representative examples of the various
other trends, such as fantastic and surrealistic painting, from Chagall to Dali
and Tanguy; and one could see the more recent Abstract Expressionists, such

as Pollock, de Kooning, and others, as well as Geometrical Abstractionists like Josef Albers, Morris Louis, and Ellsworth Kelly; and, alongside these extremely modern productions, there was the work of a painstaking realist with a romantic undertone, Andrew Wyeth, who has no small appeal to the public.

No one can blame us for becoming a little confused when faced with this abundance of diverse trends. Even if we realize that the abstract trend has become increasingly dominant in the course of the twentieth century—which is perhaps an unavoidable reflection of our scientific and technological culture—we may still be at a loss to find standards of judgment and evaluation that embrace both representational and abstract art, and everything that falls between.

However, if we glance back at the criteria of excellence which we have evolved thus far from works of the fifteenth to the end of the nineteenth century, the situation does not seem so hopeless. In fact, many of these criteria— as we shall try to show—are still applicable, in spite of the turning away from natural vision to abstract forms, because the principles of artistic organization remain the same. We shall now carry our method into the twentieth century—the method of seeking criteria of excellence by comparing a presumably major artist and a minor one who works in the same or a similar style, hoping to find confirmation for our assumption as to who is the major and who the minor artist by means of an intense analysis which concentrates on formal qualities. But we shall remain ready to reverse our judgment, if necessary. The increasing elusiveness of content, easily observed in the development from representational to abstract art, will not be too serious an obstacle because, as we have said above, in abstract art the formal organization—its expressiveness, originality, and other qualitative aspects—is not only still noticeable, but measurable, at least to a fair degree. We shall examine prints as well as drawings for our discussion of the twentieth century.

Only when we have reached the end of our road, in search of criteria of quality, shall we assess the value and the limitations of our efforts and take up some broader questions which have remained unanswered. Such questions are:

1) How much general validity do our criteria have when extended beyond the field of drawings and prints?

2) Can we possibly make a comparative quality judgment on works of different periods (which we have so far avoided by keeping our comparisons within one and the same style)?

3) How does content condition quality (and not only form, with which we have been largely concerned)? Is the gradual disappearance or elusiveness of content in twentieth-century art detrimental to artistic quality?

4) What is the usefulness of all our endeavors when we can attain only a *relative* certainty in our criteria, and an *absolute* standard is beyond our reach?

We show first a large lithograph of 1924 by Henri Matisse representing a nude reclining in an upholstered armchair [155], and beside it a drawing in black chalk of a similar subject by Suzanne Valadon [156]. For our purposes the comparison of prints and drawings seems permissible in twentieth-century art, since both lithography and etching can attain a character very similar to drawing, and are often little else but drawings multiplied by a special printing process.

Matisse's great significance along with Picasso's is no longer contested; he is definitely one of the leaders of the twentieth century. This lithograph gives a full indication of his high quality. We find clarity and subtlety, plastic power and rhythmical movement, a masterful setting which seems informal yet creates a design of almost abstract beauty. An architectural feeling pervades the composition. The upward movement of the figure is interwoven with the accents on the chair. And there is a balance of attraction between the head, framed by the arms, and the legs so interestingly set one above the other. Wonderful are the control over the modeling function of the light and the charm of its gradations and reflections on the face and elsewhere. Economy of accents is here paired with rich plastic animation. The design is not only of a tectonic firmness but also full of rhythmical life. It has unity and balance, vitality and order, and is free of academic coldness or self-consciousness.

Suzanne Valadon, the author of the drawing, was a contemporary of Matisse, somewhat admired in her day for her daring draftsmanship and for a kind of primitive power—because of the latter, her reputation seems to be in the ascendant again. This study is earlier than the Matisse and in a rather different mode, more in the Toulouse-Lautrec than in the Cézanne tradition

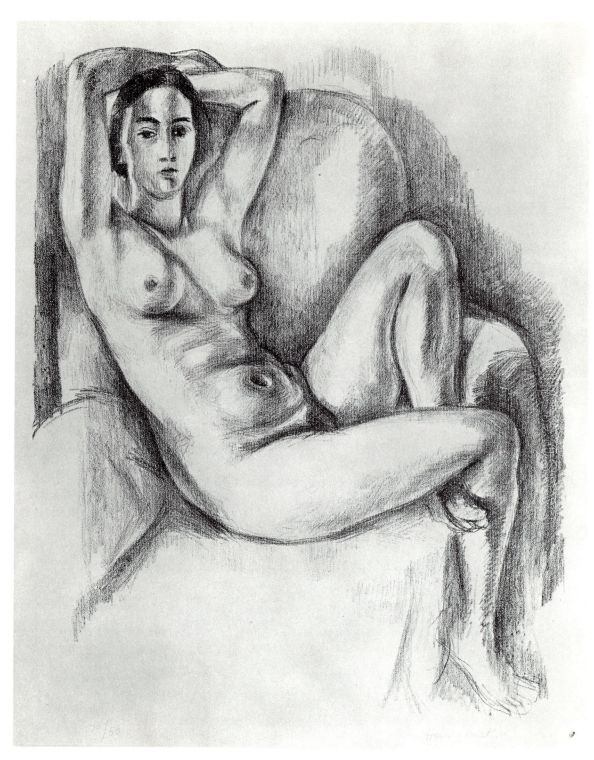

155 Matisse: *Nude in an Armchair.* 1924

(which the Matisse lithograph reflects). Yet it can well be compared to the Matisse from the point of view of quality. It certainly is not inexpressive and not without originality in the girl's very informal pose on the couch. However, the movement of her figure is not brought out with the same plastic clarity and power that we admired in the Matisse. The outlines are harsh and unrelated to the swelling of the forms. Gradation is lacking, so that the streaks of heavy shadow along her right side and on the ground are somewhat inconsistent with the emptiness of the drawing elsewhere. The composition has holes and suffers from a rather abrupt spatial accentuation that inadequately relates the space in all parts.

156 Suzanne Valadon: *Nude Reclining*

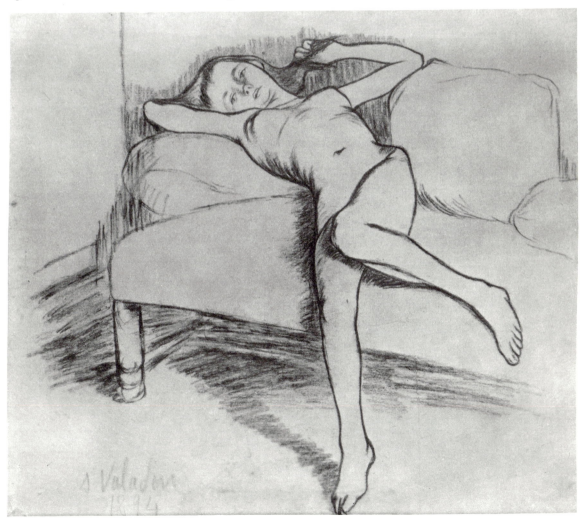

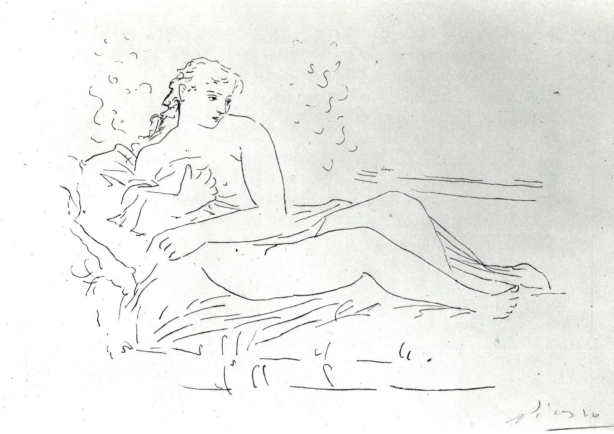

157 Picasso: *Reclining Woman.* 1924

Picasso's master hand is easily evident in his so-called classical line draw-
ings, which he often created side by side with his abstract designs. (We shall
present an example of his abstract art later in this chapter.) First, we show a
lithograph done in pen, dating from the same year as the Matisse—1924 [157].
It represents a reclining nude in a landscape near the shore, and breathes that
Mediterranean serenity which Picasso could express as no one else could,
except perhaps Matisse. A light and happy atmosphere pervades the whole
scene: the figure in her poise, the drapery that only slightly covers the nude
and is spread out under her, and the indications of landscape with a luminous,
open space. Picasso is here a master of economical and suggestive line. Its
repeated interruptions are needed for the over-all effect of a brilliant atmos-
phere. They also prevent the forms and planes from crowding, thus allowing

their easy interconnection as well as creating a sensitive balance. The figure, for all its massiveness—this is from Picasso's period of so-called "colossal classicism"—has elegance in the animated *contraposto* movement and is well integrated with the environment. Thus the whole dominates, rather than any of the details, although there is sufficient attraction given to the nymph's face and gestures. It is little short of a miracle how full, how clear, and how articulate is this outdoor scene, achieved with the barest minimum of fine lines.

When we turn to a similar subject in a pen drawing by Raoul Dufy [158], we feel a lowering of quality in spite of the work's undeniable charm. Here the line is more calligraphic for calligraphy's sake, without the sensitive suggestion of form that makes the Picasso so admirable. The Dufy drawing also lacks the greater master's economy. The lines are slightly repetitious; the figure is less convincingly articulated in structure and posture. Furthermore, we notice that the spatial relationships are somewhat less controlled. The whole upper left part remains unrelated to the foreground, whereas the cor-

158 Raoul Dufy: *Reclining Female Nude*

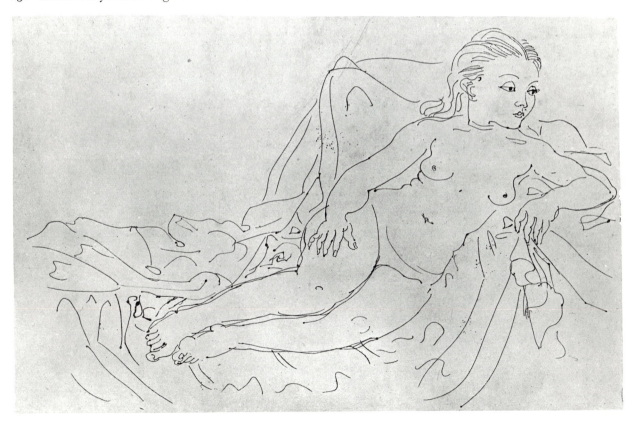

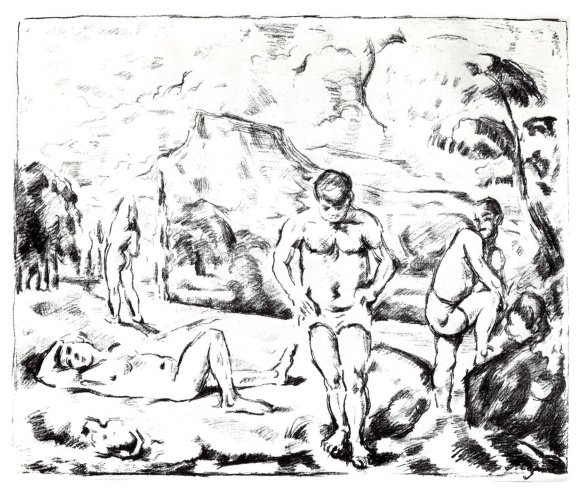

159 Cézanne: *The Bathers* (larger plate)

responding empty area in the Picasso suggests depth, distance, and atmosphere. We have the impression that the woman here is suspended in the foreground, at least that her body sticks too much to the front plane and lacks that free existence in space which the Picasso shows. Finally, we miss the greater artist's superb compositional balance, which related so well all parts of the design. Of course, I cannot deny Dufy's charm and personal qualities, which are more apparent perhaps in other works than here, and which can result in an appealing decorative effect. But the fact remains that this drawing is not on the same artistic level as the Picasso, as the application of our criteria may have shown.

We may turn now to some landscapes, first to a late work of Cézanne, his lithograph of a landscape with bathers and Mont-Ste.-Victoire in the background [159]. Certainly Cézanne cannot be called a contemporary, although this, one of his late works, falls within the twentieth century. The reason for including it is that we cannot omit Cézanne when discussing twentieth-century art, because he is one of its chief inspirers, an artist who set the highest standards in whatever he did. Nobody could equal him in placing figures into a landscape as inseparable parts of the whole, yet endowing them with plastic vigor. His figures fulfill both a rhythmical and a spatial function within the design, and thus become true partners of nature as essential carriers of the composition. The eye focuses first on the male nude coming forward in the center. And from here formal relationships play in all directions, to both sides as well as into depth. While the figure on the right links up the central nude with the tree above and behind him, the reclining female nude on the

160 Erich Heckel: *Bathers.* 1929

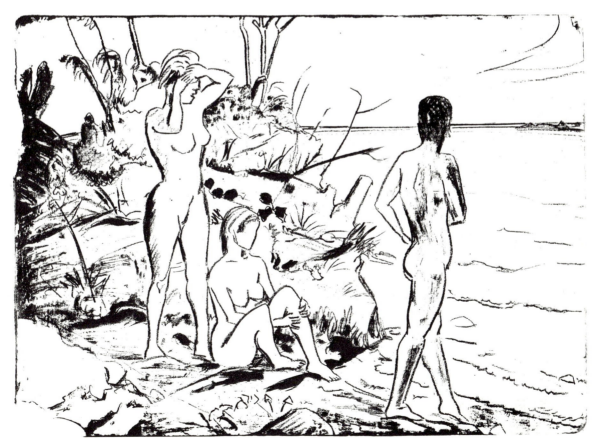

left opens the view across the nude in the middle distance to the characteris-
tic silhouette of the mountain, which, in turn, leads back to the central figure.
Thus there is an easy intercourse between the surface and the space, and also
a unity of nature and man that is happily balanced, rich in its gradations, yet
free from obvious formalism. As in all of Cézanne's mature works, we find here
a blending of Impressionism with the more constructive tendencies of present-
day art. It is not an imitative view of nature, but one built up by the artist's
creative power.

If we turn to a lithograph with a similar subject, nudes in a landscape, by
the German Expressionist Erich Heckel [160]—a lithograph which originated
a generation after Cézanne, that is, in 1929—we seem to deviate from our
path of investigation. Up to now we have refrained from making quality com-
parisons between different periods, and have limited our comparisons to
artists who belong to the same stylistic phase. The Cézanne represents a
Post-Impressionist work that moves toward twentieth-century art, while the
Heckel shows an Expressionist turning back to Post-Impressionism or Natural-
ism—as sometimes happened in the 1920's, after the Expressionist movement
had lost its vigorous creative impulses and had begun to calm down and to
compromise with the art of the past. We see here, then, a combination of
abstract and expressionistic tendencies which still emphatically stress the
graphic effect of the surface pattern, but with a somewhat realistic attitude
toward nature. The stylization is harsher than in the Cézanne. This print lacks
the consistent atmospheric quality that contributed so much to Cézanne's
design. The figures do not have the full plastic life of the French master's
forms; the spatial effect is not all-embracing. In the Cézanne, the composition
is better and more richly integrated in the relationship of the parts to the
whole. We find more variety and a more subtle gradation of accents, not only
more solidity and structural clarity. The Heckel is by no means without attrac-
tion in the directness and liveliness of its pattern, but from the point of view
of quality it does not hold up well beside the work of the great Frenchman.

Next we discuss a work of a more outright Expressionist character, a 1917
woodcut by Ernst Ludwig Kirchner, the portrait of the art dealer Ludwig
Schames [161]. Kirchner was a distinct leader, particularly in graphic art, and
was perhaps at his best in his woodcuts, handling the medium with extreme

boldness and originality. The most urgent desire of the German Expressionists was to convey their inner experience, in order to probe further and deeper than the Impressionists, who they thought were concerned only with the outward appearance of their subjects. And here indeed Kirchner has succeeded in merging both the outward aspect and his inner experience of the sitter, who was his own art dealer and an interesting, idealistic person. The spontaneity with which the artist handles the difficult knifework on wood combines effectively with an expressive and original design. For Kirchner, the whole was always at least as important, if not more so, than the details. Thus the long-bearded head that has the dignity of an old prophet and the sculptured figure of a female nude in the left background—representing one of Kirchner's own works—are fitted into the irregular shape of the block so successfully that the composition looks intergrown by necessity. The handling of the details is interesting and surprising. Kirchner's method of phrasing a beard, a nose, an eye, shows an ingenious response to both the actual form and the nature of the medium, but it is also intensely conditioned by the character of the total design, with its vivid, jagged rhythms of black and white. One of the most original features of his woodcut technique is Kirchner's flexible use of black-line and white-line design, which he combines ingeniously to enrich his graphic language and to build visual phenomena into abstract patterns. We speak of black-line design when the black lines stand out in a predominantly white area, as, for instance, here in the pattern of the beard; and of white-line design, accordingly, when white lines become outstanding against a dark area, as in the hair or the background near the neck. And there are fluid transitions from one to the other, to enliven the flickering over-all effect, which reminds one of El Greco's phosphorescent lighting. Yet the features are decisively shaped, and the inner character of the man dominates. It is indeed remarkable how much Kirchner was able to say in this rather rugged technique, and how he has combined strong stylization with vivid expressiveness.

The woodcut of Kirchner's follower, Karl F. Zähringer, is a self-portrait dated 1920 [162], and seems at first sight a close attempt to apply Kirchner's very original technique. Zähringer holds a woodcutter's knife in his hand and places himself, as Kirchner often did with his subjects, in a mountain land-

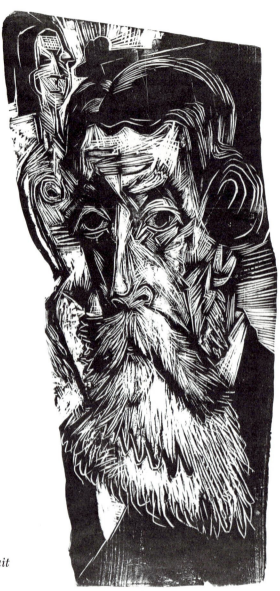

161 Ernst Ludwig Kirchner: *Portrait of Ludwig Schames.* 1917

scape. In fact, both artists lived at that time in Switzerland. On the right, one observes a young shepherd and a goat, on the left are starlike flowers (they look like edelweiss), and above the sun appears conspicuously. The slightly empty and sentimental face of the artist is not convincingly linked with this environment, because Zähringer cannot use Kirchner's woodcut technique with the same articulateness and expressiveness. The heavy, yet soft and repetitious contours which frame the head, the nose, and the eyes are weakly

related to the rest of the design: the overlighted face, the mosaic-like treatment of the mountain peaks, and the stringy lines of the hand. It is a pedestrian job compared to Kirchner's sparkling image, which can hardly be surpassed in its brilliant integration of the black and white design.

A woodcut landscape of 1933 by Kirchner [163], which follows sixteen years after the Schames portrait, shows the artist's later style, with its broader rhythms and simplified shading. This Swiss scene of snow-covered mountains towering above a pasture in which cows are grazing is another example of the German Expressionist's original vision and woodcut technique. The abstraction of the forms seems driven further here, yet not to the point of defying visual reality. It is used only to heighten the impact of a grandiose motif which the artist has forged with bold rhythms into an expressive unity. The mighty

162 Karl F. Zähringer:
Self-Portrait. 1920

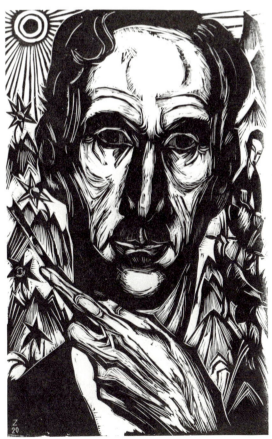

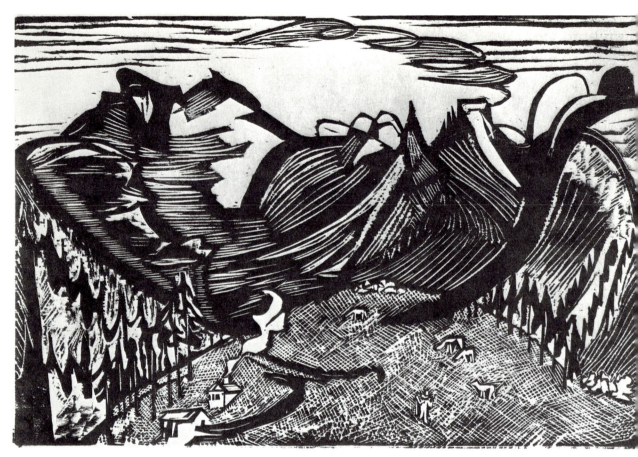

163 Kirchner: *Mountain Landscape.* 1933

black curves swinging down from the top of the glaciers do not spoil the composition. They strikingly contrast with well-graded effects, such as the white lines on the slopes, the jagged pattern of the pines on either side, and the intimate network of crosshatching on the meadow in the foreground. And the sky responds with its luminous brightness. It is again—like the Schames portrait—a highly stylized composition that vividly reflects the artist's inner experience, here of the majestic world of the high mountains in Switzerland where he spent the second part of his life.

We reproduce for comparison with Kirchner's woodcut, the watercolor of an American Expressionist, John Marin [164], representing islands off the Maine Coast. One should really see it in color. The cool, transparent blues which dominate the center and the left are effectively contrasted with a reddish brown on the right and above, while smaller patches of red, yellow,

and green enliven the coloristic composition. Marin may have been inspired
by the German Expressionists, but he developed his own style, largely in the
medium of watercolor. Here a deviation from our scheme may be permissible
because we do not show the Marin as an example of a weaker form of Ex-
pressionism, but rather as an equal to the best of the Germans, at least in
landscape. There is a delightful freshness in his vision and a remarkable power
of formal organization. His artistic language, like that of Kirchner, attains a
high degree of abstraction but never sinks to the purely decorative. And it
is always a vivid reflection of the artist's experience in nature. Here the

164 John Marin: *Maine Islands.* 1922

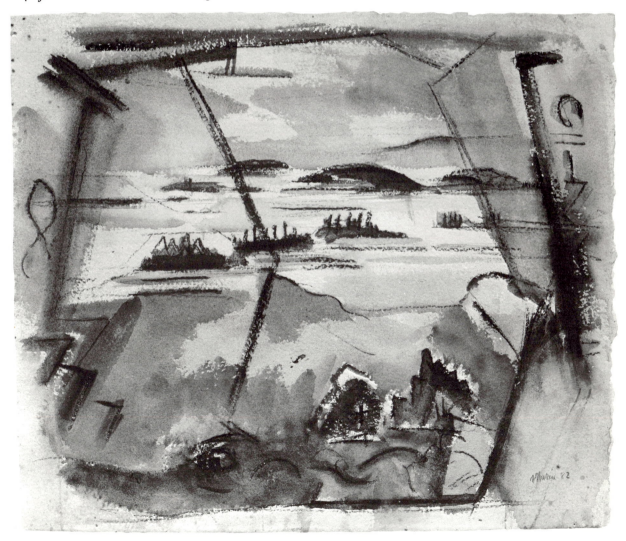

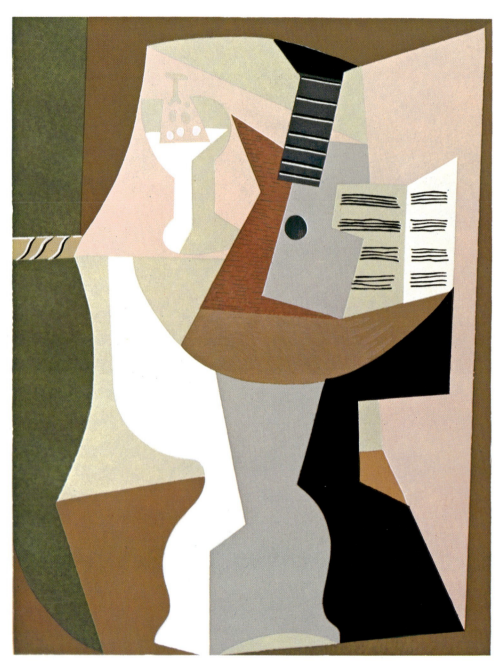

165 Picasso: *Abstraction*

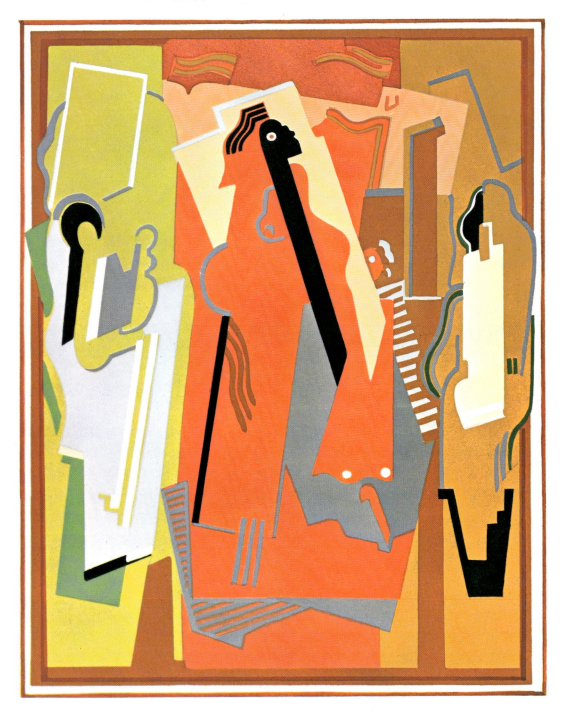

medium of watercolor helps to suggest space and atmosphere, while the daring abstract lines that frame and even cut the image heighten both the unity and the exalted quality of the vision. And there is no lack of subtlety, as we notice in the finer touches of color, line, and tone. The range of accents is wide and controlled. Winslow Homer, the greatest nineteenth-century American landscapist in watercolor, preferred this medium and handled it with striking originality; John Marin, Homer's twentieth-century counterpart in the period of Expressionism, can also be said to have made this medium his own.

The abstract elements which we have seen grow in the artistic vocabulary of twentieth-century art become definitely dominant in the Cubist works of the French school led by Picasso. We discuss now an abstraction—or, more correctly, a semi-abstraction—by him, a stencil print of about 1920 [165]. Alfred H. Barr, Jr., makes a distinction between Picasso's first phase of Cubism, 1909–12, which he calls "analytical," and the second, "synthetic" phase, which reached its climax in the early 1920's.[1] In neither phase do we yet find pure abstraction. There is still some trace of subject matter: here, a table with a goblet, a guitar, and a sheet of music. But the objects can no longer be recognized in their full identity or natural coherence in space, because Picasso has moved away from visual reality, has ripped the objects apart, transposed them into flat shapes that overlap in a surprising fashion, and reassembled them at will. However, not as arbitrarily as it may at first seem, but rather with the intention of arousing new, hitherto-unknown artistic sensations. While one may be shocked at first, at seeing visual reality gone to pieces, one cannot deny the stimulating effect of such an animated and coherent pattern. The controlled repetition, the variety and contrast of shapes and colors—essential elements of any organized design—are combined with a high degree of integration and gradation and a well-balanced distribution of attraction around the focal point of the guitar. Light and dark, cool and warm colors, striped and punctuated patterns are not merely poured out and loosely combined, but are selected with high economy and expressively related within a tightly organized design. The seeming simplicity may deceive one into overlooking the intensity of the formal relationships and their telling character. Yet there

is hardly a detail that could be changed without disturbing the balanced order of the whole.

Let us see now whether a comparison of Picasso's work with that of a minor contemporary who deals with a similar task in the same technique, will reassure us about the validity of our criteria. At first sight perhaps Albert Gleizes's *Abstraction* [166] seems much richer than the Picasso. But it is a merely quantitative richness of colors and shapes, a jumble of details that lack any strong organization or clear articulation of accents. Everything here seems to go upward in three vertical, weakly separated areas—a yellow, a reddish, and an orange-brown one. This dull repetition of verticality and the closeness of the colors have a monotonous effect. We miss the striking yet graded contrasts of the Picasso, its clear-cut quality, the more expressive variety of its shapes, and its vigorous economy.

We now move to an example of more outspoken abstract art, a lithograph by Wassily Kandinsky [167], from the *Kleine Welten* series which appeared in 1922. Here the allusion to natural forms seems abandoned. Shapes tend to be geometrical and are somewhat patterned by color or black and white. In spite of the great variety of forms and directions, which might easily have led to chaos, a concentric force is at work, which holds this little world together. The movements in and out of the circle, the many overlappings of the planes, the contrasts of color and shape, all co-operate in a concentric effect. From whatever angle one approaches the design, the eye is led into the inner circle and enjoys the variety of action, each part having a distinct function within this handsome and dynamic composition. One may well say that there is more than a merely decorative aspect and speak of a symbolic image that conjures up a little cosmos *(kleine Welt)* filled with energy yet controlled by the laws of attraction and repulsion. And we repeat: the variety, repetition, and contrast of shapes and color, their gradation in size and tone, as well as their sensitive integration into a coherent whole, contribute to this dramatic and symphonic effect.

If we look now at a colored serigraph by a later representative of the same abstract trend, Lynn Courtland—the artist calls this print *Receding Arches and Bell* [168]—we do not feel the same quality. Here also an effort seems to

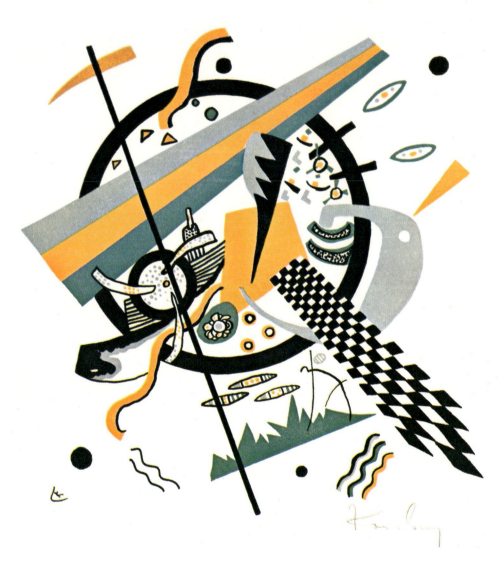

167 Wassily Kandinsky: *Abstraction* (*Kleine Welten*, Fourth Plate). 1922

have been made to suggest cosmic forces in action, by means of abstract shapes and colors and an irregular movement, but the design has little tension or coherence and is not at all as suggestive as the Kandinsky. The contrast of the large arch with the rest of the shapes and lines is rather overdone, the formal relationships in general are weak, and the color adds little to a mean-

ingful accentuation. In every way, it compares unfavorably with the inventiveness and originality that distinguish the Kandinsky.

Some readers may be disappointed that in the search for criteria of quality we do not go beyond the Kandinsky example into Abstract Expressionism or Geometrical Abstraction, both of which are favored trends of today. The reason is that, after our extended discussion of masterworks from the fifteenth to the twentieth century, I feel that in these current trends works of high artistic quality are extremely rare, not only in graphic art. If accidental features are introduced—such as color or ink dripped onto the surface, or too many amorphous scribbles supposedly indicating the subconscious—I doubt that a great work of art can result. This is also true if machine-made parts are used or technical tricks prevail, which have little or no expressive value. If, on

168 Lynn Courtland: *Receding Arches and Bell.* 1949

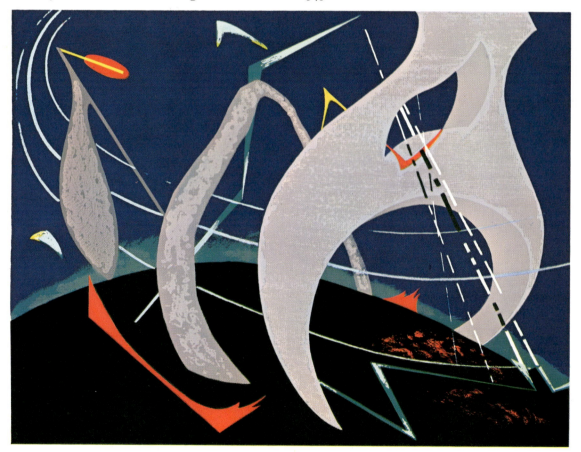

the other hand, the design is too strictly limited to a few geometrical shapes, the range of conscious creation seems to me also too narrow for the production of a work of high artistic quality, although many of these trends have an experimental value. In both movements, Abstract Expressionism and Geometrical Abstraction, we find colossal-sized works with only a few giant touches: stripes or shapes of the most simple sort. But in these I also believe that too little is present of an articulate and expressive creation to claim the rank of great art, or to hold our interest very long. As for Pop and Op art—to mention also the very latest—the same would be true. They come dangerously close to the borderline between art and non-art.

Conclusions

IF we now review the criteria of quality which we have derived from works of leading artists of the twentieth century, it will be noticed that in abstract as well as in representational art, formal organization is still an index of artistic quality. We have seen that such criteria as gradation and integration of the design are very important, as are inventiveness, originality, artistic economy, and suggestiveness. And other criteria that we observed in representational art will also be applicable, such as sensitivity, articulateness, consistency, selectiveness, vitality, range of accents, richness of formal relationships, intensity, flexibility, expressiveness, sense of balance, and feeling for the medium.

These are valid criteria, because they have sustained themselves through the ages, from the fifteenth century well into the twentieth. However, we must not forget that we derived them only from observing master drawings and graphic art, and it remains to be demonstrated that these criteria are also valid for other forms of art. The scope of our investigation will not be extended here to include these other forms, but I would like to add that, based on my own experience, it is quite possible to apply our criteria successfully to the field of painting, with some necessary adjustments, and even to the fields of

sculpture and the decorative arts, although here a more limited number will be applicable and others will have to be added. It is therefore best and most useful to search for criteria in each form of art before we make conclusions about their validity for the whole broad field.

Another serious limitation of our investigation lies in the fact that we compared only works of art of similar style and technique within the same period, but did not undertake the much more risky comparison of works of different periods and cultures, an area in which we have seen eminent critics of the past fail so badly. We will recall that Vasari and a host of followers debunked medieval art because of their own classicistic prejudices, and that Roger Fry placed Negro art above true masterworks of the Greek classical period. Something in us rebels at our inability to prove more distinctly how wrong these critics were. Could we not at least *approach* an absolute scale of quality, to the degree that we can more definitely refute those judgments that contradict so strikingly our own reaction, instead of having to be satisfied with the merely relative measurements which we have attained?

When I first published an article on our subject in 1951 under the title "The Problem of Quality in Old Master Drawings," I said at the end:

"Since we ourselves are not determining the scale of artistic values, but derive these values from the perception of the works of the great masters; since, furthermore, we can define their heights only in relation to that of their followers or contemporaries, we must beware of jumping too fast from such relative evaluations toward an absolute one.

"If we compare the great masters to mountain peaks dominating a certain range and their followers and close contemporaries to the lower mountains and hills surrounding these peaks, we have a situation somewhat analogous. In this case it is possible to measure approximately with the naked eye and without a fixed yardstick the relative heights within that mountain range. But without the help of an absolute scale and with the eye alone we are unable to compare the heights of peaks that are situated within different mountain ranges and cannot be seen at the same time. This simile may illustrate the limitations we face in our attempt to compare the artistic value of great masters [of different periods and styles].

"Yet if we have gathered sufficient experience in the evaluation of the single

great masters as compared to their surroundings, a certain general notion of the nature of great art will gradually develop, a standard of judgment which may work even without direct comparison."[1]

I still believe that this last statement holds true, but I may add that, for our insight into the nature of quality, it was not so much comparison which opened the way to full appreciation of a great work of art, as intensive analysis, backed by a broad knowledge of the artist's work and his position in history. Comparison only helped to test our criteria of excellence and to set up relative standards.

The question remains which is closely connected with the question raised about the possible extension of our *relative* quality judgment to an *absolute* one: How does content condition quality? In this book we have dealt more with the form of the works of art, and less with the content in the sense of subject matter, which in contemporary art is often elusive. Does great art really require great content, as the classicistic tradition stressed, and as both ancient Greek and medieval works and also works of later centuries seem to prove? Or can art lift the most humble subject, for instance, a few pieces of fruit—as rendered by Cézanne—to the highest level of artistic achievement?

There is no doubt that since the period of Impressionism we are inclined to assume the latter. The principle of *l'art pour l'art,* which developed in the nineteenth century, claims the independence of form from content. In fact if, for instance, we deny to Picasso's Cubism or to Kandinsky's more fully abstract art the level of high artistic quality because its content is of little significance in the traditional sense, we must also eliminate from the realm of great art not only Cézanne's apples, but also Chardin's still lifes and even Vermeer's psychologically uneventful interiors, and many more masterworks of the past. In other words, the movement to devaluate the content in favor of the purely aesthetic or pictorial aspect has been with us for a long time, at least since the seventeenth century. And therefore Cubist and Abstract art actually represent further steps in this development, bolder and more radical than all the preceding ones, because they did not shrink from experimentation' with a brand-new artistic language.

In view of this development, we dare to say only that in the past great content conditioned great art, but that in later centuries more humble and

finally more elusive content have not prevented art from reaching a considerable level of quality. There is, however, a noticeable narrowing down of the whole field of art to the purely aesthetic, and more often than not, the great ideals of humanity are no longer involved. Art thus seems more and more a reflection of our age of rigid specialization and of our strictly scientific and technological culture. That this culture is less favorable to an artistic climate and to a high level of quality than previous ones I am inclined to assume.

And in view of the increasing elusiveness of the content in contemporary art, it seems to me more and more important to rely for our value judgment primarily upon form. We cannot so easily go wrong here if we look intensely and are armed with some knowledge about the nature of artistic organization, in which abstract art—as we have tried to show—is still subject to the same laws of order and quality as the representational art of the past.

Finally, we ask again: Should we despair because our investigation has resulted only in relative standards of considerable limitations and because little more than the reaffirmation of time-tested judgments has been achieved? I do not think so. After all, we set out to go only as far as we could with reasonable certainty, in the hope of strengthening the objective aspect of our judgment while recognizing that the subjective could not be eliminated. Besides, I feel it is hardly wasteful to have had practice in making discriminations in a number of worthy works from various periods, while attempting to avoid as far as possible the pitfalls that beset critics of the past. Instead of speaking about the practicing of discrimination, one could well use the broader term: the "cultivating of sensibility and judgment," which Jacques Barzun, in a recent address,[2] defined as one of the major aims of education. In fact, I believe that only a constant effort at proper discrimination can bring us progress, and that only in this way can the prejudices and the predilections which our own time forces upon us be counteracted and to a considerable extent corrected.

NOTES

INTRODUCTION

1. Panofsky, *Meaning in the Visual Arts*, Garden City (Anchor paperback), 1955, p. 18 n.
2. Greene, *The Arts and the Art of Criticism*, Princeton, 2nd edn., 1947, p. 389.
3. Richards, *Practical Criticism*, New York and London, 1954, pp. 11–12.

CHAPTER I

1. Schlosser, *Die Kunstliteratur*, Vienna, 1924, pp. 253–304.
2. Reprinted in *Le Opere di Giorgio Vasari*, ed. G. Milanesi, Florence, 1878–1906, I–VII (hereafter referred to as "*Milanesi*"). English translation, G. Vasari, *Lives of Seventy of the Most Eminent Painters, Sculptors and Architects*, ed. E. H. and E. W. Blashfield and A. A. Hopkins, 4 vols., New York, 1923 (hereafter referred to as "*Lives*").
3. We use the term "Renaissance" in its broadest sense, including the "Late Renaissance," which is usually called "Mannerism."
4. *Lives*, IV, pp. 389–90.
5. Ibid., p. 390.
6. We shall quote for the most part from the prefaces to the *Lives*, which contain the essence of Vasari's theories and concepts; in the individual Lives themselves Vasari is primarily concerned with biographical facts and, in the tradition of *ekphrasis* from classical rhetoric, with narrative descriptions of various works (see Svetlana Leontief Alpers, "*Ekphrasis* and Aesthetic Attitudes in Vasari's *Lives*," *Journal of the Warburg and Courtauld Institutes*, XXIII, 1960, pp. 190 ff.). While Mrs. Alpers is persuasive in pointing out this relationship, her further conclusions, I believe, go too far in minimizing the presence of any theory or principles in Vasari's critical attitude. Her article, however, is full of excellent observations.
7. *Lives*, IV, pp. 394–95.
8. Ibid., pp. 396–97.
9. Ibid., p. 401.
10. Ibid., p. 402.
11. Ibid., pp. 402–3.
12. Ibid., pp. 404–5.
13. Ibid., p. 403.
14. For a discussion of this point and the following tentative synthesis of Vasari's aesthetics and criticism, see the excellent chapter "Vasari's ästhetischer und kunstkritischer Standpunkt" in Schlosser, pp. 285–94.
15. *Vasari on Technique*, tr. Louisa S. Maclehose, ed. G. Baldwin Brown, London, 1907 (New York, Dover paperback, 1960), p. 210. This volume contains the Introduction to the 1568 edition of the *Vite* (see *Milanesi*, I, pp. 168–77), which is not included in the English translation of the *Lives* referred to herein.
16. *Lives*, IV, pp. 258–59.
17. Ibid., pp. 262–63. A similar remark about Titian by Michelangelo is reported by Vasari.

18. Ibid., p. 398.

19. Ibid., pp. 291–92.

CHAPTER II

1. Roger de Piles, *Dissertation sur les ouvrages des plus fameux peintres avec la vie de Rubens*, Paris, 1681.

2. De Piles, *Cours de peinture par principes avec une balance des peintres*, Paris, 1708, pp. 27–28.

3. Ibid., pp. 19–20.

4. Amsterdam, 1766, p. 462.

5. De Piles, *Recueil de divers ouvrages sur la peinture et le coloris*, Paris, 1775, p. 6.

6. *Dissertation*, pp. 89 ff.

7. Ibid., pp. 93 ff.

8. De Piles, *Abrégé de la vie des peintres . . .* , Paris, 1699, p. 436.

9. *Cours de peinture*, p. 262: "Comparison gives things value, and it is only by comparison that one can really judge them."

CHAPTER III

1. *The Literary Works of Sir Joshua Reynolds*, ed. Henry William Beechey, Vol. II, London, 1890, pp. 205–6. Hereafter referred to as "*Works*."

2. Reynolds, *Discourses on Art*, ed. Robert R. Wark, San Marino, Calif., 1959, p. 109.

3. See Frits Lugt, *Les Marques de collections . . .* , Amsterdam, 1921, p. 441.

4. *Discourses*, pp. 163-64.

5. Ibid., pp. 109–10.

6. Ibid., pp. 147–48.

7. *Works*, II, p. 197.

8. Ibid.

9. *Discourses*, p. 249.

CHAPTER IV

1. *The Journal of Eugène Delacroix*, tr. Walter Pach, New York (Evergreen paperback), 1960, p. 253.

2. Bürger, *Musées de la Hollande*, Vol. II, Paris, 1860, pp. ix–xi.

3. Various of Thoré's Salon reviews were collected in two separate books: W. Bürger, *Salons de Théophile Thoré, 1844, 1845, 1846, 1847, 1848*, Paris, 1868; and T. Thoré, *Salons de W. Bürger, 1861 à 1868*, 2 vols., Paris, 1870.

4. Joseph C. Sloane, *French Painting Between the Past and the Present*, Princeton, 1951.

5. *Salons de T. Thoré*, p. ix.

6. For an account of other important catalogues and articles by Thoré, as well as biographical details, see H. Marguery, "Un Pionnier de l'histoire de l'art: Thoré-Bürger," *Gazette des Beaux-Arts*, 5th per., XI, 1925, pp. 229–45, 295–311, 368–80. Thoré's concept of a good catalogue is summed up in the Preface to his book *Galerie Suermondt à Aix-la-Chapelle* (Paris, 1860, pp. vii-viii):

"In my opinion, every catalogue that has the aim of popularizing a gallery ought to be accompanied by a general survey in which artistic sentiment is brought into play, mastering the creations most worthy of enthusiasm, setting them apart and in their true light,

interpreting and glorifying them. That is the procedure I have employed for the Arenberg Gallery, also for the *Musées de la Hollande,* and for the 'Trésors d'art' exhibited at Manchester [Thoré's principal catalogues]."

7. *Musées de la Hollande,* Vol. I, Paris, 1858, p. 22.

8. Ibid., p. 78.

9. Ibid., p. 79. Toward the end of his life Thoré made minor adjustments in this evaluation and came even closer to our present estimation by identifying Rembrandt, Frans Hals, and Vermeer as the three most outstanding masters.

10. Ibid., I, pp. 37–38.

11. Ibid., I, pp. 200–201.

12. Ibid., II, pp. 9–10.

13. Ibid., II, pp. 121–22.

14. See A. Heppner, "Thoré-Bürger en Holland," *Oud-Holland,* LV, 1938, pp. 17–34, 67–82, 129–44.

15. *Gazette des Beaux-Arts,* 1st per., XXI, 1866, pp. 297–330, 458–70, 542–75; also printed separately.

16. *Musées de la Hollande,* I, p. 272.

17. Ibid., II, pp. 68–69.

18. Ibid., II, p. 71.

19. Ibid., II, pp. 73–75.

20. Ibid., II, pp. 76–77.

21. Ibid., II, p. 79.

22. Ibid., II, pp. 79–80.

23. Ibid., I, pp. 271–72; II, 132–35.

24. Ibid., I, pp. 118–19, 123–26.

25. Ibid., I, pp. 211–19.

26. Ibid., I, pp. 126–36.

27. Ibid., I, pp. 143–44.

28. *Salons de W. Bürger,* I, pp. 91–101.

29. Ibid., II, p. 531.

30. *Musées de la Hollande,* I, p. 19.

31. Wilhelm von Bode, *Mein Leben,* Berlin, 1930, I, p. 26.

32. In *Zeitschrift für bildende Kunst,* Leipzig, 1869, p. 346.

CHAPTER V

1. Kenneth Clark, Introduction to Fry's *Last Lectures,* New York and Cambridge, 1939, p. ix.

2. For an account of his life, see Virginia Woolf, *Roger Fry: A Biography,* London, 1940.

3. Fry, "Giotto," *Monthly Review,* December 1900, pp. 139–57; and February 1901, pp. 96–121, also reprinted in *Vision and Design,* New York, 1927, pp. 87 ff.

4. Fry, *Cézanne: A Study of His Development,* New York and London, 1927.

5. Ibid., pp. 21–22.

6. Ibid., pp. 38–39.

7. Ibid., pp. 42–43, 47.

8. Ibid., pp. 58–59.

9. Ibid., pp. 63–64.

10. Ibid., pp. 71–74.

11. Ibid., pp. 78, 80.

12. See Fry, *Transformations: Critical and Speculative Studies on Art,* London, 1926, pp. 96 ff.

13. Fry, *Last Lectures,* p. 28.

14. Ibid., p. 40.

15. Ibid., pp. 42–43.

16. Ibid., p. 44.

17. Ibid., p. 48.

18. Ibid., p. 114.

19. Ibid., p. 194.

20. Ibid.

21. Ibid., pp. 194–95.

22. Ibid., p. 195.

23. Fry, *The Arts of Painting and Sculpture,* London, 1932.

24. Clark, Introduction to Fry's *Last Lectures,* p. xxv.

CHAPTER VI

1. O. Fischel, "Die Zeichnungen der Umbrer, ii," *Jahrbuch der preussischen Kunstsammlungen,* Supplement, 1917, pp. 89 and 95.

2. *London, British Museum. Italian Drawings in the Department of Prints and Drawings in the British Museum. Raphael and His Circle,* catalogue by Philip Pouncey and J. A. Gere, 1962, i, pp. 48 ff. and 155 (therein called a copy after Viti).

CHAPTER VII

1. Some retouching of the Madonna's right eye has resulted in a slight distortion which, however, does not impair the lofty character of this head.

2. Published by Justus Müller-Hofstede, *Pantheon,* xxiii, May–June 1965, pp. 163 ff., fig. 17.

3. *Paris, Musée du Louvre. Inventaire général de dessins des écoles du nord. Ecole hollandaise: iii, Rembrandt, ses élèves, ses imitateurs, ses copistes,* by Frits Lugt, 1933, p. 19, No. 1152.

CHAPTER VIII

1. Alfred H. Barr, Jr., *Picasso: Fifty Years of His Art,* New York, 1946, p. 82.

CONCLUSIONS

1. Jakob Rosenberg, "The Problem of Quality in Old Master Drawings," *Bulletin,* Allen Memorial Art Museum at Oberlin College, viii, Winter 1951, p. 49.

2. Jacques Barzun, "The Vanishing College," *Harvard Alumni Bulletin,* February 15, 1964, p. 379.

APPENDIXES

I · ROGER DE PILES

p. 32

Cours de peinture par principes avec une balance des peintres, Paris, 1708, pp. 27–28:

J'aime tout ce qui est bon dans les Ouvrages des grans Maîtres sans distinction des noms & sans aucune complaisance. J'aime la diversité des Ecoles célèbres; j'aime Raphaël, j'aime le Titien, & j'aime Rubens: je fais tout mon possible pour penetrer les rares qualites de ces grans Peintres: mais quelques perfection qu'ils ayent, j'aime encore mieux la vérité.

pp. 32–33

Cours de peinture, pp. 19–20:

. . . le Coloris, composé de toutes ses parties qui sont le clair-obscur, l'harmonie des couleurs, & ces mêmes couleurs que nous appellons Locales, lors qu'elles imitent fidellement chacune en particulier la couleur des objets naturels que le Peintre veut representer.

p. 33

Elémens de peinture pratique, Amsterdam, 1766, p. 462:

Ceux qui n'ont pas cultivé leur esprit par les connoissances des principes, au moins spéculativement, pourront bien etre sensibles à l'effet d'un beau tableau, mais ils ne pourront jamais rendre raison des jugemens qu'ils en auront porté.

p. 33

Première conversation sur la peinture, in *Recueil de divers ouvrages sur la peinture et le coloris,* Paris, 1775, p. 6:

La véritable connoissance de la peinture consiste à sçavoir si un tableau est bon ou mauvais, à faire la distinction de ce qui est bien dans un même ouvrage d'avec ce qui est mal, & de rendre raison du jugement qu'on en aura porté.

pp. 33–34

Dissertation sur les ouvrages des plus fameux peintres avec la vie de Rubens, Paris, 1681, pp. 89 ff.:

The page numbers in the left column indicate the text of this volume, where the passages are quoted in English.

... Le caractére de ce Tableau est proprement le désordre et le desespoir, dont Rubens n'a point eu d'autre modéle, que l'idée qu'il s'est faite de ces paroles de l'Evangile: 'Allez maudits aux flammes eternelles, le sejour du desordre et de l'horreur.' Cet horreur et ce desordre paroissent dans tout l'Ouvrage. C'est un grand nombre de malheureux, abandonnez à la rage et au desespoir; qui par la pesanteur naturelle de leur corps, et par la maniére dont ils sont disposéz, semblent estre dans le moment d'une chute actuelle & précipitée, pendant qu'une infinité d'autres sont brûlez dans les flammes, ou plongez, selon les termes de l'Ecriture, dans un estang de souffre. Et pour trouver de la diversité dans ses figures, il a representé ces damnez sous la laideur de sept pechez mortels, qu'il a marquez particuliérement par le dragon à sept testes de l'Apocalypse, & chacun y est diversement tourmenté, selon la diversité de son crime, & toujours par où il a offensé; mais cela avec un variété si ingénieuse, qu'il ne se peut rien davantage: & la seule chose en quoy toutes ses figures se resemblent, c'est qu'elles portent avec elles un caractére de malédiction.

pp. 34–36 *Dissertation*, pp. 93 ff.:

Le Dessin en est savant, & d'un grand goust; & l'extrème difficulté pour ne pas dire l'impossibilité de se servir du Naturel, pour peindre, ou dessiner ces sortes d'actions qui sont en l'air, doit nous convaincre plénement, que Rubens estoit tres-savant dans la partie du Dessin, & que son génie, joint à une expérience consommée le rendoit maitre absolu de son Art & de ses regles.

Les expressions des testes sont vives & pénétrantes; & on y voit la nature de leur crime & l'excés de leur tourment.

Les liaisons d'objets, si nécessaires en Peinture, ou pour parler, comme les Peintres, les groupes qui se rencontrent en ce Tableau sont inventez avec tant d'imagination, tant d'esprit, & tant d'Art, qu'ils surpassent de beaucoup tout ce qui s'est fait jusqu'icy dans ce genre, & quelque debroüillez que soient ces groupes & separez les uns des autres, ils concourent neanmoins tous à l'assemblage des lumiéres & des ombres, & à l'effet du Tout-ensemble: en sorte que ce grand fracas de figures se laisse voir avec autant de facilité & de repos, que s'il n'y en avoit qu'une seule. Et ce qui est de remarquable entr'autres choses dans ce grand Ouvrage, c'est qu'il n'y a rien d'inutile, & que les moindres choses considérées toutes en particulier, paroissent un effort de l'imagination du Peintre. Enfin, tout contribuë a l'unité de l'objet, par une admirable intelligence de lumiére

& d'ombre, comme tout contribuë à l'unité d'action, par une expression genérále & particuliére de tout ce que l'on peut imaginer de plus terrible.

L'artifice du *Coloris* y est merveilleux dans son accord, dans son opposition, et dans sa variété, & cette variété de carnation parmi un si grand nombre de figures nuës, n'est pas une des moindres perfections du Tableau.

Il y a tant de beautez dans le général & dans le particulier de cet Ouvrage, qu'il faudroit un long discours, pour en faire une description bien exacte: Et aprés tout, j'avouë que celuy que je m'éforcerois de faire seroit fort au dessous de d'idée que j'en conçois. J'adjouteray seulement que cet Ouvrage, qui est le désespoir des damnez, est aussi celuy des Peintres: car la veuë des autres Ouvrages de Rubens leur échauffe bien l'imagination, et leur laisse croire, qu'en s'efforçant de les imiter ils pourroient avec le tems parvenir à quelque chose de semblable: mais en voyant celuy-cy, ils confessent tous qu'il est inimitable, & que si Rubens par ses autres productions, a ou égalé, ou passé tous les Peintres, il s'est mis par celle-cy au dessus de luy-mesme, & ne permet pas d'esperer qu'à l'avenir nous puissions rien voir qui en approche.

p. 43 *Abrégé de la vie de peintres. Idée du peintre parfait,* Paris, 1699, p. 436:

 . . . une infinité de pensées qui n'ont pas moins de sel & de piquant que les productions des meilleurs Peintres.

p. 236, n. 9 *Cours de peinture,* p. 262:

La comparaison fait valoir les choses, & ce n'est que elle qu'on en peut bien juger.

II · THÉOPHILE THORÉ (W. BÜRGER)

pp. 67–69 *Musées de la Hollande,* Paris, 1860, ii, pp. ix–xi:

Par un mirage singulier, toutes les fois que nous pensons à Rembrandt et aux Hollandais, aussitôt Raphaël et les Italiens nous apparaissent, en contraste aux artistes du Nord. Durant des années, nous avons donc vécu presque sans cesse, moitié avec les Italiens et Raphaël, moitié avec nos Hollandais et Rembrandt qui jamais ne nous quitte. Ces morts illustres, notre seule compagnie dans la solitude, nous ont tourmenté, le jour et la nuit, en nous proposant sans cesse leurs énigmes si divergentes.

Un matin, trouvant dans un *magazine* à images les portraits de Raphaël et de Rembrandt, nous nous mîmes à les découper machinalement pour les accrocher avec une épingle à la muraille, comme font les plébéiens, les enfants et les artistes. Raphaël est tourné à gauche, Rembrandt à droite. Impossible de les attacher face à face: ça aurait l'air d'une double ironie. Naïvement, nous les accolâmes dos à dos, et, au-dessus des deux têtes rapprochées à rebours et à contre-poil, nous écrivîmes: JANUS...

Tel fut le résumé instinctif de toutes nos élucubrations sur ces deux grands génies.

A eux deux, en effet, ne sont-ils pas le Janus de l'art? Raphaël regarde en arrière; Rembrandt regard en avant. L'un a vu l'humanité abstraite, sous les symboles de Vénus et de Vierge, d'Apollon et de Christ; l'autre a vu directement, et de ses propres yeux, une humanité réelle et vivante. L'un est le passé, l'autre l'avenir.

Nous dirions encore volontiers que le grand art italien est l'épanouissement suprême d'une société toute développée et qui allait se faner; que le petit art hollandais est le germe d'une société encore latente et qui doit pousser et verdir;—que Raphaël est une fleur, et Rembrandt une racine.

pp. 73–74 *Musées de la Hollande,* Paris, 1858, i, p. 22:

...l'un est tout en dedans, l'autre tout en dehors; l'un est mystérieux, profond, insaisissable, et vous fait replier sur vous-même:

toute peinture de Rembrandt, même connue d'avance par des descriptions ou des estampes, cause toujours, quand on la voit pour la première fois, une indéfinissable surprise; ce n'est jamais ce à quoi on s'attendait; on ne sait que dire; on se tait et on réfléchit;—l'autre est expansif, entraînant, irrésistible, et vous fait épanouir: toute peinture de Rubens communique la joie, la santé, une exubérance extérieure de la vie. Devant Rembrandt on se recueille, devant Rubens on s'exalte.

Grands magiciens tous deux, mais par des procédés absolument inverses.

pp. 74–77 *Musées,* I, pp. 78–79:

Gérard Dou passe pour le premier des *petits* peintres hollandais, comme son maître Rembrandt pour le plus grand artiste de la Hollande.

Cela est vrai de Rembrandt, qui, en effet, domine incommensurablement tous ses compatriotes, et a pris rang dans la pléiade suprême, consacrée, au-dessus des nationalités diverses, par l'humanité entière. Le Vinci, Michel-Ange, Raphaël, Corrège, Titien, Velazquez,—Jan van Eyck, Albrecht Dürer, Rubens, Rembrandt,— comme Dante, Cervantes, Molière, Shakespeare, Goethe,—appartiennent à tous les peuples.

Rembrandt est sans pareil dans son pays—et dans le monde. Gérard Dou a beaucoup d'égaux dans son pays, quoiqu'il n'ait des semblables nulle part. Les trois Adriaan (le nom est de bonheur!)— van Ostade, Brouwer et van de Velde,—Aalbert Cuijp, Paul Potter, Jan Steen, Pieter de Hooch, Terburg, Metsu, Philips Wouwerman, Willem van de Velde, Ruijsdael, Hobbema, valent assurément Gérard Dou, chacun en son genre, et avec un génie différent.

p. 77 *Musées,* I, pp. 37–38:

Il est très-curieux de passer quelques heures entre ces deux chefs-d'œuvre qui se sont toujours disputé *la palme* de la grand école hollandaise et ont souvent excité des fanatismes exclusifs. On se retourne de l'un à l'autre, on s'étudie, on s'interroge pour chercher à s'expliquer la divergence absolue des impressions qu'ils causent.

Tous deux, chacun à sa manière, poussent la *réalité* jusqu'à l'*illusion.* Mais ce rapprochement de mots lui-même prouve qu'il n'y a rien de moins réel que la *réalité* en peinture. Ce qu'on appelle ainsi dépend de la *manière de voir* des individus. Car toutes les combinaisons de l'effet que peut produire un corps quelconque sont dans la nature, et dans ces combinaisons, infiniment diverses, on

voit plus ou moins ceci ou cela, selon son imagination intérieure. Les artistes vraiment doués de la faculté poétique ont des manières de voir très-particulières. Ce que Léonard a vu dans *la Joconde,* personne ne l'y eût vu sans doute. . . . Si tout à coup, sans songer à peinture, on se trouvait face à face avec l'homme jaune de *la Ronde,* on s'effacerait pour le laisser passer avec sa pertuisane. C'est donc aussi la réalité, mais comme l'a vue Rembrandt sous un éclair de génie.

La manière de voir de van der Helst, au contraire, est plus générale, ou plus vulgaire, c'est le même mot. Elle s'accorde mieux avec le sens commun à la foule. La scène du *Banquet* apparaîtrait ainsi, ou à peu près, à tout le monde. Et c'est pourquoi le tableau de van der Helst a toujours eu un succès plus universel que le tableau de Rembrandt.

p. 78 *Musées,* i, pp. 200–201:

Je ne crois pas que dans aucune école il y ait un tableau qui représente plus sincèrement et plus intimement la nature.

Ainsi parfaite, *la Leçon d'anatomie* ne serait-elle pas un chef-d'œuvre de premier ordre? Peut-être. Les raffinés lui préfèrent, et de beaucoup, plusieurs autres tableaux de Rembrandt: *la Ronde de nuit,* incomparablement. Cette *Leçon d'anatomie* est la nature, mais un peu comme tout le monde la voit (est-ce le suprême mérite dans les arts?) et comme la rendrait une belle photographie. Le génie particulier qui saisit un aspect imprévu de la vie n'a point passé par là, et "la griffe du lion" n'y a point gravé son empreinte. Le signe mystérieux, qui éclate dans *la Ronde de nuit* et stupéfie tout le monde au premier regard, n'y est point. Rembrandt à ce moment-la, s'il était de la force des premiers maîtres, ne s'était pas encore cependant trouvé lui-même tout entier.

pp. 78–81 *Musées,* ii, pp. 9–10:

La figure entière de la fiancée, tête, mains,—la droite surtout est admirable,—ajustements et bijoux, est absolument terminée, même avec amour et avec un extrême bonheur d'exécution. La tête de l'homme aussi est travaillé jusque dans les derniers accents du modelé. Elle rappelle un peu, comme ampleur de pratique, certaines têtes des *Syndics,* et tout à fait, comme profondeur de physionomie et comme ton, la tête de Jan Six dans l'incomparable portrait de la galerie Six van Hillegom. Mais le vêtement jaune semble à l'état de brusque et grossière ébauche, et la manche jaune est maçonnée lourdement avec une pâte en relief, que Rembrandt se proposait

sans doute de gratter pour n'en conserver que des dessous vigou-
reux. Car ce tableau n'est pas fini, et le fond est demeuré à l'état
fantastique. . . .

Mais que cet état imparfait du tableau est intéressant pour les
peintres, et quel enseignement il leur offre! et comme il révèle bien
la manière de procéder de Rembrandt! Ah! donc il enlevait d'abord
ses personnages, les faisait sortir de néant, les modelait, les caressait
dans leurs traits principaux, les animait, leur donnait la vie, occupé
seulement de sa création humaine, bien sûr d'harmoniser ensuite
avec ses êtres vivants tous les accessoires de l'entourage. Le fond
indéfini demeurait en arrière comme un voile frotté seulement au
ton convenable pour faire éclater les têtes et la tournure caractéris-
tique de l'ensemble. Puis, sur ces espèces de limbes neutres, le
maître trouvait n'importe quoi, des masses d'arbres, quelque palais
féerique dans les profondeurs, et tout à coup l'air et l'espace étaient
créés autour des personnages.

Alors le tableau était fait et parfait.

p. 82 *Musées*, II, pp. 121–122:

Ses grands tableaux de l'hôtel de ville de Haarlem, représentant
des officiers du S. *Joris Doelen* . . . sont bien précieux, comme types
précisément de ses deux manières: l'un est de la même année que
ce portrait du musée van der Hoop, 1639: dix-neuf figures, de
grandeur naturelle, vues jusqu'au-dessous des genoux; ce sont les
arquebusiers de la compagnie du colonel Johan van Loo, groupés
autour de lui; Hals en est, le deuxième à gauche, vers le sommet.
Tenez que c'est un des chefs-d'œuvre de la haute école hollandaise.
Une maestria incomparable, un dessin accusé, solide, grandiose et
libre, comme dans le Tintoret, à qui on a souvent envie de comparer
Frans Hals. Il connait la peinture de Rembrandt alors, et cette jeune
concurrence sans doute l'a poussé à une couleur plus profonde, à
une expression plus intime des physionomies, à un effet plus har-
monieux et plus tranquille, tout en conservant la brusquerie éner-
gique de l'exécution.

pp. 85–86 *Musées*, I, p. 272:

Mais voici un grand peintre, dont la biographie n'est pas plus
connue que celle de Hobbema, et dont les œuvres sont encore bien
plus rares. On sait seulement qu'il est né à Delft vers 1632, et c'est
pourquoi, afin de le distinguer de ses homonymes, on l'appelle van
der Meer de Delft . . .

Où trouver de ses tableaux, pour le connaître en l'étudiant? C'est seulement chez M. Six van Hillegom, dans deux tableaux très-différents, une *Vue d'intérieur de ville hollandaise,* et une *figure de Femme,* découpée sur un lambris pâle, qu'on peut avoir une idée de cet artiste bizarre. Il manie la pâte comme Rembrandt; il fait jouer la lumière comme Pieter de Hooch, qu'il imite un peu; il a aussi quelque chose d'Aalbert Cuijp; et il tourne ses personnages avec une certaine violence, très-particulière et très-fantasque.

Dans le tableau de La Haye, *Vue de la ville de Delft, du côté du canal,* il a poussé les empâtements à une exagération qu'on rencontre parfois aujourd'hui chez M. Decamps. On dirait qu'il a voulu bâtir sa ville avec une truelle, et ses murs sont de vrai mortier. Trop est trop. Rembrandt n'est jamais tombé dans ces excès. S'il empâte les clairs quand un vif rayon fait jaillir une forme, il est sobre dans les demi-teintes, et il obtient la profondeur des ombres par de simples et légers frottis.

La *Vue de Delft,* malgré cette maçonnerie, est pourtant une peinture magistrale et tout à fait surprenante pour les amateurs à qui van der Meer n'est pas familier. Elle a été payée 2,900 florins à la vente Stinstra, en 1822.

pp. 87–88 *Musées,* II, pp. 68–69:

L'exécution de cette peinture singulière est très-délicate, presque mince, la pâte très légère, la couleur faible et même un peu sèche. Il est vrai que ce tableau est très-frotté. D'habitude, au contraire, van der Meer de Delft a la touche franche et la pâte grasse et abondante, même exagérée dans sa *Vue de Delft,* au musée de La Haye; une incomparable fermeté de dessin et de modelé dans la *Laitière* de la galerie Six van Hillegom; un coloris extrêmement chaud et harmonieux dans la *Façade d'une maison hollandaise,* même galerie.

Ces différences de pratique nous ont fait hésiter longtemps sur l'originalité de la *Liseuse* du musée van der Hoop. Cependant la physionomie de cette femme est d'une finesse exquise; les bras nus, la main qui tient le papier, sont dessinés à merveille; l'ensemble a beaucoup d'étrangeté; et puis, cette lumière pâle, ces bleus tendres, tout cela accuse Delftsche van der Meer.—Ce diable d'artiste a eu sans doute des manières diverses.

Le tableau avait même une signature, sur un livre ouvert sur la table, et quoique les lettres en soient presque effacées, on y devine encore: *Meer.* Il a d'ailleurs une tradition que nous avons retrouvée: dans le catalogue . . . d'une vente à Paris en 1809 . . .

p. 88 *Musées*, II, pp. 73, 75:

Ce tableau de Brunswick est encore tout autre de style, de composition, et de pratique, que les tableaux mentionnés précédemment. Il contient trois personnages, dans un intérieur très-élégant.... Les figurines ont la dimension de celles de Terburg et de Metsu....

Je ne connais pas de plus delicieux tableau *de genre* dans toute l'école hollandaise du dix-septième siècle ... Ici, van der Meer n'est plus le peintre brusque de son paysage du musée de La Haye; ce qu'il cherche, ce n'est plus la fermeté et le caractère de la *Laitière* de la galerie Six; c'est la suprême élégance dans cette coquette aux formes fines et allongées, à la physionomie attrayante, voluptueuse, spirituelle. L'exécution est sobre, serrée, sans empâtements, si ce n'est quelques petites touches de rehaut dans les clairs et les accessoires. Terburg n'est pas plus léger de pinceau et de coloris.

pp. 88–89 *Musées*, II, pp. 76–77:

Mais voici bien un autre chef-d'œuvre de van der Meer de Delft, —à ce même musée de Dresde, si célèbre, et que toute l'Europe artiste doit connaître sans doute! un tableau ... avec quatre figures de *grandeur naturelle!* Et ce tableau est exposé au plus bel endroit, dans la vaste salle des Hollandais, précisement au-dessus d'un des plus précieux tableaux de toute la collection, du portrait de "Rembrandt tenant sur les genoux sa femme Saskia!" Et il y fait à merveille! Et personne, apparemment, n'a été intrigué par ce "*Jacob* van der Meer, *né à Utrecht*," à qui la peinture est attribuée dans le catalogue! Ce *Jacob d'Utrecht* a toujours été confondu avec le Jan de Schoonhaven, et pour moi je ne connais point ses œuvres. S'il était l'auteur de ce tableau de Dresde, il mériterait place parmi les premiers maîtres de l'école hollandaise.

p. 89 *Musées*, II, pp. 79–80:

Le corsage jaune de la courtisane est peint à pleine pâte et par paquets drus, sans huile, comme les écorces de citron dans les tableaux des de Heem, et c'est devenu un émail profond. La force et l'harmonie de la couleur, le naturel des attitudes, l'esprit des physionomies, la puissance et bizarrerie de l'effet, tout indique Jan van der Meer de Delft....

... la première qu'on puisse signaler sur une peinture de Delftsche. Elle permet d'en tirer bien des déductions, et d'éclaircir un peu la biographie du *sphinx*.

Mettons que van der Meer soit né en 1632, comme on le suppose.

Le voilà en 1656, a vingt-quatre ans, aussi fort que les maîtres. Et d'où sort-il? Il sort de chez Rembrandt. Ce tableau de Dresde suffirait seul à le prouver. L'homme à la guitare est tout à fait rembranesque. L'audace des tons francs combinés avec des dégradations prodigieuses de clair-obscur, la sincérité profonde des expressions, la pose de la pâte ferme dans les lumières, les frottis transparents dans les ombres, c'était Rembrandt qui enseignait ces secrets-là.—1656! C'était juste aussi la bonne époque de Nicolaas Maes, avec qui van der Meer a beaucoup d'analogie; c'est encore l'époque où commençait Pieter de Hooch, cet autre sosie de van der Meer. Pour moi, il n'y a plus de doute que Jan van der Meer de Delft n'ait travaillé chez Rembrandt, de 1650 à 1655, en même temps que Nicolaas Maes, et probablement que Pieter de Hooch.

p. 96 *Musées,* II, p. 19, n. 1.

Il y a bien longtemps que j'étudie la peinture, mais il n'y a pas très-longtemps que je me suis aperçu que je n'en savais presque rien. J'avais toujours eu pourtant une passion extrême, un œil vif et sûr, un instinct presque infaillible, et néanmoins je n'avais guère d'autre certitude que cet instinct seulement. Pourquoi? C'est que, d'ordinaire, je n'avais étudié chaque tableau que pour ses qualités particulières, sans me tourmenter des circonstances où il avait été peint, ni de son classement chronologique dans l'œuvre du maître, ni de la biographie du maître lui-même.

Lorsque de longs voyages m'ont permis d'examiner à loisir la plupart des collections de l'Europe et d'étudier à fond celles de quelques pays, j'ai perçu confusément la série des œuvres de chaque maître, objet de mon inquiétude spéciale; j'ai compris que, pour pénétrer le caractère d'un artiste, il fallait reconstruire l'ensemble de son œuvre, et que c'était dans la peinture même qu'on retrouverait les éléments perdus de la biographie du peintre.

J'ai donc procédé à nouveau, comme un homme ne sachant rien de tout et oubliant ce que les autres croyaient savoir; et "allant avec simplicité du connu à l'inconnu," ainsi que je le dis dans la préface des *Musées d'Amsterdam et de La Haye,* j'ai rapproché successivement, les uns des autres, les tableaux à mesure que je les voyais. Peu à peu la lumière c'est faite, et aujourd'hui je sais mes principaux Hollandais, de leur origine à leur fin,—pour quelques-uns, année par année, sans interruption depuis leurs premiers essais d'écolier, sous l'influence de tel ou tel maître, jusqu'à leurs ultièmes productions.

Si je raconte ces choses personnelles, c'est pour recommander le même procédé aux amoureux de l'art érudits, critiques ou collectionneurs.

p. 236, n. 6 *Galerie Suermondt à Aix-la-Chapelle,* Paris, 1860, pp. vii–viii:

A notre avis tout catalogue qui a pour but de populariser une galerie doit être accompagné d'une revue générale où le sentiment artiste intervient à son tour, s'empare des créations les plus dignes d'enthousiasme, les met hors ligne et dans leur vrai jour, les interprète et les glorifie; c'est le procédé que nous avons employé pour la Galerie d'Arenberg, et aussi pour les Musées de la Hollande et pour les "Trésors d'art" exposés à Manchester.

INDEX

A page number preceded by an asterisk indicates an illustration.